AngloModern

AngloModern

*Painting and Modernity
in Britain and the United States*

JANET WOLFF

CORNELL UNIVERSITY PRESS

ITHACA AND LONDON

Copyright © 2003 by Cornell University

All rights reserved. Except for brief quotations in a review, this book, or parts
thereof, must not be reproduced in any form without permission in writing from the
publisher. For information, address Cornell University Press, Sage House, 512 East
State Street, Ithaca, New York 14850.

First published 2003 by Cornell University Press

First printing, Cornell Paperbacks, 2003

Printed in the United States of America

Library of Congress Cataloging-in-Publication Data

Wolff, Janet.
Anglomodern : painting and modernity in Britain and the United States
/ Janet Wolff.
p. cm.
ISBN 0–8014–3923–X (cloth : alk. paper)—ISBN 0–8014–8742–0 (pbk. :
alk, paper)
1. Modernism (Art)—Unites States. 2. Modernism (Art)—Great Britain.
3. Painting, American—20th century. 4. Painting, British—20th
century. 5. Gender identity in art. 6. Ethnicity in art. I. Title.
ND212.5.M63 W65 2003
 709'.41'0904—dc21 2002152331

Cornell University Press strives to use environmentally responsible suppliers and
materials to the fullest extent possible in the publishing of its books. Such materials
include vegetable-based, low-VOC inks and acid-free papers that are recycled,
totally chlorine-free, or partly composed of nonwood fibers. For
further information, visit our website at www.cornellpress.cornell.edu.

Cloth printing 10 9 8 7 6 5 4 3 2 1

Paperback printing 10 9 8 7 6 5 4 3 2 1

Contents

Illustrations

Acknowledgments

The earliest essay in this book (chapter 5) was written during the year I received a John Simon Guggenheim Memorial Foundation Fellowship (1993–94), and I thank the foundation for that award. In 1999–2000 I was awarded a fellowship to study at the Society for the Humanities at Cornell University, where I was able to do a good deal more work on this project; many thanks to Dominick LaCapra and to colleagues at the society for their support and helpful criticism. I would also like to thank Michael Ann Holly and Michael Conforti at the Clark Art Institute for facilitating a symposium I convened there in May 2000 on the theme "Modernism/Realism/Revisionism," and to the participants in that three-day event: Tim Barringer, David Peters Corbett, Michael Leja, Nancy Mowll Mathews, Elizabeth Prettejohn, Lisa Tickner, and Sylvia Yount.

For most of the time I was writing this book, I was director of the Visual and Cultural Studies Graduate Program at the University of Rochester. I thank my colleagues there—and especially Michael Holly, Douglas Crimp, Grace Seiberling, Ralph Locke, Trevor Hope, Liz Goodstein, and Bob Foster—for many conversations about shared intellectual concerns, and for the wonderful camaraderie that I look back on with gratitude and great affection. The VCS community of graduate students was for me the ideal *Gemeinschaft*; the difficulty of separating from it when it was time for me to leave Rochester has only been mitigated by the fact that I knew that I would remain friends with many of the Rochester students past and present. Some of them are thanked individually for research assistance and other help in the

paragraphs that follow. Here I thank them all collectively, and especially those who participated in my various classes on modernism and gender. I would also like to thank the students in my modernism class at Cornell University in 2000 (which included seven Rochester students who drove down to Ithaca each week); I know that our discussions in class have informed my thinking for this book. I completed this book during my first year at the School of the Arts, Columbia University; I would like to thank Bruce Ferguson and my other colleagues there—faculty, staff, and students—for providing such a pleasant and friendly environment, as well as the flexibility that allowed me to finish my editing.

Thanks to David Peters Corbett for encouraging my growing interest in English art, and for many conversations and e-mail exchanges about English art and modernism. Thanks to Martin Berger, Doug Howard, Howard Singerman, Lucy Curzon, Cyril Reade, Keith Moxey, and Sarah Webb for discussions about the central themes of this book.

By chapter, I make the following acknowledgments. For Chapter 1, thanks to Howard Singerman, Martin Berger, and Evelyn Hankins for very helpful discussions of this project; to Anita Duquette at the Whitney Museum for invaluable advice and assistance; and to the late Charles Wright for research assistance. I'd also like to thank those who attended and responded to various talks I gave on this topic at the University of North Carolina, Chapel Hill; the Nova Scotia College of Art and Design; the City University of New York Graduate Center; McGill University, Montreal; and the Susan B. Anthony Institute for Gender and Women's Studies at the University of Rochester.

For Chapter 2, thanks to Marc Leger for invaluable preliminary research on McEnery in Rochester, and to Lucy Curzon for extensive archival and internet research and for many helpful conversations. Thanks, too, to Professor Alessandra Comini at Southern Methodist University, and to Brandon Pope, fine arts librarian at SMU, for arranging to send me Eleanor Tufts's notes on McEnery and the NMWA exhibition. Finally, thanks to all the people I interviewed in Rochester between the fall of 2000 and the summer of 2001, and to the Cunningham/Williams family in California, Virginia, Washington, D.C., New York, Connecticut, Vermont, Massachusetts, and Oregon for information and the loan of letters and documents, for allowing me to visit them and photograph works, and for their warmth and hospitality.

Chapter 3 was first presented in the form of a lecture delivered at the Bunkier Gallery of Contemporary Art in Cracow, Poland, in March 2000. Thanks to Adam Budak for inviting me to participate in his lecture series there.

Various versions of chapter 4 were presented as lectures at the following locations: Getty Summer Institute, University of Rochester, N.Y.; Department of Art History, University of California, Santa Cruz; Cornell University Art History Graduate Conference, Ithaca, N.Y.; Institute of Cultural Studies, Adam Mickiewicz University, Poznan, Poland. Thanks to all those who extended invitations and to audiences and respondents.

An earlier version of chapter 5 was first presented at a conference held in April 1994 at the Graduate Center of the City University of New York; thanks to Gene Lebovics and Patricia Mainardi for organizing the conference, and to participants for their comments. This talk was subsequently given at an interdisciplinary seminar held at the University of Saskatchewan in November 1994; thanks to Lynne Bell for inviting me and to members of the seminar—especially Keith Bell—for their comments.

The issues raised in the afterword were discussed in a lecture presented at the 1999 conference "The European Axes of British Modernism," held at Falmouth College of Art in England; thanks to David Cottington for inviting me to speak there. I also lectured on this topic at the Prague Academy of Art in 2000; thanks to Jindrich Vybiral and Martina Pachmanova for inviting me and to participants for their response.

Finally, four of the essays in this book have been published elsewhere, and I am grateful for permission to reprint them here with revisions: "Women at the Whitney, 1910–1930: Feminism/Sociology/Aesthetics," *Modernism/Modernity* 6 (September 1999); "The Feminine in Modern Art: Benjamin, Simmel, and the Gender of Modernity," *Theory, Culture & Society* 17 (December 2000); "The Failure of a Hard Sponge: Class, Ethnicity, and the Art of Mark Gertler," *New Formations* no. 28 (May 1996); and "The 'Jewish Mark' in English Painting: Cultural Identity and Modern Art," in *English Art, 1860–1914: Modern Artists and Identity*, ed. David Peters Corbett and Lara Perry (Manchester: Manchester University Press, 2000).

AngloModern

Introduction

AngloModern: The Painting of Modern Life

At the very end of the twentieth century, it seemed that the story of art had been hurriedly rewritten. Activities in the museums and galleries of New York City suggested a collective decision to overthrow what had been the dominant narrative about modern art for the past half century. The fact that this was taking place in New York was particularly significant because this had been the central locus of the construction of that narrative ever since, as Serge Guilbaut has put it, New York stole the idea of modern art after the Second World War.[1] In the late 1990s and in the year 2000, art that had been marginalized or rendered invisible by museum practice and art-historical discourse—notably realist and figurative art—was suddenly high profile. Gallery exhibitions of the work of realist painters proliferated.[2] End-of-century blockbuster exhibitions at the Museum of Modern Art, the Whitney Museum of American Art, and the Guggenheim Museum all broke with the practice of favoring modernism in their accounts of the early twentieth century, offering a radically eclectic view of visual cul-

[1] Serge Guilbaut, *How New York Stole the Idea of Modern Art: Abstract Expressionism, Freedom, and the Cold War* (Chicago: University of Chicago Press, 1983).

[2] Examples include: Margarett Sargent at Berry-Hill Galleries (September 1996); Jane Peterson at Hirschl & Adler Galleries (September 2001); Fairfield Porter at the AXA Gallery (April 2000); Lucian Freud at the Acquavella Gallery (April 2000). Museum exhibitions included Eastman Johnson at the Brooklyn Museum of Art (October 1999); William Merritt Chase at the Brooklyn Museum of Art (May 2000); and Ben Shahn at the Jewish Museum (November 1998). Outside New York City: "The School of London and Their Friends" at the Neuberger Museum of Art, Purchase (March 2001).

1

ture in the period.[3] The Guggenheim's "1900" show presented work in the salon style of that period, refusing to differentiate between modern artists (Cézanne, Degas, Matisse, Picasso) and academic, traditional, and sentimental (kitsch) painters—referred to by art critic Robert Hughes as "the stuff modernism overthrew."[4] A hundred years after the fact, viewers were implicitly invited to take an anthropological and historical interest in this eclecticism and, as one of the organizers put it, "to identify what, before modernism was born, still looks modern today."[5] Reviewers certainly had no trouble separating out the real art from the "second-rate."[6] Although it may have done nothing to challenge aesthetic hierarchies, the experience of encountering such unexpected juxtapositions certainly offered the possibility of seeing differently—of beginning to raise questions about how such a narrow and linear account of Western art could have emerged from what, in hindsight, appears as a chaotic, undifferentiated mass. The same was true of MoMA's three-part "MoMA 2000," exhibit, whose first installment, "Modern Starts" (1880–1920), went further in mixing media (painting, prints, photographs, posters, and even furniture).[7] Here the impulse was not so much to recreate the contemporary experience but rather to put works in historical context, as well as to make thought-provoking connections between images and between images and artifacts (not necessarily on the basis of synchrony).[8] The culmination of this startlingly revisionist behavior on the part of art professionals was the arrival in art museums of major exhibitions pre-

[3] "The American Century: Art and Culture, 1900–1950" (Whitney Museum of American Art, 1999); "Modern Starts: People, Places and Things" (Museum of Modern Art, 1999); "1900: Art at the Crossroads" (Guggenheim Museum, 2000; also shown at the Royal Academy in London).

[4] Robert Hughes, "The Stuff Modernism Overthrew," *Time*, June 5, 2000, 78–80.

[5] Norman Rosenthal, quoted by Alan Riding, "Three Shows on 1900, not as a Landmark but as a Bridge," *New York Times*, April 5, 2000.

[6] See, e.g., Peter Schjeldahl, "The Pleasure Principle: The Case for Promiscuity at the Guggenheim," *The New Yorker*, August 7, 2000, 80. See also Michael Kimmelman, "Kitsch in Sync with Treasures," *New York Times*, May 19, 2000.

[7] The second and third parts were "Making Choices" (1920–1960) and "Open Ends" (1960–2000), respectively.

[8] For a summary and discussion of the "MOMA 2000" exhibit, see Michael Kimmelman, "A Nonlinear Way to Grasp the Past," *New York Times*, September 12, 1999; Peter Schjeldahl, "The Reinvention of MOMA: Millennial Narcissism at the Museum of Modern Art," *The New Yorker*, January 17, 2000; Holland Cotter, "Time Jumps the Track," *New York Times*, October 8, 1999; Roberta Smith, "Art Every Which Way But Straight Ahead," *New York Times*, November 21, 1999; Holland Cotter, "A Postwar Survey Semi-Wild at Heart," *New York Times*, September 29, 2000.

senting the work of illustrators Maxfield Parrish and Norman Rockwell; after tours of the country, both exhibitions ended up in New York (at the Brooklyn Museum of Art in 2000 and the Guggenheim in 2001, respectively).

The story of modern art that is challenged by these events is the narrative tracing the development of Western painting from France to the United States, in a lineage more or less running from Manet and Post-Impressionism, by way of Cubism and Surrealism, to Abstract Expressionism. It is a story produced and reinforced by critics, academics, curators, and museum directors—most famously (or notoriously) formulated early on by Alfred Barr, MoMA's first curator of painting and sculpture, and subsequently enshrined in that museum's collection and display.[9] Barr's 1936 diagram, which mapped the early stages of this trajectory on the occasion of the MoMA exhibition "Cubism and Abstract Art," paved the way for the New York School to be seen, a couple of decades later, as inheriting the spirit of modernism, and for the institutional and aesthetic confirmation of a newly streamlined narrative, in place by the mid-twentieth century.[10] The negative effect of this discursive shift was, among other things, the sidelining of other artists, movements, and styles. As has often been pointed out, the Francocentric prejudice has marginalized German and Russian modernism (Expressionism, Neue Sachlichkeit, Constructivism), at the same time as it has excluded nonmodernist modern art in the United States and in other Western countries.[11] It has privileged modernist (post-Cubist) and abstract art at the expense of realist and figurative work. The challenge to this hegemony, however, is not new. In 1977 the artists R. B. Kitaj and David Hockney were discussing "the

[9] See, e.g., Carol Duncan and Alan Wallach, "The Museum of Modern Art as Late Capitalist Ritual: An Iconographic Analysis," *Marxist Perspectives* 4 (1978): 28–51.
[10] See Glen Macleod, "The Visual Arts," in *The Cambridge Companion to Modernism,* ed. Michael Levenson (Cambridge: Cambridge University Press, 1999), 194–98.
[11] On the occasion of the opening in New York in the fall of 2001 of the Neue Galerie, a new art museum devoted to German and Austrian modernism (1890–1940), a reviewer welcomed its advent at a time when it was still the case that "in New York, European modernism tends to be dominated by the French." See Roberta Smith, "A Museum Finds Small Is Beautiful," *New York Times,* November 16, 2001. Earlier she had pointed out ("Art Every Which Way but Straight Ahead," *New York Times,* November 21, 1999) that the first installment of "MoMA 2000" "still radiates an oppressive Francophilia, reflected in the ubiquity of works by Picasso, Cézanne and Matisse, the constant references to Paris and the absence of much painting by anyone else—Americans, Germans, British."

case for a return to the figurative" (a long-term campaign for both men); in the 1980s a number of important exhibitions in Britain and the United States took on the task of foregrounding figurative art.[12] Scholars of British twentieth-century art, taking up issues originally raised by Charles Harrison in 1981, have made the case for a serious revision of our notion of what "modern art" might be in different cultural and geographical contexts.[13] The various critiques of art-historical orthodoxy and curatorial practice—from feminist and minority artists and critics, postcolonial perspectives, and critical museology and visual cultural studies—have inevitably had their impact on museum professionals, with implications for exhibition planning and display in the early-twenty-first century.

The Whitney Museum's "century" show was of particular interest at this historic moment of reconsideration. For the first part of the two-part exhibition ("The American Century"), which covered the years 1900–1950, the curators were obliged to show the American art world as it had really been in the first half of the century and not as post-1950 art historians have portrayed it. It was mainly in retrospect that Ashcan and other realist artists suffered a drastic decline in reputation, and it was only in retrospect that the 1913 Armory Show, in introducing European modernism to the United States, appeared to have achieved the instant dismissal of what in 1908 had itself seemed

[12] R. B. Kitaj and David Hockney, untitled conversation, *New Review* 3, nos. 34–35 (January–February 1977): 75–77. See also Linda Nochlin, "The Realist Criminal and the Abstract Law," *Art in America* 61 (September 1973): 54–61, and (November–December 1973): 96–103. Exhibitions include: "The Human Clay" (curated by R. B. Kitaj), Hayward Gallery, London, 1976; "The Figurative Tradition and the Whitney Museum of American Art," Whitney Museum of American Art, 1980; "A New Spirit in Painting," Royal Academy of Arts, London, 1981; "The Hard-Won Image: Traditional Method and Subject in Recent British Art," The Tate Gallery, London, 1984; and "The Pursuit of the Real: British Figurative Painting from Sickert to Bacon," Manchester City Art Galleries, 1990. French nineteenth-century realism was given prominence in a major exhibition which traveled to Cleveland, New York (Brooklyn Museum of Art), St. Louis, and Glasgow in 1980–82; issues raised by the show are discussed by Charles Rosen and Henri Lerner in "What Is, and Is Not, Realism," *New York Review of Books*, February 18, 1982, 21–26 and March 4, 1982, 29–33.

[13] Charles Harrison, *English Art and Modernism, 1900–1939*, 2nd ed. (New Haven: Yale University Press, 1994); David Peters Corbett, *The Modernity of English Art, 1914–30* (Manchester: Manchester University Press, 1997); David Peters Corbett and Lara Perry, eds., *English Art, 1860–1914: Modern Artists and Identity* (Manchester: Manchester University Press, 2000); Lisa Tickner, *Modern Life and Modern Subjects: British Art in the Early Twentieth Century* (New Haven: Yale University Press, 2000).

ultramodern art to its contemporary viewers.[14] In fact, in the decades before the Second World War the New York art world was much more open and heterogeneous.[15] Even the Whitney Museum did not align itself with the MoMA narrative until the 1950s; its storage facilities tell the story of its prewar aesthetic choices.[16] Although the critics were at best polite and at worst dismissive about the work on display—Peter Schjeldahl said of the rediscovered "little masters" in the show, "I now find myself understanding why each of them came to be neglected in the first place"; he greeted the opening of the second part (1950–2000) with the words "This is more like it"— for once viewers were given the chance of seeing American modern art that was not oriented to Europe.[17] Until now prestige has accrued mainly to artists in the Alfred Stieglitz circle (Georgia O'Keeffe, Marsden Hartley, Arthur Dove, John Marin) and other modernists who had studied in Paris and Berlin or been influenced by European modern art (Max Weber, Man Ray, Stanton Macdonald-Wright, Morgan Russell, Charles Sheeler, Stuart Davis).[18] An important exhibition in Washington, D.C., in 1996, with an accompanying catalogue of essays and illustrations, reintroduced the Ashcan artists to viewers—and, I would suggest, to the canon—at about the same time as major exhibitions displaying the works of the figurative artists R. B. Kitaj, Edward Hopper, and Lucian Freud appeared in key museums.[19] The Whitney Mu-

[14] Here I am challenging the more usual view, expressed in an exhibition review by Ken Johnson: "Early in the 20th century American art was finding its own way just fine, thank you. Then along came the Armory Show, and the juggernaut of European Modernism brushed the Eight, the Ash Can School and all that into the dust bin of outmoded parochialism." "Inheriting Cubism," *New York Times*, December 7, 2001.

[15] As Holland Cotter put it, the exhibition forced a rethinking of the "blinkered view" of the dominant story of American art, allowing an understanding that "American art in the first half of the century was an unruly, multifaceted, undefinable phenomenon, alternatively hyped up and strung out, streetwise and above it all, emerging from a patchwork of disparate constituencies for whom no national style, modernist or otherwise would ever do." ("Nation's Legacy, Icon by Icon," *New York Times*, April 23, 1999).

[16] See chapter 2 for a discussion of this shift.

[17] See Peter Schjeldahl, "American Pie: The Whitney's Empty Blockbuster," *The New Yorker*, May 17, 1999, and "All That Jazz: The Whitney Celebrates the Triumph of Postwar American Art," *The New Yorker*, October 18 and 25, 1999.

[18] See Abraham A. Davidson, *Early American Modernist Painting, 1910–1935*, 2nd ed. (New York: Da Capo, 1994).

[19] See Rebecca Zurier, Robert W. Snyder, and Virginia M. Mecklenburg, *Metropolitan Lives: The Ashcan Artists and Their New York* (New York: Norton, 1996). The show

seum itself allowed what could be seen as a critical comment on its own postwar prejudices in the form of an exhibition organized by invited curators from London, whose emphasis was on the continuing (but somewhat hidden) tradition of American realism.[20]

In the final chapter of this book I consider the extent of this revisionism and the prospects for a real transformation of the art-historical orthodoxies we have lived with for the past fifty years. The primary focus of the essays in this book, however, is the exploration of the construction of those orthodoxies and not their dismantling. I am interested in the social coordinates of the production of "modernism," both at the moment of its emergence in the early twentieth century and in the later context of the politics and institutions of the postwar period in which the history of modern art was reformulated and consolidated. A good deal has been written about the art-historical discourses during and after the mid-century and their role in producing a linear and exclusionary narrative about modern art.[21] The complicated intersections of cultural policy, international politics, institutional imperatives, and aesthetic debates—centered in but not confined to New York—resulted in the privileging of post-Cubist modern art over other contemporary forms of visual representation. The ways in which questions of race and gender were implicated in these negotiations have recently come under critical investigation.[22] My own interest is in the art practice of the first decades of the last century, and in several chapters of this book I explore the particular social arrangements in which artists in England and the United States (primarily in London and New York) practiced, exhibited, and were judged by the critics. In some cases, tracing their reputations has necessarily in-

was held at the National Museum of American Art. The Kitaj exhibition was at the Tate Gallery, the Los Angeles County Museum of Art, and the Metropolitan Museum of Art (1994–95); the Hopper exhibition was at the Whitney Museum in 1995; and the Freud exhibition was seen at the Whitechapel Gallery, London, the Metropolitan Museum, and the Nacional Centro de Arte Reina Sofia, Madrid, in 1993–94.

[20] See Nicholas Serota, Sandy Nairne, and Adam D. Weinberg, eds., *American Realities* (New York: Whitney Museum of American Art, 1997).

[21] See Guilbaut, *How New York Stole the Idea of Modern Art*; the essays in *Pollock and After: The Critical Debate*, ed. Francis Frascina (London: Harper & Row, 1985); and Francis Frascina and Charles Harrison, eds., *Modern Art and Modernism: A Critical Anthology* (London: Harper & Row, 1982).

[22] See, e.g., Michael Leja, *Reframing Abstract Expressionism: Subjectivity and Painting in the 1940s* (New Haven: Yale University Press, 1993); and Ann Eden Gibson, *Abstract Expressionism: Other Politics* (New Haven: Yale University Press, 1997).

volved looking at the later reception of their work, as in the case of the "Whitney women" (chapter 1) and the New York/Rochester artist Kathleen McEnery (chapter 2). The question of gender is central to four of these investigations; in particular, I have attempted to map the "gendering" of visual discourse onto the rise and fall of realist and figurative painters. But here (especially in the first and fourth chapters) I stress that this is not necessarily a question of women's work. The gendering of realism as "feminine" applies equally to men's work.[23] In the case of the Whitney women, this strategy was both contemporary and—perhaps more important—retroactive from the point of a high modernism with a clearly masculinist bias.[24] Chapters 3 and 4 address more general questions of gender and modernity, suggesting that we move from a "politics of correction" (in which the exclusions and prejudices of gender are noted) to a "politics of interrogation" (exploring instead the construct of masculinity, with its immanent contradictions). Chapters 5 and 6 consider the place of ethnic difference in early-twentieth-century British visual culture, specifically Jewish identity in relation to modernist and nonmodernist art practice.

It is a regret of mine that I have not here been able to devote more attention to the intersections between gender and ethnicity or, for that matter, between each of these axes of differentiation and categories of class. In my discussion of the English artist Mark Gertler (chapter 5) I suggest that social class played a central role in Gertler's self-perception, determining his ambiguous situation within the Bloomsbury group and shaping the more or less radical tendencies in his aesthetic practice. In my study of the life and work of Kathleen McEnery (chapter 2) I discuss her early success and her subsequent "disappearance" in terms of the multiple, cross-cutting factors of gender, class, provincialism/cosmopolitanism, and amateurism/professionalism. In gen-

[23] In a very helpful reader's report on my book, Michael Leja made the important point that realism has also been aggressively masculine at certain moments, while modernism itself has been "feminized" by such strategies. I am aware that in characterizing these gendering tendencies in twentieth-century art discourses I am sometimes simplifying a more complex set of negotiations—and that these varied somewhat from decade to decade. Nevertheless, it is the general tendency I am keen to identify, and I do believe that in the cases I discuss the primary effect is the equation of realism with "the feminine," especially in the retrospective view of the postwar period.

[24] See Leja, *Reframing Abstract Expressionism*.

eral, though, my focus has been more singular, with the result that what I present here is a series of case studies, each dealing primarily or solely with questions of gender or questions of ethnicity. I am sure there is a great deal more to be said about the ways in which class complicates the matter in each case, or the ways in which ethnicity always has its own gender dimension. Perhaps more problematic is the suggestion of an implicit underlying contradiction, a clear split between the essays on gender and the essays on ethnicity and Jewish identity.[25] In my discussion of the gendering of realism, there is a way in which I am "siding" with the feminine (the excluded) against what is dominant ("masculine" modernism). At least my project is the critical analysis of the exclusionary, hierarchical, discursive practices of a high-modernist position. In the two chapters on Jewish artists in England—particularly in chapter 6, where I discuss the negative critical discourses equating "modernism" with "foreign-ness" (and with Jews) in the early twentieth century—I act as the champion of the modernists (Gertler, Bomberg, Epstein). I think part of the explanation for this apparent inconsistency is chronological. That is, the negative evaluation of realism that I challenge is largely (though not entirely) retroactive from the point of view of a postwar perspective in which modernism is highly privileged. As I suggest in the chapter on the Whitney women, the prewar moment was much more fluid and open, without the kind of orthodoxy that developed later. The negative evaluation of modernism as the work of foreigners and outsiders, which I also analyze and challenge, was a contemporary fact—it was the evaluation of critics and audiences immersed in that early moment well before modernism had become dominant (or even respectable). The establishment, engaged in apparently contradictory evaluations (pro and contra modernism) was very different in 1910–20 and in 1950–60 (and since).

The other explanation for the dual nature of the "AngloModern" in my text is no doubt autobiographical. In my work on Kathleen McEnery—the chapter devoted to her was the last one written for this book—I spent over a year "living within" the upper middle class in Rochester, both in the sense that I was immersing myself in the biog-

[25] I wish to thank David Lubin for pointing this out. It was something that I had not fully articulated, and his perceptive critique gave me the opportunity to think this matter through.

raphy and story of a rich, leisured, privileged woman who came from a wealthy New England background and married into one of the elite families of Rochester, New York, and also in the sense that I devoted a lot of time to interviewing people who had known her (including several impressive women in their nineties) and who shared her background and her lifestyle. Talk of servants, summers in Europe, debutante balls, and acquaintance with social and cultural elites became less and less strange to me as I spent the last of my ten years in Rochester getting to know East Avenue (the beautiful boulevard where George Eastman had his mansion, where the upper middle classes had lived since 1900—and where, in the year 1999–2000, some of them still did). The contrast with my personal involvement in the Mark Gertler study (the first of these chapters to be written) could not be more striking. Living in England (which I did until my mid-forties), I was, like everyone else there, finely attuned to class difference and class prejudice. My family background was lower middle class, and I was also Jewish and from a northern industrial city. The upper-middle-class world of the Bloomsbury group would have been as alien to me as it seems to have been to Gertler. The 1905 Aliens Act (which I discuss in chapter 5) was designed to keep out of England Jews like my mother's parents, who emigrated as children from eastern Europe in the first years of the twentieth century. (A later wave of immigration and rejection occurred in the 1930s, when my father came to England in 1938 as a refugee from Germany.)[26] It is not that I think that England is an antisemitic society or, for that matter, that the United States is a classless society. But as an "alien" myself (technically a "resident alien"), I was far less invested in the subtleties of belonging and exclusion in my different life in Rochester and in the United States. What is more, as a Brit I could "pass" with regard to class and social background, the clues of voice and accent being far less detectable; indeed, in conversation with people who spoke the New England version of American English I probably fit in very well. I am well aware that this is much more a question of "seeing oneself seen" than objectively grasping the actual processes of classification

[26] See David Cesarani, "An Alien Concept? The Continuity of Anti-Alienism in British Society Before 1940," in *The Internment of Aliens in Twentieth Century Britain,* ed. David Cesarani and Tony Kushner (London: Frank Cass, 1993), 25–52; Tony Kushner, *The Persistence of Prejudice: Anti-Semitism in British Society During the Second World War* (Manchester: Manchester University Press, 1989).

among my respondents and my new friends. But even in the historical study of the women at the Whitney (chapter 1), which did not involve interviews or meetings, I was conscious of "mixing," without my usual English inhibitions, in circles to which I did not belong. Identifying less with structures of class and ethnicity in the American case studies, I could focus on gender without being beset by anxieties of other kinds of social difference. This, I want to make clear, is by way of biographical explanation of interest in and orientation to my research. It does not invalidate the projects in either case. As we know very well by now, scholarly work is always motivated, always partial and perspectival, and very often (especially in the humanities) fundamentally connected to the personal.

The case studies in this book discuss art and artists in two countries, both of which have seen much of their artistic production in the decades before 1950 marginalized or denigrated by critics and historians. (The term "AngloModern," which I employ to link these studies, is not intended to do more than identify my two primary fields of interest as English-speaking cultures and perhaps also to draw attention to some interesting parallels in the development of their art worlds over a forty- or fifty-year period.)[27] Even the modernist art produced in Britain and America in those years has generally been considered inferior to European modernism. More to the point, the predominance of a continuing realist and figurative tradition in both places at that time has worked very much to the disadvantage of the international prestige of the artists and schools in question. One of the primary defenses for this hierarchy of aesthetic styles—sometimes explicit but more often implied—is that only modernism is "the painting of modern life."[28] Though the Ashcan artists in the United States

[27] I claim no stronger connections than these, and certainly no relationship of dependence. What they have in common, as I argue in the particular cases, is marginalization (of both their realisms and their modernisms) in relation to the modernism of Continental—and especially French—modernism.

[28] The term, of course, is taken from both Charles Baudelaire (who was writing about the mid-nineteenth-century illustrator Constantin Guys) and T. J. Clark (whose book of that title is about French Impressionism); in the twentieth century the assumption has generally been that modernism is par excellence the painting of modern life. See Charles Baudelaire, "The Painter of Modern Life" [1863] in *The Painter of Modern Life and Other Essays*, trans. and ed. Jonathan Mayne (Oxford: Phaidon, 1964); T. J. Clark, *The Painting of Modern Life: Paris in the Art of Manet and His Followers* (New York: Knopf, 1985).

and the Camden Town artists in England were among the first to paint modern subjects, the perception has been that Cubism, Expressionism, and Futurism were best able to capture the speed, fragmentation, and alienation of modern urban life.[29] The critic Ken Johnson has asked the question: "How can stable realism ever depict an unstable era in which reality is always in flux?"

> The essence of modern life, as Robert Hughes explained in his essential modern-art textbook *The Shock of the New*, is process. More than fixed structures, it is flux that most deeply characterizes city life, and the forms of art that have flourished in modern times—Cubism, Expressionism and Surrealism—have come about because premodern forms, made for a world that changed imperceptibly slowly, could not adequately represent a world in which nothing is stable, where all that is solid melts into air.[30]

(The kind of thinking that underlies this commitment to homology of form has been nicely undermined by Hal Foster's critique of assumptions about Expressionism.)[31] The preference for modernism has also been reinforced in political terms by those persuaded by the Brechtian and Frankfurt School argument (taken up in the 1970s in film theory) that realist texts (visual or literary) fail to represent real contradictions and effect false closure, resolution, and harmony, or a kind of apolitical aesthetic catharsis, at the expense of political and social critique.[32] Gradually, though, the progressive aspects of realism have begun to be identified and the possibility of a *non*modernist

[29] The following is typical: "Clearly [modernism] is an art of a rapidly modernizing world, a world of rapid industrial development, advanced technology, urbanization, secularization and mass forms of social life. Clearly, too, it is the art of a world from which many traditional certainties had departed, and a certain sort of Victorian confidence not only in the onward progress of mankind but in the very solidity and visibility of reality itself has evaporated." Malcolm Bradbury and James McFarlane, eds., *Modernism, 1890–1930* (Harmondsworth, Eng.: Penguin, 1976), 57.

[30] Ken Johnson, "Following the Fickle Modern Beat," *New York Times*, July 14, 2000. This is a review of an exhibition ("Manhattan Contrasts: 20th Century Paintings of New York from the Collection of the New York Historical Society") consisting of "generally conservative, representational paintings."

[31] Hal Foster, "The Expressive Fallacy," in his *Recodings: Art, Spectacle, Cultural Politics* (Seattle: Bay Press, 1985), 59–77.

[32] See Eugene Lunn, *Marxism and Modernism: An Historical Study of Lukács, Brecht, Benjamin, and Adorno* (London: Verso, 1985); Colin MacCabe, "Realism and the Cinema: Notes on Some Brechtian Theses," *Screen* 15, no. 2 (1974): 7–27.

modern art affirmed.[33] Indeed, a major section of "MoMA 2000," with its own substantial catalogue, was called "Modern Art Despite Modernism," its focus the "anti-modernist impulse" of figurative art.[34] For some the divide between modernism and nonmodernism (realism) is far from clear; it is certainly the case that the terminology becomes very confused. (Modernism is not necessarily abstract—the figure appears in Cubist and Futurist work—which makes the opposition of modernism/figurative art suspect. As many critics have also pointed out, the definition of "realism" is by no means fixed.)[35] Despite this, I have found it useful to employ what, after all, has long operated (though always with a certain blurring at the boundary) as a dichotomy of style. The notion of the "AngloModern," with which I undertake these explorations, already puts into question the long-standing view that in the early twentieth century it was only modernism that was "the painting of modern life."

The first four chapters focus on questions of gender and modern art. I begin chapter 1 with a description of the idea for an exhibition I was invited to propose (to the Whitney Museum). It explains the failure of this exhibition to materialize through an examination of its proposed theme (the work of women artists in the Whitney Studio Club) and an account of the changing focus of my research on the project. The discovery that these artists—for the most part hardly known now

[33] See, e.g., Abigail Solomon-Godeau, "Realism Revisited," in *Self and History: A Tribute to Linda Nochlin*, ed. Aruna D'Souza (London: Thames and Hudson, 2001), 69–75. However, in the preface to the second edition of his groundbreaking study *English Art and Modernism, 1900–1939*, Charles Harrison reaffirms the view that realism is inherently conservative.

[34] See Robert Storr, *Modern Art Despite Modernism* (New York: Museum of Modern Art, 2000).

[35] David Solkin has suggested that "much stands to be gained by reopening the boundaries between modernist and other forms of painterly practice." See "The British and the Modern" in *Towards a Modern Art World*, ed. Brian Allen (New Haven: Yale University Press, 1995), 6. Andrew Causey, pointing out that "the concept of the real is not a stable one right through the [twentieth] century," maintains that for British artists like David Bomberg and Frank Auerbach "realism needs to be redefined." See "The Possibilities of British Realism," in *The Pursuit of the Real*, ed. Tim Wilcox (London: Lund Humphries, 1990), 19, 26. David Peters Corbett and Lara Perry are prepared to extend the term "modernism" to include realist painting (which is not necessarily formally innovative); see introduction to *English Art, 1860–1914*, 2. Brendan Prendeville argues that the meaning of "realism" shifts, and that we can see "the real as modern"; *Realism in 20th Century Painting* (London: Thames and Hudson, 2000), 14.

(as measured, for example, by a survey of books on American art or exhibition catalogues)—were, in fact, rather successful in the interwar years led me to consider the complex intersections of gender and aesthetics in this case. In short, I argue that the denigration of their work (and, incidentally, of related work by their male colleagues and associates) has to be understood as an aspect of the denigration—and feminization—of realist and figurative art of that period. The fact that this process of evaluation was consolidated after the Second World War makes it clear how the Whitney Museum was still exhibiting the work of these artists until the late 1940s, and how they could have disappeared from sight since then. My research (and the nonexhibition) raises interesting questions of aesthetics and of curatorial practice, which I return to in the final chapter. In chapter 2 I present a case study of the American woman artist Kathleen McEnery, whose career I trace, including her early success (inclusion in the 1913 Armory Show in New York), subsequent "disappearance" from the national and international art scene, and "rediscovery" in 1987 on the occasion of the inaugural exhibition of the National Museum of Women in the Arts in Washington, D.C. The interplay of the aesthetic, the discursive, and the sociological can clearly be seen in this case study, which, as I have indicated, raises questions of gender, class, professional status, and geography.

In chapter 3 I review current literature on the *flâneur* and attempts by a number of feminist historians and cultural critics to claim for women the position of *flâneuse*. This continues to be a crucial debate in the study of modernity (and hence of modernism in the arts), and it has been the focus of several books and articles. Against the tendency of much of this work, I maintain that despite the proliferation of available public spaces for women (department store, movie theater), the particular activity of *flânerie* was never a possibility for them. My main objective in this chapter, though, is to "demote" the *flâneur* from his position of prominence in social and cultural theory in order to facilitate a conceptualization of "the modern" which no longer renders women invisible or marginal. My suggestion here is that current work in urban theory will prove useful in this endeavor.

My aim in chapter 4 is to retrieve the notion (or *a* notion) of "the feminine" in the study of modern art. That is, I review the indisputably valuable work of feminist art historians who have demonstrated the operation of the term in the denigration of women's work,

and who have also exposed the masculinist bias of modernism (and of discourses about modern art). However, I propose that one can mobilize the concept of "the feminine" in the service of the interrogation of modernism—both in the sense of examining the construction (and contradictions) of "the masculine" in modern art and in the sense of identifying moments of "femininity." My intention here, of course, is to introduce an entirely nonessentialist concept of "the feminine," one that permits access to the discursive and visual production of gendered meanings. To accomplish this, I discuss at some length the contributions of Georg Simmel and Walter Benjamin to the analysis of "the gender of modernity," which, I suggest, help us to see just *how* modernity (and, by extension, modern art) came to be gendered.

The next two chapters address ethnicity in modern art, in particular the question of Jewishness in visual culture. In chapter 5 I discuss the work of the English artist Mark Gertler, situate his art practice in the context of the class culture of early-twentieth-century England, and explore the ways in which class, ideology, and Jewish identity manifest themselves in visual texts. In chapter 6 I take up the same theme, but here I focus on the ways in which the discourse of "Englishness" (very much in formation in this period) was dependent on its (then) paradigmatic Other—the Jew. I next consider this discursive process, discussed by a number of social historians, as applied to the field of art criticism by examining critical responses to the work of certain Jewish artists based in England during this period. In the afterword I return to the late-twentieth-century moment of art-historical revisionism in order to assess its extent and its implications—for curatorial practice, art-historical writing, and aesthetic judgment.

Women at the Whitney, 1910–30

Feminism, Sociology, Aesthetics

In October 1994 I was invited by the Whitney Museum of American Art to develop a proposal for an exhibition in the museum's series "Collection in Context."[1] The series, which began in June 1993 with an exhibition on Edward Hopper in Paris, consisted of shows "featuring key works in the Whitney Museum's Permanent Collection," with the intention "not to isolate the works exhibited, but rather to set them in two different but related contexts: first, as products of their original time and place; second, in terms of their relevance to contemporary critics and today's audiences."[2] The exhibitions were conceived and organized by outside curators, scholars, and artists; they were displayed in a single room (roughly 40 feet by 23 feet in size) on the first floor of the museum and typically ran for about three months. Other themes of exhibitions in the series included "Gorky's Betrothals," "A Year from the Collection, circa 1952," "Joseph Cornell: Cosmic Travels," and "Breuer's Whitney—Anniversary Exhibition."

I was encouraged to develop a proposal that would bring feminist scholarship to the project. Since my own interests are primarily in art of the early twentieth century, I decided to focus on women artists from that period whose work was prominent in the collection when the museum opened in November 1931. It became clear that this would involve looking at social networks and art circles connected

[1] Letter dated October 7, 1994, in author's possession, from John G. Hanhardt, Curator, Film and Video, Whitney Museum of American Art (hereafter WMAA).

[2] Adam D. Weinberg, Curator, Permanent Collection, WMAA, "Hopper in Paris" (exh. brochure, 1993).

with Gertrude Vanderbilt Whitney and her assistant, Juliana Force, and particularly the Whitney Studio Club, which operated from 1918 to 1928. Eventually—this rather extended process was dependent on visits to New York and finding time between other commitments—I submitted a proposal in January 1996, suggesting an exhibition of the work of some of these women artists, specifically sixteen works by fourteen artists. After another delay (and a change of curator at the Whitney), I arranged to go to New York and look at the works themselves. (Up to this point I had only been able to look at reproductions at the museum. All the work I was interested in—and this itself is part of the story—had long been in storage in the Whitney's warehouse in downtown Manhattan.) This visit to look at the paintings, which I did in the company of the curator of the permanent collection, proved to be more or less decisive. In short, our joint assessment seemed to be that the work simply did not merit exhibition. I postponed the decision for a few months, but more or less abandoned any idea of doing this show—at least at the Whitney Museum—by early 1997.

The story of the nonmaterialization of the exhibition is, I think, an interesting one that raises many questions. The point here is that in retrospect (actually very soon after these events transpired) I began to question this ostensibly "aesthetic" judgment. On a number of occasions I showed slides of the work of these women artists in the context of talks I gave on the subject, and each time at least some of those present expressed real interest in the images and encouraged me to pursue the idea of an exhibition. I started to ask myself what was involved in the assessment of these paintings as uninteresting or second-rate. It also occurred to me that the conditions under which I had viewed the works were far from ideal—brought up from storage and propped on the floor by a couple of warehouse employees. As a novice curator (I had only organized one other exhibition),[3] I was also aware that I was deferring, to some extent, to the judgment of the Whitney curator who was with me. Looking back, I realized that my disappointment in the work was, among other things, very much a product of my own aesthetic (modernist) prejudices, which coincided with and were strongly reinforced by those of the Whitney (in the per-

[3] This exhibition, "Pictured Women," was held at the Memorial Art Gallery in Rochester, New York, in 1995.

son of the curator). Not long after my visit to New York to view the work, the art critic of the *New York Times* wrote a scathing and sarcastic review of the then current exhibition in the series, which showed the work of Raphael Montañez Ortiz, in which he dismissed the academic pretensions of its curator and responded to the latter's description of the artist in the accompanying brochure ("one of the central figures in . . . a now-forgotten international movement") with the comment: "It certainly is."[4] The last thing I wanted was a review of an exhibition of the "Whitney women" which both denigrated the work and implied that the display of such second-rate fare was the consequence of misguided feminist revisionism. The fact that I was already predicting such a review was, I now think, a measure not so much of my uncertainty in the face of art-world experts but of my collusion in what for the past half century has been the aesthetic orthodoxy in the history of art, namely, the elevation of modernist and abstract art over realism.[5] The work that I was interested in, and which I proposed including in the small exhibition, was realist painting in the relatively progressive style of the Ashcan School[6] but not at all influenced by the more avant-garde developments (Cubism, Fauvism, Futurism) already well established in Europe and visible in the work of other New York artists as early as 1910. It became clear that my project, which started out as the rather unexciting one of feminist retrieval (reclaiming women artists "hidden from history"),[7] might not be about gender at all, since the postwar modernist orthodoxy marginalized realist work by men in just the same way.

In this chapter I relate the progress of my research and thought as it developed, in particular the ways in which the question of gender was initially superseded by sociological questions of patronage, net-

[4] Michael Kimmelman, "The Return of the Well-Trampled Clavier," *New York Times*, Friday, January 3, 1997.

[5] Andrew Hemingway has demonstrated how this ideology has rendered all but invisible most American art produced in the first half of the twentieth century in his paper "How the Tale of Taste Wags the Dog of History: American Art Pre-1945 and the Problem of Art History's Object" (paper presented at the meeting of the College Art Association, Los Angeles, February 1999).

[6] Susan Noyes Platt has described this work as "mildly modern" in *Modernism in the 1920s: Interpretations of Modern Art in New York from Expressionism to Constructivism*, 2d ed. (Ann Arbor: UMI Research Press, 1985), 17.

[7] This is Sheila Rowbotham's phrase in *Hidden from History: 300 Years of Women's Oppression and the Fight Against It* (London: Pluto, 1973).

works, and social influence and subsequently by the broader issue of the historical development of key institutions and their aesthetic ideologies. Inspired by the recent work of feminist scholars of modernism and modernity, I ultimately came to see that this was, after all, very much a feminist project, though not in the way I had at first envisaged. If one can characterize feminist revisionism (rediscovering women artists and incorporating them into the canon) as 1970s feminism, then I would say (at the risk of equally broad generalization) that the Whitney project became one of 1990s feminism—the analysis of gender construction as it operates in the field of modern art and its institutions.[8]

The Whitney Museum of American Art opened in November 1931. Its founding collection consisted of nearly seven hundred works of art, about two hundred of them acquired since January 1930, when plans for the museum were officially announced.[9] All of these works had been in the collections of Gertrude Vanderbilt Whitney, the museum's founder, and Juliana Force, her assistant since 1907 and the museum's first director (1931–48), and most had been acquired in the context of the three institutions which had preceded and resulted in the opening of the museum in 1931: the Whitney Studio (1914–18), the Whitney Studio Club (1918–28), and the Whitney Studio Galleries (1928–30). The first of these, the Whitney Studio, was initially founded by Gertrude Vanderbilt Whitney (who had herself been working as a sculptor in a studio in Greenwich Village since 1907) as a place to organize an art exhibition for the benefit of war relief.[10] Over the next four years Whitney and Force organized wide-ranging exhibitions at the Whitney Studio which emphasized the work of young American artists. In 1918 they found new premises (a brownstone on West Fourth Street), which they opened as the Whitney Studio Club, with Juliana Force as its director. The new club, which combined exhibition space with recreational rooms and a library, maintained an active exhibition program for the next ten years. It was disbanded in

[8] As Jackie Stacey has insisted, however, such periodization is often quite unfair to early feminist theory, as well as blind to the important continuities in feminist work during the past twenty-five years. See her essay "Feminist Theory: Capital F, Capital T," in *Introducing Women's Studies: Feminist Theory and Practice*, ed. Victoria Robinson and Diane Richardson, 2d ed. (London: Macmillan, 1997), 54–76.

[9] See Avis Berman, *Rebels on Eighth Street: Juliana Force and the Whitney Museum of American Art* (New York: Atheneum, 1990), 311, 277.

[10] Berman, *Rebels on Eighth Street*, 111.

1928, having grown too large,[11] and was replaced by the Whitney Studio Galleries, with the narrower aim of exhibiting and selling work. This, in turn, closed in 1930 once the decision was made to found a permanent museum.

The catalogue of the collection, published at the museum's opening in 1931, includes about 500 paintings (oils and watercolors), 115 sculptures, and "drawings, etchings, lithographs and works in other mediums, to the number of seven hundred,"[12] all, of course, the work of American artists. Some of the names listed are familiar today, including Ashcan painters and other realists associated with the Art Students League (George Bellows, William Glackens, Robert Henri, Ernest Lawson, George Luks, Reginald Marsh, Kenneth Hayes Miller, John Sloan, Arthur B. Davies, and Maurice Prendergast) and one or two American modernists (Stuart Davis and one work each by Marsden Hartley and Georgia O'Keeffe). There is one Edward Hopper and a few works by Precisionist artists Charles Sheeler, Elsie Driggs, and Charles Demuth. Most striking is the fact that many of the most prominent names in the catalogue (that is, the artists with several works in the collection) are not well known: Arnold and Lucile Blanch, Ernest Fiene, Emil Ganso, Anne Goldthwaite, Leon Hartl, Joseph Pollet, Paul Rohland, Katherine Schmidt, Niles Spencer, and a few others. These names appear with great frequency in the records of exhibitions held at the Whitney Studio, the Whitney Studio Club, and the Whitney Studio Galleries in the sixteen years leading up to the founding of the museum.[13] In other words, they are artists supported by Whitney and Force during that period, whose work was often bought at their Whitney exhibitions and who were, for the most part, active participants in the club and regular members of the social networks in which Juliana Force, in particular, operated. They were connected with one another through their artistic training (in several cases at the Art Students League) and through social contact and, in some instances, marriage. (The artists Peggy Bacon and Alexander

[11] By then it had more than four hundred members—and a long waiting list. Berman, *Rebels on Eighth Street*, 253.

[12] Hermon More, curator's introduction to the *Catalogue of the Collection* (New York: WMAA, 1931), 11.

[13] See WMAA, *Juliana Force and American Art: A Memorial Exhibition* (New York: WMAA, 1949); WMAA, *Exhibitions, 1914–1949* (New York: WMAA, 1949), 64–66; and *The Annual and Biennial Exhibition Record of the Whitney Museum of American Art, 1918–1989* (Madison, Conn.: Sound View, 1991).

Brook were husband and wife, as were Katherine Schmidt and Yasuo Kuniyoshi, all of whom played a central role in the Whitney enterprise.) Many of them had summer homes in the art colony in Woodstock, in upstate New York, particularly in the period beginning in the early 1920s; Juliana Force herself was a frequent visitor there.[14] What they also had in common was a commitment to a contemporary realist aesthetic, in many cases learned from their teachers (Henri, Sloan, and Miller) at the Art Students League.[15]

I had begun research for this project by identifying the women artists in the museum's collection who were active in the years leading up to the founding of the museum in 1931. Since I was using the museum's card index, which only includes works currently owned by the museum, this did not give me access to those few women artists whose work has since been deaccessioned—which I discovered later by looking at the 1931 catalogue and at other records.[16] I also decided to limit my focus to works not only produced in this period but also *acquired* then (that is, in 1931 or soon thereafter)[17] since my interest was in the events and practices of the Whitney institutions at the time. For example, a work by the artist Florine Stettheimer, though painted in 1931, was not included because it was not acquired by the museum until 1973.[18] I was also well aware that Force engaged in a program of rather energetic "corrective buying" immediately before the opening of the museum. The inclusion of a work by Georgia O'Keeffe (*Skunk Cabbage*, 1922), bought by Force in 1931 and followed by the purchase of two more O'Keeffes the next year and a fourth in 1933,[19] was

[14] Berman, *Rebels on Eighth Street*, 230. Other "Whitney artists" who had homes in Woodstock, or who spent time there on a regular basis, included Alexander Brook, Peggy Bacon, Dorothy Varian, Rosella Hartman, Arnold and Lucile Blanch, and Eugene Speicher. See Alexander Brook, "The Woodstock Whirl," *The Arts* 3–4 (1923): 415–420; and Karal Ann Marling, introduction to *Woodstock: An American Art Colony, 1902–1977* (Poughkeepsie: Vassar College Art Gallery, 1977).

[15] Schmidt, Bacon, Varian, Luce, Kuniyoshi, and Brook were among those who had studied at the Art Students League.

[16] Among those women artists whose work was included in the museum's collection at its opening but was subsequently deaccessioned were Rose Clark, Dorothea Schwarcz, and Molly Luce.

[17] In the Whitney's records, works acquired by Whitney and Force before the museum's founding still bear an acquisition date of 1931.

[18] The painting in question is Stettheimer's *Sun*.

[19] Berman, *Rebels on Eighth Street*, 303–4. *Skunk Cabbage* was later exchanged for another work by O'Keeffe. It is now in the Montclair Art Museum (*New York Times*, December 24, 1998). Thanks to Nancy Mowll Mathews, Eugénie Prendergast Curator at

prompted by the prospect of a permanent museum of American art—something very different from a private collection or a studio club—which led to the recognition of important gaps in the collection and of the necessity to rectify this. Avis Berman, a historian of the Whitney Museum and of Force's role in its development, records the results of her hectic "shopping trips" and her acquisitions over a period of a couple of years. Particularly interesting was the accommodation reached with Alfred Stieglitz and the American modernist artists associated with his gallery—O'Keeffe, Marin, Hartley, and Dove. The absence of friendly relations between Whitney and Stieglitz over the years had long been clear (Stieglitz opened his first gallery for modern American art, the Little Galleries of the Photo-Secession, or 291, in 1905), as had the radically different aesthetic commitments of the two institutions and their associated artists. But in 1931 Force was making a serious attempt to rectify imbalances in the Whitney's collection, which meant the purchase of more avant-garde, European-influenced work. Nevertheless, this last-minute corrective buying, though obviously important in the formation of the museum, should not obscure either the dominant tendency in the Whitney circle or the particular sociology of artistic production in the pre-1931 period; nor, in the end, did it make a great deal of difference to the continuing practices of the museum following its founding.

I compiled a list of twenty-four women artists active in the Whitney circle in the period preceding the opening of the museum in 1931. Seventeen of these women had work included in the catalogue at the opening. Interestingly, eleven of the twenty-four were also included in the 1949 Whitney exhibition which served as a memorial to Force (who had died the previous year) and which still manifested a predominantly realist aesthetic (see table 1).[20] Most of these artists had an active exhibition record with the various incarnations of the Whitney Studio. They were represented regularly in group shows, and several of them had solo shows—in some cases more than once. Molly Luce, Dorothea Schwarcz, Rosella Hartman (fig. 1.1), and Georgina Klitgaard each had solo exhibitions of their work. Katherine Schmidt (fig. 1.2), Lucile

the Williams College Museum of Art, for clarifying this point for me. Another O'Keeffe entitled *Skunk Cabbage*, which Avis Berman identifies as the Whitney version, is in the collection of the Williams College Museum of Art.

[20] WMAA, *Juliana Force and American Art*.

Table 1.

Women Artists Active in the Whitney Studio Club and/or Exhibiting Regularly at the WS, WSC, and WSG

Peggy Bacon*†	Mabel Dwight*	Jane Peterson
Virginia Beresford	Anne Goldthwaite*	Caroline S. Rohland*†
Pamela Bianco*	Rosella Hartman*†	Katherine Schmidt*†
Isabel Bishop†	Isabella Howland*	Dorothea Schwarcz*
Lucile Blanch*†	Georgina Klitgaard*†	Madeline Shiff
Rose Clark*	Molly Luce*†	Dorothy Varian*†
Lucille Corcos	Harriette G. Miller	Nan Watson*†
Elsie Driggs*	Maud Morgan	Marguerite Zorach*†

* included in the collection, 1931
†included in the exhibition, 1949

1.1 Rosella Hartman: *Landscape*, 1930 (Whitney Museum of American Art)

1.2 Katherine Schmidt: *White Factory*, 1928 (Whitney Museum of American Art)

Blanch (fig. 1.3), Caroline Rohland, and Dorothy Varian (fig. 1.4) had two solo shows; and Nan Watson (fig. 1.5) had four solo shows. Peggy Bacon, who exhibited her prints and drawings regularly at other New York galleries in the 1920s and 1930s, was included frequently in the Whitney Studio Club exhibitions (fig. 1.6).[21] It is clear that women artists were able to thrive in the context of the Whitney Studio Club. According to Berman, women accounted for between 30 and 35 percent of works exhibited in the Whitney exhibitions and the Whitney and Force collections. She quotes Force's nephew, who stresses his aunt's firm belief in the equality of women: "She believed in applying the same standards to men and women alike. She would never use the once-familiar 'aviatrix' any more than she would say 'painteress.' Years later, as a museum director, she refused to hold special exhibits for women artists on the grounds that this was condescending to

[21] See *Peggy Bacon: Personalities and Places* (Washington, D.C.: Smithsonian Institution Press, 1975), 65–71.

1.3 Lucile Blanch: *August Landscape*, 1932 (Whitney Museum of American Art)

women."[22] (This is not to say, however, that the usual processes of gender selectivity were not in play at the time, including the critical response to the Whitney's activities. The art critic Henry McBride, reviewing the opening exhibition of the WMAA in 1931, does not mention a single woman artist by name, but he makes a point of identifying twelve male artists who are, for him, the stars of the show.)[23]

If the relative success of women artists in the Whitney circle is apparent, then so is the (relatively) gender-neutral decline of their reputations in later years. Soon after the 1949 memorial exhibition at the Whitney, in which several of them were still exhibiting their work, the museum became far more receptive to European-influenced modern

[22] Berman, *Rebels on Eighth Street*, 134.
[23] "Among these who already better their reputations by this event are Edward Hopper, Niles Spencer, Stuart Davis, Louis Eilshemius, Joseph Pollet, Henry McFee, Reginald Marsh, Charles Rosen, Vincent Canadé, Bernard Karfiol, Gaston Lachaise and Cecil Howard." Henry McBride, "Opening of the Whitney Museum," *New York Sun*, November 21, 1931; rpt. in *The Flow of Art: Essays and Criticisms*, 2d ed., ed. Daniel Catton Rich (New Haven: Yale University Press, 1997), 281.

1.4 Dorothy Varian: *Fruit*, 1930 (Whitney Museum of American Art)

art, including abstraction. The international success of Abstract Expressionism in the 1950s rendered it imperative that *the* museum of American art play an active part in exhibiting and acquiring these works. Under the next two directors following Force's death in 1948—Herman More (1948–58) and Lloyd Goodrich (1958–68)—the Whitney Museum's aesthetic was radically transformed. In the foreword to the 1950 annual exhibition catalogue More wrote: "If modern art in its many forms, such as expressionism, abstraction, and surrealism, predominates in the show, it is because it is the leading movement in art today, and has influenced the greatest number of younger artists."[24] In 1954 the museum moved from its original location in adjacent town houses in Greenwich Village to a building on West Fifty-fourth Street, near the Museum of Modern Art (and, in fact, owned by MoMA).[25] The display of works in the context of a more "modern" building co-

[24] Quoted in *The Annual and Biennial Exhibition Record of the Whitney Museum of American Art*, 28.
[25] *Ibid.*, 27.

1.5 Nan Watson: *Portrait*, n.d. (acq. 1931, Whitney Museum of American Art)

incided with the move toward a conception of "modern art" that was defined by MoMA (specifically by its first director, Alfred Barr) and already more or less established as the art-historical orthodoxy in America and western Europe. The narrative of this story—elaborated in Barr's famous diagram in the 1936 MoMA catalogue *Cubism and Abstract Art* and developed by his successors (critics and curators in

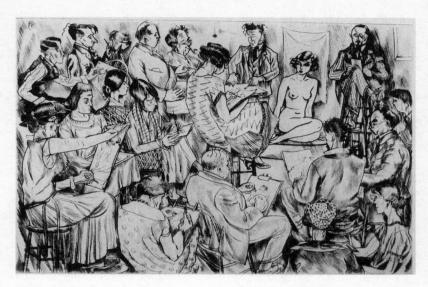

1.6 Peggy Bacon: *The Whitney Studio Club*, 1925, drypoint (Whitney Museum of American Art)

New York)—follows a line of development from Impressionism and Postimpressionism, to Cubism, Surrealism, and ultimately Abstract Expressionism (in other words, from Paris to New York).[26] Among the obvious consequences of the acceptance of this narrative is the marginalization of realism in the twentieth century. After the Second World War, the MoMA story was not only the dominant one: it was—at least in educated circles in the art world—the *only* story. The Whitney's belated subscription to this version of the canon and to the aesthetic that upheld it had the practical result of consigning a good deal of the work of the Whitney Studio Club members to storage. This reassessment affected the work of men as well as women artists. Paintings by club artists Alexander Brook, Yasuo Kuniyoshi, and Guy Pène

[26] See Griselda Pollock, "Modernity and the Spaces of Femininity," in her *Vision and Difference: Femininity, Feminism, and Histories of Art* (London and New York: Routledge, 1988), 50–90 (the diagram is reproduced on p. 51). See also Carol Duncan, "The Modern Art Museum: It's a Man's World," in her *Civilizing Rituals: Inside Public Art Museums* (New York: Routledge, 1995), 102–132; Serge Guilbaut, *How New York Stole the Idea of Modern Art: Abstract Expressionism, Freedom, and the Cold War*, trans. Arthur Goldhammer (Chicago: University of Chicago Press, 1983); and Alan Wallach, "The Museum of Modern Art: The Past's Future," in his *Exhibiting Contradiction: Essays on the Art Museum in the United States* (Amherst: University of Massachusetts Press, 1998), 73–87.

du Bois (fig. 1.7) suffered the same fate, with the ascendancy of modernism over realism in the postwar Whitney Museum.[27]

During the two decades prior to the founding of the Whitney Museum, it was still possible to pursue and promote an aesthetic other than the Euro-modernist version. Certainly modernism was already much in evidence in New York during the years of the Whitney Studio and the Whitney Studio Club. Stieglitz's gallery, founded in 1905, remained an important exhibition space for modernist painting and photography. The 1913 Armory Show had introduced European avant-garde movements—notably Cubism and Fauvism—to American audiences and, in addition, had included works by American modernists (Marin, Hartley, Morgan Russell, Davis, and others). In 1920 Katharine Dreier and Marcel Duchamp had founded the Société Anonyme, "America's first museum of modern art,"[28] which showed European and American modernist art. In 1927 A. E. Gallatin's Gallery of Living Art opened at New York University, showing Gallatin's own collection of modern art.[29] The Museum of Modern Art was itself founded in 1929 based on the private collections of European modern art owned by Lillie Bliss and Mary Sullivan as well as Abby Aldrich Rockefeller's collection of American folk and modern art.[30] Several galleries and dealers in New York exhibited modernist art (Daniel Gallery, Montross Gallery, Modern Gallery, Kraushaar's, and Wildenstein's, among others).[31] Collectors such as John Quinn and Duncan Phillips

[27] This is not entirely true. Though these artists are certainly not as well known as, say, Arthur Dove or Marsden Hartley, their modernist contemporaries, who have remained in favor throughout the century, it is more likely that their work will be on display in exhibitions of American art than that of their female counterparts. With regard to the Whitney's adoption of MoMA's aesthetic, Bruce Lineker stresses the continuing attachment to its earlier realist tendencies: "For six decades of American art, the surveys documented the Whitney Museum's consistent support of the Realist tradition. One can also trace in the exhibition program the emergence of abstraction in the 1930s and 1940s, it's [sic] extraordinary success in Abstract Expressionism of the 1950s, and abstraction's subsequent induction into the mainstream vocabulary of American art. However, even when critical attention overwhelmingly shifted toward abstraction, the program retained its original dedication to realism." *Annual and Biennial Exhibition Record*, 11–12.

[28] Abraham A. Davidson, *Early American Modernist Painting, 1910–1935* (New York: Harper & Row, 1981), 89. The collection is now housed at Yale University.

[29] See Gail Stavitsky, "A. E. Gallatin's Gallery and Museum of Living Art (1927–1943)," *American Art* 7, no. 2 (1993): 47–63. In 1943 the collection was transferred to the Philadelphia Museum of Art.

[30] Platt, *Modernism in the 1920s*, 137.

[31] Ibid., 19–33.

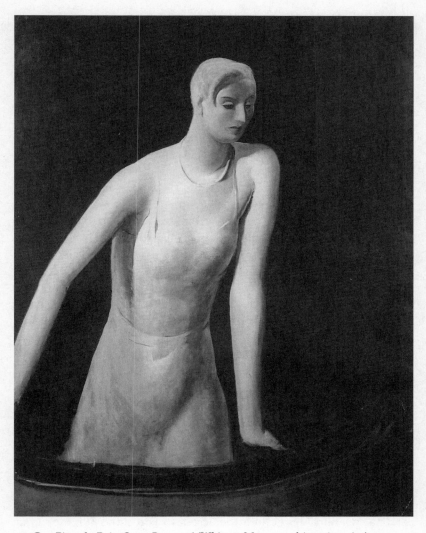

1.7 Guy Pène du Bois: *Opera Box*, 1926 (Whitney Museum of American Art)

were buying European and American modernist works in the first decades of the century. At the same time, it was entirely possible in this period for a nonmodernist aesthetic to flourish alongside these developments. Gertrude Vanderbilt Whitney's taste was for early-twentieth-century American realism of a type that was, in fact, considered progressive in its time. She bought four of the seven paintings sold at the

groundbreaking 1908 Macbeth Gallery exhibition of The Eight—the so-called Ashcan painters of realist urban scenes (Henri, Luks, Sloan, Shinn, Glackens, Prendergast, Davies, and Lawson) who were showing work at the Macbeth Gallery very different from, and opposed to, the prevailing traditions of the National Academy of Design. At the Whitney Studio and the Whitney Studio Club, she and Force continued to exhibit the work of these artists, as well as the younger artists who had studied with them. Their taste, then, though not avant-garde, was forward-looking in terms of then current established aesthetic conventions. Their hostility to modernism, too, should not be exaggerated. (Berman suggests that the Whitney Studio Club is better seen as anti-Stieglitz rather than antimodern.)[32] Whitney herself was involved in planning for the radical 1913 Armory Show. She supported the photographer Edward Steichen in the rather peculiar court case in 1926–27, in which he attempted to convince U.S. Customs that Brancusi's ultra-modernist sculpture *Bird in Space* was, in fact, a work of art and therefore exempt from import duty;[33] Whitney took over the appeal and absorbed all Steichen's costs. The Whitney Studio Club also exhibited and supported several modernist artists, including Stuart Davis and Oscar Bluemner, and sponsored individual modernist shows (such as Mario de Zayas's important Picasso exhibition in 1923). But the overall tendency is clear, all the more so in light of those concurrent developments in the New York art world. As Adam Weinberg has said, "In a cursory examination of the Whitney's exhibition program, publications, and acquisitions from the founding of the Whitney Studio Club in 1918 until Juliana Force's death in 1948, the record does substantiate an overwhelming emphasis on realist artists."[34]

At the Whitney Studio Club, the high visibility of women artists and their success in terms of exhibitions and sales has to be seen as the product of a complex social network of friendships, patronage, and personal relationships.[35] Both the access to Force and Whitney (and

[32] Berman, *Rebels on Eighth Street*, 223.

[33] Customs officials had listed it under "kitchen utensils and hospital supplies" and charged Steichen $240 duty when he brought the work back from France. Berman, *Rebels on Eighth Street*, 243.

[34] Adam Weinberg, "The Real Whitney: The Tradition of Diversity," in *American Realities*, ed. Nicholas Serota, Sandy Nairne, and Adam D. Weinberg (New York: Whitney Museum of American Art, 1997), 25.

[35] This approach is well established among sociologists of culture, who have long insisted on the importance of understanding artistic success and canon formation in

thus to exhibitions and sales) and the shared aesthetic were related aspects of these close interactions. Several of the artists were founding members of the Whitney Studio Club (Schmidt, Varian, Watson, Bacon, Dwight; Isabel Bishop joined in 1920). The Woodstock connection referred to earlier was an important structural feature in the interplay of social and professional relations,[36] as was the shared history of training at the Art Students League (where Schmidt, Bacon, Varian, Luce, and Bishop had studied, as had Yasuo Kuniyoshi and Alexander Brook). Mabel Dwight worked as secretary/receptionist for Force at the Whitney Studio Club in its early days; Katherine Schmidt ran the club's evening sketch class for two years; and Alexander Brook (the husband of Peggy Bacon) acted as Force's assistant from 1923 until 1927.[37] The artist Nan Watson (who had four solo shows and had the fourth largest number of works—a total of eight—in the collection when the museum opened in 1931)[38] was the wife of the critic Forbes Watson, who not only maintained close connections with the Whitney circle but also was Juliana Force's lover for twelve years, beginning in 1919. A sociology of cultural production and reception in the Whitney circle would certainly focus on the patterns of influence and decision that emerged from these and other connections, as well as on the particular relations between the Whitney artists and the many other New York art institutions (galleries, critics, schools) against which they were defined. It is likely, though, that what now seems the rather unprofessional (though perhaps not so unusual) set of art-world relations in which the Whitney artists operated provided the very conditions in which women could succeed on the same terms as men.

terms of social relations of cultural production and institutions—patrons, dealers, critics, museums, art schools, art-critical discourses, and so on—that facilitate and enable (and sometimes obstruct) such success. With regard to gender, feminists have also answered Linda Nochlin's question "Why have there been no great women artists?" by focusing on the social relations and institutions that exclude or permit women's participation in the making of art. Nochlin's 1971 essay, which bears the same title as the question, is reprinted in *Art and Sexual Politics*, ed. Thomas B. Hess and Elizabeth C. Baker (New York: Collier, 1973), 1–39. For an interesting example of a study of social networks and patronage in cultural production in a different context, see David Morgan, "Cultural Work and Friendship Work: The Case of 'Bloomsbury,'" *Media, Culture and Society* 4 (1982): 19–32.

[36] Berman suggests that the consequent "top-heaviness of Woodstock on the Whitney exhibition roster and in the permanent collection" was rather unfortunate and uncritical on Force's part. *Rebels on Eighth Street*, 231.

[37] Ibid., 157, 195–96, 239.

[38] Of these, four were deaccessioned after Force's death in 1948. Ibid., 166.

The ascendancy and postwar consolidation of the "MoMA narrative" had the effect of producing an impressive collective amnesia in American visual culture. For the past fifty years the history of early American art has been the story of the emergence and eventual success of the American avant-garde. The more comprehensive surveys of American art do include discussions of American Impressionism and the Ashcan painters,[39] though artists in the Whitney circle are rarely considered. Even in these accounts the realist painters of the Ashcan group are often treated as a necessary—but quickly surpassed—stage on the path to modernism. The following excerpt from a catalogue introduction to a 1997 exhibition of the work of The Eight (the exhibitors in the 1908 exhibition) presents a typical account of this relationship:

> By breaking away from and rebelling against the narrow confines of traditional art typically displayed at the National Academy of Design, Henri and his seven colleagues effectively opened the door for more innovation in painting in the United States. By exhibiting more experimental, progressive work to a wide public audience, The Eight helped create an environment more willing and able to accept the shocking trends which would affront the American art community at the Armory Show in 1913. The Eight's exhibition helped build an effective bridge between the art of the nineteenth century and the Modernism of the twentieth.[40]

With the exception of general survey books on American art, until recently most publications dealing with the early twentieth century have focused on American modernism—the Armory Show and its consequences, the Stieglitz artists, and the varieties of American modernism in the 1910s and 1920s.[41] (The return to realism in the 1930s—for example, in work associated with the Works Progress Administra-

[39] See, e.g., Matthew Baigell, *A Concise History of American Painting and Sculpture* (New York: HarperCollins, 1984); and Joshua C. Taylor: *The Fine Arts in America* (Chicago: University of Chicago Press, 1979).

[40] Brian Paul Clamp, "The Eight: Bridging The Art of the Nineteenth and Twentieth Centuries," *The Eight* (New York: Owen Gallery, 1997), n.p. Clamp rightly points out that the group of eight artists does not exactly coincide with the group collectively known as the Ashcan School.

[41] See, e.g., Milton W. Brown, *American Painting: From the Armory Show to the Depression* (Princeton: Princeton University Press, 1955); idem, *Avant-Garde Painting and Sculpture in America, 1910–25* (Wilmington: Delaware Art Museum, 1975); see also Davidson, *Early American Modernist Painting.*

tion (WPA) and with regionalism—is another matter, but even this work, impossible to ignore or write out of American art history, is invariably treated as a subplot—perhaps even an embarrassing one—to the main story.)[42] Internationally, nonmodernist American art barely registers in the art-historical community (with one or two exceptions, like Edward Hopper), and the same is true within the United States among those whose area of interest is not specifically the history of American art.[43]

The Whitney Museum itself was so radically transformed in the years after Force's death that in 1960 a group of realist artists wrote to the then director (Lloyd Goodrich) about the lack of representational art in the museum's recent annual exhibition, pointing out that of the 145 paintings included "102 were non-objective, 17 abstract and 17 semi-abstract, leaving only 9 paintings in which the image had not receded or disappeared, whereas in former exhibitions the Whitney Museum showed a much larger cross section of style and method in work in progress."[44] As Adam Weinberg reports, Goodrich admitted that "the abstract trend is dominant, particularly among the younger generation."[45] Although Weinberg is concerned to stress the Whitney's long-standing openness to both realist and modernist (including abstract) art, the context of his essay is evidence of the museum's postwar collusion in the privileging of modernism. It appears in a catalogue for a 1997 exhibition at the Whitney, the third in a series called "Views from Abroad," in which museum directors from other coun-

[42] Brown, e.g., puts it like this: "After the [First World] war, realism continued, with many changes in character, but as a minor and neglected phase of American art." Unusually, Brook, Kuniyoshi, and Pène du Bois do appear in his book, though none of the Whitney women do. See Wanda M. Corn's book *The Great American Thing: Modern Art and National Identity, 1915–1935* (Berkeley: University of California Press, 1999).

[43] I came across a marvelous example of this as I was writing this chapter. In a publisher's catalogue advertising a recent edition of the reprinted essays of the art critic Henry McBride—one of the most important critics active in New York between about 1913 and 1950—a prominent place is given to a line from a review of the book by the art historian Svetlana Alpers: "Until I read this book I had never heard of [McBride], but his collected reviews make for good reading." It says something, of course, about the fate of early-twentieth-century art and art criticism that such a sentence stands as a compliment. The issue of the invisibility of much American art within the discipline of art history was addressed by Hemingway in "How the Tale of Taste Wags the Dog of History," cited earlier.

[44] Quoted by Weinberg, "The Real Whitney," 28.

[45] Ibid.

tries were invited to curate work from the Whitney's permanent collection. This particular show was organized by Nicholas Serota and Sandy Nairne of the Tate Gallery in London and, as *The New Yorker* put it at the time, "This is American art viewed through eyes used to looking at Francis Bacon and Lucian Freud."[46] The curators entitled the exhibition "American Realities," and one of its primary aims was to reinstate the figurative tradition. Reflecting on the fact that the Tate had earlier displayed an exhibition of the work of American artists that had been organized by the Museum of Modern Art, Serota explains his interest in its omissions:

> The exhibition played a small but influential part in transforming the European assessment of American art from provincial and peripheral to revolutionary, highly influential, and central to developments worldwide. But this perception clearly obscured the existence of an earlier, prewar cosmopolitanism, which manifested different forms of radical modern figuration. . . . This led us on a track of the "real" for "Views from Abroad." Admittedly using the term in an elastic way, we have explored the idea of bringing particular, sometimes neglected, works to critical attention and reviving a broader view of modernism which does not regard an interest in the figure as being, by definition, antimodern.[47]

Included in the exhibition was work by Pène du Bois, Sloan, Soyer, Bishop, Luks, Marsh, and Driggs,[48] alongside the more usual selection of works by the early modernists Dove, Hartley, O'Keeffe, and Avery, and the postwar modernists Pollock, Rothko, Kline, and Diebenkorn. The exhibition was, I believe, an indication of an interesting development in museum practice and associated art-critical discourses (and, not incidentally, art market sales) in the past couple of years, namely, the beginning of a reevaluation of the realist and figurative tradition.[49]

[46] *The New Yorker*, September 15, 1997, listings.

[47] Nicholas Serota, introduction to *American Realities*, ed. Nicholas Serota, Sandy Nairne, and Adam D. Weinberg (New York: WMAA, 1997), 10.

[48] Bishop and Driggs are the only women represented here, and of the group of twenty-four artists I have been considering, they are the only women whose work has continued to be shown, perhaps with the exception of Marguerite Zorach.

[49] Other examples of this new attempt to reinstate realism as serious art include: the Whitney's 1995 Florine Stettheimer retrospective and 1998 Edward Hopper retrospective; a major exhibition held at the National Museum of American Art in Washington, D.C., in 1995 entitled "Metropolitan Lives: The Ashcan Artists and Their New York"; an exhibition of the work of Peggy Bacon at the Kraushaar Galleries, New

Despite these efforts, however, the dominant aesthetic at the Whitney, as elsewhere in the art world, has remained one founded in the story of modernism and its postwar successors. There is some evidence of a certain nervousness about the revival of the realist tradition, as two minor anecdotes about my own Whitney proposal demonstrate. The first was the suggestion made to me by the Whitney's curator that although an exhibition of the work of these women artists might not work for the museum, I might propose it to the curator of a museum outside Manhattan.[50] The second was the rather surprising discovery that a year after my fateful (fatal) visit to New York to view the paintings, the Whitney did, in fact, mount a version of the show I was proposing, except that this was an exhibition solely devoted to works on paper by these women artists, and it took place at the Whitney's branch in Champion, Connecticut.[51] It seemed that the work was good enough for the provinces, but it could not (yet) be risked in New York City.

My inquiries into the invisibility of the "Whitney women" had quickly made clear to me that this was not, after all, the feminist project of rediscovering women artists who had been marginalized either in relation to the conditions of cultural production or by the normal practices of art-historical discourse—the project of the recovery of a "hidden heritage."[52] These artists worked on equal terms with men— and apparently with more or less equivalent success and visibility at the time. Their disappearance both from the Whitney's own exhibitions and from official histories of American art in general was therefore not a matter of gender prejudice but rather a consequence of the resolution of competing aesthetic narratives, one which sidelined the work of male realist artists to (almost) the same degree as that of

York, in December 1995; an exhibition of the work of Lucille Corcos at the Susan Teller Gallery, New York, in the fall of 1997. Also included—no doubt a more trivial example—the selection of American realist art to hang on the walls of the home of an extremely rich young couple (played by Mel Gibson and Rene Russo) in the movie *Ransom*: Avis Berman: "In the Script, the Art Says 'They're Rich,'" *New York Times*, November 3, 1996.

[50] In fact, he suggested the Montclair Art Museum, with whose curator I did subsequently exchange letters.

[51] The exhibition, entitled "Between the Wars: Women Artists of the Whitney Studio Club and Museum," was held at the Whitney's Connecticut branch in 1997.

[52] The phrase is from the title of one of several volumes published in the 1970s which undertook this task. See Eleanor Tufts, *Our Hidden Heritage: Five Centuries of Women Artists* (New York: Paddington, 1974).

women. In the end, the exhibition I proposed to the Whitney was not a specifically feminist project but one whose conceptual underpinning had much more to do with foregrounding a sociology of cultural production—the relevance and centrality of social relations and networks in the production and reception of art. As I have said, the decision not to take this further was an aesthetic one, based on an assessment of whether the paintings were worth exhibiting. At the time I tried to think about this assessment in light of what we have learned from feminist criticism over the past couple of decades, in an attempt to identify any deeper prejudices which might be gender-related. Feminist art historians have demonstrated the ways in which aesthetic hierarchies are clearly gender-based, with work associated with women (still life and flower painting, for example) invariably being considered "decorative" or "lesser arts."[53] Critical work in feminist aesthetics has alerted us to certain androcentric tendencies in Western philosophy of art (the gendering of the opposition of the beautiful and the sublime; the inseparability of the practical and the personal—including gender identity—from the aesthetic for the spectator of a work of art).[54] But there was no obvious difference in content or style between the work of the Whitney women and the paintings of Alexander Brook and Yasuo Kuniyoshi, nor did there seem to be any reason to suppose that questions of gender entered into the appreciation or judgment of the works. The belated recognition that this was, after all, a feminist project grew out of my subsequent doubts (and self-doubt) about the privileging of modernism over realism. The point is that the discourse of modernism *is itself a masculinist discourse*. This means that the marginalization of realism, though ostensibly an aesthetic move, is at the same time fundamentally gendered. Viewed in this perspective, it does not matter that some of the work thus denigrated happened to be made by men; it is still gendered "feminine" by a discourse that produces modernism as masculine. In the remainder of this chapter I consider this question of "the gender of mod-

[53] See Rozsika Parker and Griselda Pollock, "Crafty Women and the Hierarchy of the Arts," in their *Old Mistresses: Women, Art and Ideology* (London: Routledge & Kegan Paul, 1981), 50–81.

[54] See Paul Mattick Jr., "Beautiful and Sublime: 'Gender Totemism' in the Constitution of Art"; and editors' introduction in *Feminism and Tradition in Aesthetics*, ed. Peggy Zeglin Brand and Carolyn Korsmeyer (Philadelphia: Pennsylvania State University Press, 1995), 27—48, 1–22.

ernism" as a way of returning to the Whitney women and the problem of assessing their work.

The recognition that modernism in the visual arts has always had strong masculinist (and often misogynistic) tendencies is by now well established. In an article first published in 1973, Carol Duncan identified a preoccupation with virility in avant-garde painting in the early twentieth century, an obsession that she related to the contemporary anxieties about the emancipation of women and their increased participation in the public world of work and politics.[55] Much of Griselda Pollock's work is concerned with addressing the question of "why the territory of modernism so often is a way of dealing with masculine sexuality and its sign, the bodies of women—why the nude, the brothel, the bar?"[56] In another context, Andreas Huyssen has explored the nineteenth-century discourses that produced modernism as male, in this case in opposition to a mass culture that was gendered female.[57] These gendered discourses of early modernism were subsequently definitively reinforced by the postwar narrative of twentieth-century art history, seen from the vantage point of the international success and prominence of the New York School. As Ann Gibson has shown, the invisibility of women and minority artists among the Abstract Expressionists—and there were plenty who were active in the late 1940s and early 1950s—is the necessary by-product of the universalizing ideology of this movement and its associated critics.

> This universalism was delivered by men who aspired to be artistic heroes. This claim, to which sympathetic contemporary viewers readily responded and which subsequent historians have made specific, was not seen as the movement's implicit story about itself, that is, as literary, but simply as wondrous fact. . . . This notion established grounds for the distinction that, in segregated America, only white heterosexual males

[55] Carol Duncan, "Virility and Domination in Early Twentieth-Century Vanguard Painting," in her *The Aesthetics of Power: Essays in Critical Art History* (Cambridge: Cambridge University Press, 1993), 81–108.

[56] Pollock, "Modernity and the Spaces of Femininity," 54.

[57] Andreas Huyssen, "Mass Culture as Woman: Modernism's Other," in his *After the Great Divide: Modernism, Mass Culture and Postmodernism* (Bloomington: Indiana University Press, 1986), 44–62. On a related topic, see Rita Felski, *The Gender of Modernity* (Cambridge: Harvard University Press, 1995), and Barbara L. Marshall, *Engendering Modernity: Feminism, Social Theory and Social Change* (Boston: Northeastern University Press, 1994), both of which identify the recuperative possibilities for women and for feminism within a "masculinized" but complex modernity.

could attain: generating a universal product that could speak for everyone. Women, African Americans, and avowed homosexuals could not do that because their audiences would not accept their work as universal.[58]

Michael Leja has explained the andocentric nature of Abstract Expressionism in terms of the type of subjectivity produced by its discourses, one founded on a new image of self (the "Modern Man" subject, as he calls it) which deployed notions of the "primitive" and the unconscious and which was "profoundly gendered."[59] The point then, he concludes, is "not to document the exclusion of women from Abstract Expressionism, but rather to examine the processes and mechanisms by which that exclusion was effected then and now. What made Abstract Expressionism so inhospitable to artists who were women? . . . The answer centers, I believe, on the subjectivity inscribed in Abstract Expressionist art."[60] The exclusion of women, then, is a structural and discursive operation, integral to the production and maintenance of a particular conception of subject and artist.

The rewriting of early-twentieth-century American art from the point of view of the 1950s—the project that I have suggested was involved in the transformation of the Whitney's history—can now be seen as more than a matter of aesthetic revision. The privileging of modernism in the earlier period, in the production of a specific lineage for the New York School, was also an exercise in engendering visual culture. In other words, the marginalization of certain kinds of realist and figurative painting is the marginalization of the "feminine," a process which does not necessarily have much to do with the question of whether the work involved is by women or men. This retroactive strategy has taken up and restated those gender discourses around early modernism, with their own tendency to equate the modern with the masculine. As Rita Felski has argued, although the gender of modernity and of modernism was relatively open-ended in the early twentieth century—so that the androcentric discourses could still be contested and countered and a feminine/feminist "modernism" proposed—there is plenty of evidence of what was to become

[58] Ann Eden Gibson, *Abstract Expressionism: Other Politics* (New Haven: Yale University Press, 1997), xxvi.

[59] Michael Leja, *Reframing Abstract Expressionism: Subjectivity and Painting in the 1940s* (New Haven: Yale University Press, 1993), 258.

[60] Leja, *Reframing Abstract Expressionism*, 257.

the dominant narrative, in which the realist/feminine was denigrated in relation to the modernist/masculine. This is clear in the case of the contemporaneous establishment of the Whitney Museum and the Museum of Modern Art. In an important and highly original study of the contrasting display strategies of the two museums and their precursors between the wars, Evelyn Hankins has demonstrated the ascendancy of the "modern" approach (the museum as white cube) in relation to the "decorative" (moderne), the latter being characteristic of the Whitney's displays, which were associated with the feminine in contemporary criticism and discourse. In particular, the exhibition of works in the "domestic" setting of the brownstones of the Whitney Studio Club and the museum itself in its early years, as well as the employment of Beaux Arts architects and designers to renovate the buildings, was in stark contrast to MoMA, permitting a reading of the Whitney as a feminine space.[61]

The invisibility of the Whitney artists in most histories of twentieth-century American art is, after all, a feminist issue inasmuch as the denigration of realism has depended on a fundamentally gendered discursive strategy. I conclude by considering the implications of this for the current revival of interest in realist art, which I referred to earlier. The critical challenge to "the MoMA story," for example, in the 1997 "American Realities" exhibition at the Whitney, which reintegrated figurative art into the history of American art, is necessarily also a process of deconstructing the dominant gender hierarchies of modernism and realism. And yet it is striking that there were no women artists from the Whitney Studio Club included among the realists in that show, with the exception of Isabel Bishop and Elsie Driggs (fig. 1.8), neither of whom was quite typical of the Whitney artists and their work.[62] (The same was true of the 1999 blockbuster Whitney exhibition "The American Century," which opened as I was completing work on this chapter.)[63] It could be that this brings me

[61] Evelyn C. Hankins, "Homes for the Modern: En/Gendering Modernist Display in New York City, 1913–39" (Ph.D. diss., Stanford University, 1999).

[62] Bishop has always maintained a certain status in histories of American art, largely because of her importance as a member of the Fourteenth Street School of urban realist painters. Driggs's 1927 painting *Pittsburgh*, which has remained on view in the Whitney's permanent exhibition, is unlike the work of her Whitney Studio Club contemporaries in its more modernist, Precisionist style.

[63] The full title was "The American Century: Art and Culture, 1900–1950," and it ran from April through August 1999.

1.8 Elsie Driggs: *Pittsburgh*, 1927 (Whitney Museum of American Art)

back to the vexed question of "quality" (and hence to my dilemma when confronted with the paintings).[64] At the very least it suggests that we look carefully at both the aesthetic and the gender implications of the revival of realism in the late twentieth century, a revival which may, after all, still turn out to be on modernism's terms.

[64] A disconcerting little aside in an article about the Whitney in the late 1990s refers to the uncritical buying policies of Gertrude Vanderbilt Whitney, "who, lore has it, would sometimes purchase a second-rate picture in an artist's show, knowing that the best work would find another buyer." Arthur Lubow, "The Curse of the Whitney," *New York Times Magazine*, April 11, 1999, 58. See also n. 36.

Questions of Discovery

The Art of Kathleen McEnery

Included in the 1987 inaugural exhibition of the National Museum of Women in the Arts in Washington, D.C., were two paintings by the artist Kathleen McEnery. The exhibition, which also traveled to Minneapolis, Hartford, San Diego, and Dallas, was devoted to the work of American women artists active from 1830 to 1930, and the seventy-nine artists whose works were represented ranged from the well known (Cecilia Beaux, Georgia O'Keeffe, Katherine Dreier, Susan Macdowell Eakins, Florine Stettheimer) to the more obscure. Eleanor Tufts, the exhibition curator, made a point of finding and exhibiting work by artists who were not well known; to that extent the exhibition (and the accompanying catalogue) were a valuable contribution to the feminist project, begun in the early 1970s, of retrieving "lost" women artists from obscurity.[1] According to Tufts, "Kathleen McEnery is one of the discoveries of this exhibition."[2] She was represented in the show by two paintings: *Breakfast Still Life* (fig. 2.1) and *Going to the Bath* (fig. 2.2), both dating from the period 1913–15.

[1] Eleanor Tufts, introduction to *American Women Artists, 1830–1930* (Washington D.C.: National Museum of Women in the Arts, 1987), 10–11.

[2] Tufts, *American Women Artists*, cat. no. 55. As evidenced by a letter dated March 17, 1986, from Tufts to Joan Cunningham Williams, McEnery's daughter, this view was shared by another expert. Wishing to let Mrs. Williams know which two works had been selected for the exhibition, Tufts writes: "I do want you to know that one of the professors of American Art who looked at my selections commented that your mother's work is one of the great discoveries of this exhibition" (Eleanor Tufts Papers, Southern Methodist University).

2.1 Kathleen McEnery: *Breakfast Still Life*, c. 1915 (Private collection)

I am interested in the question of what it means to "discover" an artist. For Eleanor Tufts the hope was that her own research, and the opportunity she had to show her "discoveries" in such a high-profile venue, would be part of the ongoing project of making women artists visible again. Indeed, the National Museum of Women in the Arts is itself a product of such feminist revisionism, and Tufts was one of the earliest practitioners (as historian and as curator) of this recuperative

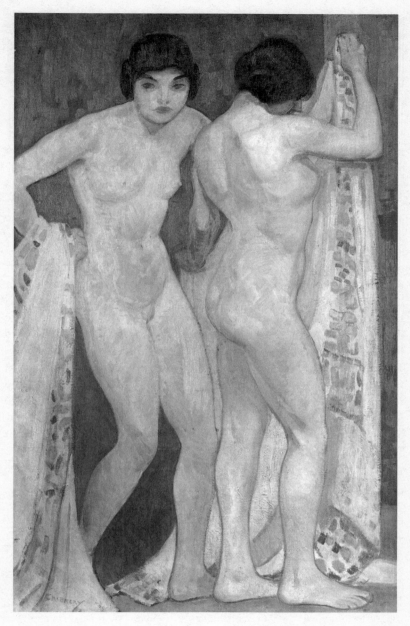

2.2 Kathleen McEnery: *Going to the Bath*, c. 1913 (Smithsonian American Art Museum, gift of Peter Cunningham and Joan Cunningham Williams)

work.[3] The career of Kathleen McEnery is particularly instructive because it makes clear the often haphazard processes of success and decline, of visibility and disappearance, thus revealing the complex nature of canon formation. It also intersects in crucial ways with the history of early-twentieth-century modernism and its subsequent retelling, which is the central theme of this book.

Like many of the women artists rediscovered by feminist historians, McEnery enjoyed early success. A student of Robert Henri, she exhibited her work in New York and other galleries in the period preceding the First World War. Two of her paintings—including *Going to the Bath*, which Eleanor Tufts showed in the 1987 exhibition (it is now in the collection of the Smithsonian American Art Museum in Washington)—were exhibited in the 1913 Armory Show in New York. She showed work in exhibitions in New York and Philadelphia alongside Stuart Davis, Robert Henri, George Bellows, Edward Hopper, and other artists who went on to achieve lasting renown. In 1914 she married and left New York for Rochester, where she spent the rest of her life. (She died in 1971.)[4] She continued to paint through the 1940s, and she exhibited locally (at least once in New York) throughout those decades. But for the most part she practiced her art quite apart from the international, national, and even metropolitan (New York) scene. Though her two Armory Show paintings were included in the 1963 fiftieth-anniversary exhibition of that show, this did not lead to any revival of interest in her work.[5] Nor was she any more visible to those focusing on American women artists. She is not mentioned in Charlotte Rubinstein's comprehensive survey of 1982 (though Eleanor Tufts did include a note on her in the revised edition of her own bibliographic guide to American women artists in 1989).[6] As far as I know,

[3] See Eleanor Tufts, *Our Hidden Heritage: Five Centuries of Women Artists* (New York: Paddington, 1974).

[4] The date of her birth is less certain. Her gravestone in the Holy Sepulchre Cemetery in Rochester, N.Y., gives 1888 as her date of birth, but a letter/card dated September 14, 1986, from her daughter to Tufts gives McEnery's date of birth as 1885 (Eleanor Tufts Papers, Southern Methodist University). Tufts died in December 1991 and Joan Williams died in 1997. The catalogue for a 1972 memorial exhibition for McEnery at the Memorial Art Gallery, Rochester, gives her date of birth as 1888, but a later exhibition at the same gallery that included her work gives 1885.

[5] *1913 Armory Show 50th Anniversary Exhibition* (Utica, N.Y.: Munson-Williams-Proctor Institute, 1963). McEnery's paintings are reproduced on page 113 and were listed as catalogue numbers 3 and 4—as they had been in the original Armory Show.

[6] Charlotte S. Rubinstein, *American Women Artists from Early Indian Times to the Present* (New York: Avon, 1982); Eleanor Tufts, *American Women Artists, Past and Pres-*

the 1987 exhibition did not make any difference either—in other words, Kathleen McEnery has not, to date, been one of those artists rescued from obscurity and restored to their place in the story of twentieth-century art.

Of course, the revisionist project of feminist art history has itself been challenged, particularly during the last two decades of the past century, by feminist art historians whose objection was that such recovery operations leave the disciplines of art history and art criticism intact. According to that view, it should not be a question of adding women (or, for that matter, museums of women's art) to what has traditionally been a male preserve. Rather, it is argued, the challenge is to rethink the *terms* of the academic disciplines (and the associated practices of curators and museums) in order to examine and transform the more fundamental ways in which art practice, representation, and critical discourse are already gendered.[7] In chapter 1 I discussed the work of women artists in the Whitney circle in these terms, focusing less on the obvious processes of gender exclusion and more on the subtler ways in which artistic styles may themselves be gendered, with indirect consequences for women artists. As I suggest in this chapter, similar factors are at work in the case of Kathleen McEnery, whose disappearance (despite periodic "discoveries") is at least partly explained by her unapologetic commitment to figurative work, and to what one might refer to as a pre-Cubist modernism. If, as I argued in the case of the Whitney circle, realist/figurative painting is gendered "feminine," then the ultimate success and hegemony of the story of Francocentric ("masculine") modernism accounts not only for the historical marginalization of certain styles of work but also for the gender coordinates of these exclusions. I must repeat here that this applies equally to male and female artists. McEnery's exclusion on the basis of aesthetic hierarchies has nothing—at least overtly—to do with her status as a woman artist. (I come back to the question of the connection between her life

ent, vol. 2, *A Selected Bibliographical Guide* (New York: Garland, 1989), 281. There is also an entry on McEnery, written by Tufts, in *North American Women Artists of the Twentieth Century: A Biographical Dictionary*, ed. Jules Heller and Nancy G. Heller (New York: Garland, 1995), 373, a book dedicated to Eleanor Tufts.

 [7] Among the many critics whose work along these lines has been of crucial importance are Lisa Tickner, Linda Nochlin, and Griselda Pollock. A central text here is Pollock's *Vision and Difference: Femininity, Feminism and the Histories of Art* (London: Routledge, 1988).

as a woman—wife, mother, philanthropist, teacher—and her work later in this chapter.)[8]

Since the late 1990s, some feminist art historians have become convinced of the need to return to that 1970s project of revisionism—discovering women artists, writing about their lives and work, even producing monographic studies (though based on new models informed by the critical theory and methods of the 1980s and 1990s). The organizer of a panel at the February 2000 meeting of the College Art Association entitled "Historiography/Feminisms/Strategies" asked the following question in her opening remarks: "Is some of the impulse towards discovering/assessing the work of 'forgotten' women no longer seen as urgent? Or is it just not 'hip' enough?"[9] Two of the speakers took this up directly. Whitney Chadwick's comments took the form of a reflection on her own involvement in feminist art history, in particular the kind of work represented by her 1985 book *Women Artists and the Surrealist Movement* and its relationship to poststructuralist theories of art history.[10]

> I found myself digging in the archives at a time when there were sexier intellectual things to do, and the publication that resulted raised as many questions as it answered. Among them were the place of recuperative histories within both feminism and art history, the construction of gendered narratives, the question of whether or not it was possible for archival research and theorization to coexist in a meaningful way in the same publication.[11]

Well aware of the value of feminist work on the social construction of gender and the inscription of sexual difference, Chadwick nevertheless insists on the importance of investigating individual women's practices: "Working on women artists may not have much intellectual *cachet* at the moment in some quarters, but it seems to me that our fail-

[8] A profile of McEnery in the Rochester local newpaper (which referred to her by her married name) refused the obvious "gendering" of her work: "There is nothing feminine about Mrs. Cunningham's work except its intuitive qualities. In her best work her brush strokes have a direct sweep that is very powerful." Rochester *Times-Union*, February 22, 1927.

[9] Hilary Robinson, introduction to "Historiography/Feminisms/Strategies," *N.Paradoxa* 12 (March 2000), at http://web.ukonline.co.uk/n.paradoxa/panel.htm.

[10] Whitney Chadwick, *Women Artists and the Surrealist Movement* (London: Thames and Hudson, 1985).

[11] Whitney Chadwick, *N.Paradoxa* 12 (March 2000) (see n. 9).

ure to attend to the realities of women's production, and to add to its record, risks knocking the history out of feminism and art history."[12] Marsha Meskimmon, author of a book on German women modernists, also challenges what she calls "the recalcitrant binary thinking which dogs feminist art history, pitting the 'untrendy' reclamation of women artists against 'trendy' theoretical revisions of the discipline as two opposing forms of scholarship." Her suggestion is that a focus on *process* (rather than object) will avoid this binary divide and produce feminist scholarship that retains a link between primary research and theoretical reconception.[13]

It is in this spirit that I hope to demonstrate the rewards of focusing on one woman artist. I think it is clear that the contemporary version of what Chadwick and Meskimmon call the reclamation project is very different from its 1970s incarnation. For one thing, critical theory has taught us that we cannot pretend to tell *the* story of a life. Theories of (auto)biography and a whole body of literature on the nature of memoir have made it clear that any such story is a construction—partial, selective, very likely ideologically motivated. The challenge is to present the life (in an essay, a catalogue, a monograph) in a form that both admits and exposes its constructed nature. It is no longer possible to try to "tell the truth" about an artist.[14] In addition, one's starting point is no longer the existence of an art-historical canon, albeit one with systematic exclusions. Rather, the process of canon formation itself is the subject of analysis, as is the question of aesthetic value. The very particular, local exploration of an artist and her work should throw some light, however obliquely, on the institutions and practices of artistic creation and canon formation at a specific historical moment. I begin with no assumptions about the place of gender in all this, though inevitably my investigation addresses the specificities of a woman's life, as well as the discursive "gendering" of the kind of work she was engaged in. The notion of "discovery" is, I think, a good starting point for an examination of how the history of art tells its story. In this particular case, a central theme—one that weaves

[12] Ibid.

[13] Marsha Meskimmon, *N.Paradoxa* 12 (March 2000). See also her book *We Were Not Modern Enough: Women Artists and the Limits of German Modernism* (Berkeley: University of California Press, 1999).

[14] For a fascinating discussion of this problem in the context of a fictional exploration of a woman artist's life, see Alison Lurie's novel *The Truth about Lorin Jones* (Boston: Little, Brown, 1988).

throughout this book—is the relationship between realism and modernism. However, as I will suggest, there are other coordinates and other oppositions at play, such as the professional versus the amateur, the metropolitan versus the provincial, and the leisured versus the working classes.

My own "discovery" of Kathleen McEnery was entirely serendipitous and had nothing to do with either her inclusion in the 1913 Armory Show or her appearance in the 1987 Washington, D.C., exhibition. Although I knew about both and had looked at the latter's catalogue more than once, I never noticed either her name or her work. In the mid-1990s I was asked to curate a small, one-room exhibition at the Memorial Art Gallery in Rochester, New York, as part of a much larger show designed to celebrate the seventy-fifth anniversary of women's suffrage in 1995. There was no budget (or time) for travel or for loans, so my task was to put together a small exhibition of "images of women" from the collection. (Two other sections of the larger project exhibited work by women.) I came across McEnery's work while searching the collection that was in storage. In fact, there are eight of her paintings at the gallery, only two of which are usually on display.[15] The painting I chose—I liked it and it worked very well thematically and visually with the sixteen other portraits and genre paintings I had selected—was entitled *Mood* (fig. 2.3). Like most of her paintings, it is not dated, but it was first exhibited in a solo show at the gallery in 1927.[16] It was acquired by the gallery on that occasion, presented by a group of donors.[17] As I later came to see, after discovering more of McEnery's work, it is typical of the type of painting she produced during her years in Rochester, namely, intimate portraits of mainly female friends and acquaintances in which she captures the moment and the personality in a style which unambiguously registers the sitter as a "modern" woman. It is clear that there has already been a significant break from the style of her early work, much of which is very obviously indebted to her teacher, Robert Henri. It is not just the

15 These are *Woman with an Ermine Collar* and *In the Loggia*—the latter displayed in the gallery's café.

16 As is the case with many of McEnery's portraits, the subject is not identified. A letter dated January 18, 1972, from Peter Cunningham, the artist's son, to Isabel (misspelled as Isabelle) Herdle, the then assistant director for curatorial services and former associate director, identifies the sitter as Marjorie Quetchenbach (MAG archives).

17 *Rochester Democrat and Chronicle*, March 27, 1927.

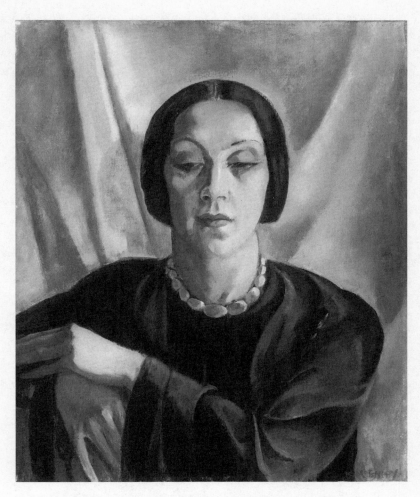

2.3 Kathleen McEnery: *Mood*, 1927 (Memorial Art Gallery of the University of Rochester)

difference in dress that distinguishes *Mood* from the 1909 *Woman in an Ermine Collar* (fig. 2.4). The shift from a turn-of-the-century realism to a figurative art influenced by early-twentieth-century modernism is apparent, all the more so if one considers other works of the 1920s— for example, her portrait of the landscape architect and art educator Fritz Trautman, exhibited in 1929 (fig. 2.5), a work that verges on the expressionist in its psychological intensity and its bold use of color to reflect character.

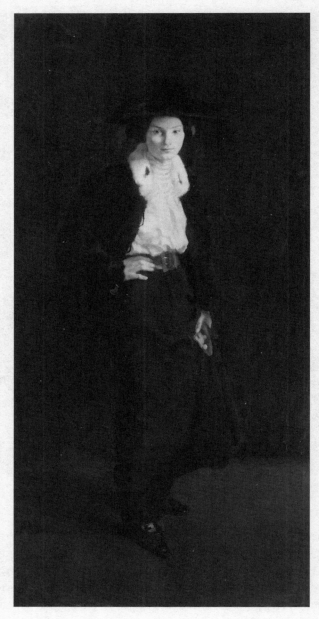

2.4 Kathleen McEnery: *Woman in an Ermine Collar*, 1909
(Memorial Art Gallery of the University of Rochester)

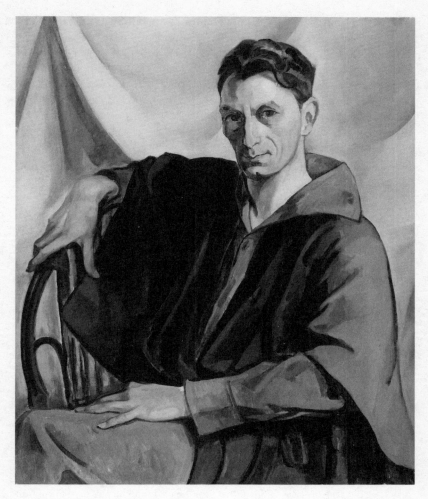

2.5 Kathleen McEnery: *Portrait of Fritz Trautmann*, c. 1929 (Memorial Art Gallery of the University of Rochester)

Indeed, the encounter with an artist such as Kathleen McEnery reminds us how unhelpful the predominant art-critical dichotomy of modernism/realism can be. Certainly, in the context of provincial Rochester in the 1920s and 1930s, McEnery's work was firmly positioned in the "modern school." The local paper said of *Mood* that it "adds an excelling example of modernism at its best to the more conservative range of realistic paintings in which the permanent collec-

tion predominates [sic]."[18] A later review of an exhibition in which another of her portraits was included pointed out that "the artist has progressed far beyond the merely realistic portrayal of feature and character. . . . Kathleen McEnery has a cosmopolitan view-point."[19] Interestingly, in her letters home during her period of study in Paris, McEnery was firmly dismissive of the more modern work in the 1908 Salon:

> Spent the afternoon at the Salon. There is more good than I thought in it. Many frightful pictures belonging to what is called the Neo-impressionistic school. They are quite impossible, at first they made me laugh but afterwards *mad*. I'm not going to visit it any more, its bad for me. I feel all the time that I could do better, so now I'm going to confine myself to the Louvre where I'm troubled by no such foolish thoughts.[20]

And yet, as contemporary reviewers pointed out, her extended stay in Paris radically transformed her work.[21] After an early period of study in New York, first at the Pratt Institute and then with Henri at the New York School of Art, she accompanied Henri and his class to Spain in 1908 for a two-month period of work—copying in museums, doing her first outdoor painting, and working in the studio with her class.[22] At the end of August she traveled to Paris (after a short stay in

[18] Ibid.

[19] Ibid., December 5, 1926.

[20] Letter from Paris dated fall 1908 to her mother (family archive).

[21] For example, a clipping in the family archive (unfortunately without the newspaper's name or date), reviewing an exhibition at the MacDowell Club in 1915, reads: "Miss Cunningham . . . has evidently been to Paris, and has adopted a palette more or less affected by the modern cult for Cezanne."

[22] According to some accounts, she also went to Spain with Henri in 1906. Although he did take his class to Spain that year, I have found no evidence to confirm McEnery's involvement. Her letters home in 1908 make no mention of an earlier visit. The statement by her daughter, Joan, in a card dated September 14, 1986, addressed to Eleanor Tufts, that McEnery went to Spain in 1905 must be mistaken, based perhaps on a date on one of the letters which I conclude was an error on McEnery's part; as Tufts pointed out in a letter to Joan Williams dated September 24, 1986, Henri made no trip to Spain in 1905. On July 5, 1908, McEnery wrote to her sister Geraldine: "Yesterday morning, we spent in the Prado, and I got quite enthusiastic about copying. Mr. Henri doesn't quite approve of copying, but he told us of a man in Paris who had made some wonderful sketches from Velasquez, just small sketches—you know, and that's what I think I shall do if we get permission to copy in the afternoon." A few days later, in another letter home, she wrote: "I've started to paint outdoors at last and I'm crazy about it—really—I'm going to do it a lot more."

London) and established herself in a pension and a studio there.[23] It is not entirely clear how long she stayed. Biographical summaries published in connection with exhibitions during her lifetime record that she spent two years in Paris, so one must assume this is the case.[24] Certainly in November 1908 she was still waiting for her trunk to arrive from America, and one (undated) letter says she has been away for over six months. Two weeks after her arrival in Paris, still living in temporary accommodations at the Hotel Chatham, she wrote to her mother of her intention to work without a teacher:

> And now here is Mr. Henri's advice. He says that it would be foolish for me to go to a school here. That I would only learn a style of painting— that I don't need that, that I must develop by myself. He said that long before he was as advanced in painting as I am he had left the schools. This was only confirming what I already felt myself—but it made me feel all the more certain about it having a man like Henri tell me so.[25]

Nevertheless, she ended up working in the studios of at least two teachers—Lucien Simon and Anglada-Camarasa. There are no letters extant recording her developing views of contemporary art or her reactions to the most radically innovative art she surely saw during that critical two-year period (1908–10).

Upon returning to New York, she rented a studio in a building shared with other artists, including Leon Kroll.[26] She was an active participant in the New York art world during those years preceding her marriage and departure for Rochester. She was included in group shows (alongside Stuart Davis, George Bellows, Robert Henri, Edward Hopper, Leon Kroll, John Sloan, and Andrew Dasburg) held at the MacDowell Club in 1911, 1913, and 1915.[27] She also exhibited in

[23] According to an undated letter, the pension cost 7 francs per day (paid monthly) and the studio, across the road from the pension, 165 francs for three months.

[24] See, e.g., catalogue from MAG exhibition dated February 1920.

[25] Letter dated September 6, 1908 (family archive). In a later undated letter McEnery refers to her "last taste of luxury"—presumably before leaving the Hotel Chatham for her pension at 23 rue Boisonnade, chez Mme de Larue.

[26] According to exhibition records, her address was 2231 Broadway.

[27] A review of the 1911 exhibition headlined "The Fine Arts: In the New York Galleries" (which, in addition to McEnery, included Coleman, David, Henri De Mance, Rudolph Dirks, Henry J. Glintenkamp, Gus Mager, and Sigurd Schow) made this comment: "As might be expected, the one really modern note in the exhibition is

three consecutive years (1911–13) at the Pennsylvania Academy of the Fine Arts and in 1912 at the Corcoran Biennial Exhibition.[28] According to family lore (also recorded by Eleanor Tufts), when the selection process for the 1913 Armory Show took place, McEnery was recovering from pleurisy at her sister's home in Montclair, New Jersey. Leon Kroll submitted two paintings of hers, which were accepted.[29] She was one of three hundred exhibitors (showing 1,090 works). One third of the works came from Europe, selected by the organizers who had been inspired by the avant-garde art they had seen overseas.[30] As is well known, the exhibition signaled the introduction of Post-Impressionist and Cubist art in New York and in the United States, and the hostile response of both viewers and the critical press has been well documented.[31] The American section of the show, though based on a selection process likely to privilege the more progressive artists, was generally far less radical aesthetically.[32] As Milton Brown has written, "The exhibition was actually two shows in one: a selection of modern art which was creating such a furor abroad and a cross-section of American contemporary art weighted heavily in favor of the younger and more radical group among American artists, who were, however, not as yet noticeably affected by the former."[33] The American group included: Henri and Ashcan artists Sloan, Bellows, and Glackens; Impressionist Maurice Prendergast; and modernists Abraham Walkowitz, John Marin, and Marsden Hartley. Shown alongside the work of Matisse, Picasso (including a Cubist *Female Nude*), Braque, Brancusi, and especially Duchamp—whose *Nude Descending a Staircase* was the occasion for much hilarity and ridicule—most of the work by the American artists must have appeared tame and inof-

struck by a woman who disguises her nationality under the cognomen of Kathleen McEnery." *Boston Evening Transcript*, December 7, 1911.

[28] At the Corcoran, she showed *Dream*, probably the same painting she exhibited the following year at the New York Armory Show. See *The Biennial Exhibition Record of the Corcoran Gallery of Art, 1907–1967* (Madison, Conn.: Sound View Press, 1991).

[29] Note sent to Eleanor Tufts by Joan Williams, dated September 14, 1986 (Eleanor Tufts Papers, Southern Methodist University).

[30] As Milton W. Brown has pointed out, however, the Armory Show focused mainly on art from Paris, ignoring German Expressionism, Futurism, and Russian Constructivism. See his *American Painting from the Armory Show to the Depression* (Princeton: Princeton University Press, 1955), 48–49.

[31] See Milton W. Brown, *The Story of the Armory Show* (New York: Abbeville Press, 1963).

[32] On this aspect of the selection process, see Brown, *Story of the Armory Show*, 61.

[33] Brown, *American Painting*, 48.

fensive by comparison.[34] Kathleen McEnery's *Going to the Bath* (fig. 2.2) and *Dream*, informed by the influences she had absorbed in France, were the product of a certain Post-Impressionist sensibility in terms of composition, simplification of form, and (especially in the second work) the substitution of flat washes of color for the more detailed modeling of academic painting.[35] Certainly in terms of the later discourse of modernism, which made a sharp distinction between the modernists of the Stieglitz circle on the one hand, and the realists of the Ashcan School and the Whitney circle on the other, McEnery's work falls within the conservative camp. When, in 1963, Milton Brown asserted that after the Armory Show "new gods moved onto the stage and the old disappeared almost overnight," he reinforced the increasingly polarized view of American art—one that he had been influential in constructing—whereby not only the academy—or even the Ashcan School (both mentioned by him as now in eclipse)—but also any nonmodernist work was by definition retrograde and moribund.[36]

As I have suggested, at the time of the Armory Show and during her years in Rochester in the 1920s and 1930s, McEnery was very much seen as a "modern" (if not "modernist") painter. Sometimes, especially in retrospect, this view has taken the form of a critical judgment by those who preferred a more traditional style of painting grounded in nineteenth-century values and techniques.[37] For the

[34] Lucy Curzon has pointed out to me the amusing fact that McEnery's paintings were listed at $600 and $400; Duchamp's *Nude* was listed at $324 (which was what a certain Frederic C. Torrey paid for it in March 1913). A more helpful comparison would be to Henri's works, which were listed at $2,000, $1,800, and $900 (the last selling at that price in February 1913). An oil by Edward Hopper, listed at $300, sold for $250. The highest price paid was $6,700 for a Cézanne, bought by the Metropolitan Museum of Art.

[35] A reproduction of *Dream* is included in the catalogue for the fiftieth-anniversary recreation of the Armory Show. See *1913 Armory Show 50th Anniversary Exhibition*, 113.

[36] Milton Brown in *1913 Armory Show 50th Anniversary Exhibition*, 35.

[37] To take a specific example, the biographer of Carl W. Peters, a landscape painter and contemporary of McEnery's in Rochester, devoted two brief references to her in an eight-hundred-page book, reporting with approval that by the mid-1930s "the former radical-modernist trend was evaporating rapidly," and adding, "Alas, politics entered the arena even in Rochester: Mrs. Francis Cunningham, a local amateur painter who feigned modernism and happened to chair MoMA's membership committee in Rochester, was invited to show her quasi-modernist work in the special Corcoran show, the only artist who had not exhibited there or anywhere of consequence for that matter." Richard H. Love, *Carl W. Peters: American Scene Painter from Rochester to Rockport* (Rochester: University of Rochester Press, 1999), 721.

most part, at least in the cultural circles in which she moved, she was part of what was a strikingly cosmopolitan world, perhaps surprisingly so for a provincial city. In a "reminiscence" of McEnery in the catalogue for a memorial exhibition of her work the year after her death, her friend the architect Herbert Stern imagines her fear in 1914 at arriving among "philistines" after having spent considerable time in Paris and New York. Within a few years of her arrival, however, the life of the city was transformed: "It must have made her very happy when the opening of the new Eastman School of Music turned our provincial little town, almost overnight, into a cosmopolitan community."[38] The Memorial Art Gallery, founded in 1913, had an active program of exhibitions of contemporary American and European artists.[39] In the same year, the Rochester response to the Armory Show had been guarded and somewhat contradictory, with one local journalist taking the modernist work seriously and her editor concluding that the originality shown "was of the kind to be found in an insane asylum."[40] Economically, the first three decades of the twentieth century have been described as Rochester's golden age, and the centrality of Eastman-Kodak to the city's prosperity had important cultural consequences.[41] The establishment by George Eastman of the Eastman School of Music and the Eastman Theatre in 1922 was the single most important event marking the "end of provincialism." Eastman brought musicians, opera directors, and teachers to Rochester from the capitals of Europe and thus virtually single-handedly created the conditions for a new cosmopolitanism in the city. The British conductor Eugene Goossens agreed to direct the Rochester Philharmonic in 1923 and stayed until 1930. Other well-known European musicians included Russian singer Vladimir Rosing (who trained opera singers

[38] Herbert M. Stern, "A Reminiscence," *Kathleen McEnery Cunningham*, Memorial Exhibition, January 10–20, 1972, Memorial Art Gallery, Rochester.
[39] See Elizabeth Brayer, *MAGnum Opus: The Story of the Memorial Art Gallery* (Rochester: Memorial Art Gallery of the University of Rochester, 1988).
[40] Quoted by Blake McKelvey, "The First Century of Art in Rochester—to 1925," *Rochester History* 17 (April 1955): 19. McKelvey adds that the Rochester Art Club arranged a program to read and discuss several writers who defended the new trends.
[41] See Joseph W. Barnes, "The City's Golden Age," *Rochester History*, 35 (April 1973): 1–24. See also Blake McKelvey, *A Panoramic History of Rochester and Monroe County New York* (Woodland Hills, Calif.: Windsor Publications, 1979). According to Henry W. Clune, "Rochester more or less grew up and lost its provincial character shortly after World War I," suggesting that the prewar social hierarchy started to erode after the war. *The Rochester I Know* (Garden City, N.Y.: Doubleday, 1972), 105.

in Rochester), Hungarian pianist Sandor Vas, Russian voice and opera teachers Nicolas Konraty and Nicolas Slonimsky, and Russian-Armenian stage director Rouben Mamoulian.[42] A lively social and cultural world developed around this group, and McEnery (now Mrs. Francis Cunningham) was central to it.[43] There was also a connection with the literary world through the Rochester physician, editor, and avant-garde filmmaker James Sibley Watson, who was copublisher (with Scofield Thayer) of the progressive New York–based journal *The Dial* through the 1920s.[44] Contributors to *The Dial* visited the Watsons in Rochester after their return in the late 1920s; W. B. Yeats and e. e. cummings were regular visitors, as was the Watsons' close friend Marianne Moore, who edited the journal from 1926 on.[45] Martha Graham, who was hired by Mamoulian to train dancers at the Eastman Theatre, arrived in Rochester in 1925 and stayed for a year and a half.[46]

McEnery almost certainly met Francis Cunningham because of her connection with the artist Rufus J. Dryer, a cousin of the Cunning-

[42] See Blake McKelvey, *Rochester on the Genesee: The Growth of a City* (Syracuse: Syracuse University Press, 1973), 185–87; Elizabeth Brayer, *George Eastman: A Biography* (Baltimore: Johns Hopkins University Press, 1996), 460–61; Paul Horgan, "Rouben Mamoulian in the Rochester Renaissance," *A Certain Climate: Essays in History, Arts, and Letters* (Middletown: Wesleyan University Press, 1988), 195–220. Horgan describes the period from 1923 to 1926 in Rochester as a "one-man renaissance," adding, "and the man was George Eastman" (196).

[43] This world, especially its most active social institution, the Corner Club (a dining club established for concertgoers), is nicely captured in Paul Horgan's roman à clef *The Fault of Angels* (New York: Harper, 1933). The Cunninghams' membership in this club (among others) is recorded in *The Rochester Blue Book* for 1923.

[44] See Nicholas Joost, *Years of Transition: The Dial 1912–1920* (Barre, Mass.: Barre, 1967), 118–25. When *The Dial* ceased publication in 1929, Sibley Watson turned to filmmaking. He is still known for his highly innovative films *The Fall of the House of Usher* (1928) and *Lot in Sodom* (1933), both made in a stable next to his family home in Rochester. See Hildegarde Lasell Watson, *The Edge of the Woods: A Memoir* (Lunenburg, Vt.: Stinehour Press, 1979), 108. On Watson's films, see Lucy Fischer, "The Films of James Sibley Watson, Jr., and Melville Webber: A Reconsideration," *Millennium Film Journal*, no. 19 (fall/winter 1987–88): 40–49; Lisa Cartwright, "U.S. Modernism and the Emergence of 'the Right Wing of Film Art': The Films of James Sibley Watson, Jr., and Melville Webber," in *The First American Film Avant-Garde, 1919–1945*, ed. Jan-Christopher Horak (Madison: University of Wisconsin Press, 1995), 156–179; and James Sibley Watson Jr. et al., "The Films of J. S. Watson, Jr., and Melville Webber: Some Retrospective Views," *University of Rochester Library Bulletin* 28 (winter 1975): 74–108.

[45] See Cyrus Hoy, ed., "Marianne Moore: Letters to Hildegarde Watson (1933–1964)," *University of Rochester Library Bulletin* 39 (summer 1976): 93–183.

[46] Brayer, *George Eastman*, 466–67.

hams.[47] Dryer had been a student of Henri's with McEnery, and she appears to have got to know him well during their summer in Spain.[48] Francis was the son of Joseph Cunningham, president of James Cunningham, Son and Company, a Rochester coach-making firm that, since 1908, had also been manufacturing automobiles. (Cunningham produced the first automobile in America with a V-8 engine in 1916. Cunningham cars, referred to by Herbert Stern as "the nearest thing to a Rolls-Royce produced in America," were much in demand among the rich; George Eastman bought one in the 1920s.)[49] At the time, Francis (Frank) Cunningham was secretary and general manager of the company; his brother, Augustine, was president, and a cousin, James Dryer, vice-president. A third-generation member of the manufacturing family, Frank had grown up in a wealthy family, living in a large house on Rochester's elegant East Avenue (where Eastman also lived) and spending summers on an island owned by the family in Sodus Bay, east of Rochester.[50] He had returned to the family business after studying at Harvard. McEnery thus married into a well-established upper-middle-class family. Although Stern has claimed that she had considerable influence on the coloring, if not on the styling, of Cunningham cars, her own inclination was to participate in the cultural, not the business, world of the city. She was a member of several local social and cultural clubs, and she was an active participant in the Memorial Art Gallery, both as a teacher of art classes and as a member of the gallery's art committee and board of

[47] On the Dryer family, see Joseph F. Dryer, *Ancestry of Rufus K. Dryer with Notes on William Dryer of Rehoboth and Some of His Descendants* (Rochester: Du Bois, 1942). Rufus J. Dryer's art, exhibited in Rochester after his death in 1937, is discussed on pages 32–34.

[48] An early letter home during that stay—undated, but from southern Spain, where she went before arriving in Madrid—refers to "Mr. Dryer and his sister" as "both very nice (and Catholics)." McEnery was also from a Catholic family. A letter dated June 28, 1908, to her sister Vera reads: "Mr. Dryer is . . . not wildly interesting. I like him however, he's a very good sort, and his sister, Leora, I like very much. We're quite good chums already." By the time she wrote to Vera on August 18, she was referring to them as "Rufus and Leora."

[49] See Stern, "A Reminiscence," n.p., and Brayer, *George Eastman*, 236. See also Joseph W. Barnes, "Rochester and the Automobile Industry," *Rochester History* 43, nos. 2–3 (1981): 16–23; and Noël Hinrichs, *The Pursuit of Excellence: James Cunningham, Son & Co* (Rochester: KMcEC Associates, 1964). During the Second World War the company first switched to the manufacture of tanks and armored vehicles and later to telephone equipment.

[50] Hinrichs, *Pursuit of Excellence*, 26.

managers. From 1924 to 1928 she also taught art at the independent Harley School, which she helped found in 1917 and where she was president of the board of trustees from 1922 to 1925.[51] She was also an active member of the Alliance Française.[52] In her early years in Rochester, she was involved in the women's suffrage movement; later, during the Second World War, she served as vice chairman of the Rochester branch of the British War Relief Effort. Following Rochester's "renaissance,"[53] she was able to lead a life very much centered on the "high" culture of the city and, by virtue of the city's growing cultural links with New York and Europe, of the wider artistic community. Like her friend and competitor Charlotte Whitney Allen, she hosted a salon at her home where artists and writers were especially welcome. Despite her domestic and family commitments (she had three children), she was also able to travel. Her friend, the architect Claude Bragdon, who had lived and worked in Rochester until he moved to New York in 1922, records visits by her in three letters written in 1923.[54] In a letter to McEnery dated September 19, 1925, he encourages her to exhibit in New York, and she did, indeed, exhibit at the Ferargil Gallery in New York the following year.[55]

Many of McEnery's portraits were of people from the musical and cultural world in Rochester in the 1920s and 1930s. These include: the pianist Sandor Vas; the Rochester Philharmonic horn player Eddie

[51] Ruth Ewell, *A History of the Harley School, 1917–1992* (Rochester: privately printed, n.d.), n.p.

[52] She was probably instrumental in inviting the French artist and art teacher Jean Charlot as guest speaker at the Alliance in 1938. Then teaching at the Art Students League in New York, he had been the teacher of McEnery's daughter, Joan Cunningham, who was a WPA mural painter in 1940. See *Democrat and Chronicle*, November 2, 1938, and November 9, 1940.

[53] See n. 42.

[54] Quoted by his son, Henry Wilkinson Bragdon, in a letter to Peter Cunningham (McEnery's son)—undated, but on "Eisenhower-for-President-Committee" notepaper. See, e.g., November 15, 1923: "Mrs. Cunningham arrived on Tuesday and took me to the Duse Matinee." On November 18 he observed: "We had a great party here last night. . . . Kathleen and Frank Cunningham brought Arthur Alexander and the Goossens."

[55] Claude Bragdon papers, University of Rochester. Her exhibition was reviewed briefly in the *New York Times*, on January 10, 1926. In addition to trips to New York, Peter Cunningham recalls visits to Paris, and Peggy Neville (née Finucane) of Rochester recalls meeting McEnery and her children in Ireland in 1937 (interview with Peter Cunningham, December 22, 2000; telephone interview with Peggy Neville, February 6, 2001).

Murphy; the conductor Eugene Goossens (fig. 2.6); Nancy Royce, wife of the composer Edward Royce; and Lilian Rogers, wife of Bernard Rogers, chair of composition at the Eastman School of Music (fig. 2.7).[56] She also painted Toto the clown and actor Glenn Hunter (in character as Peter Ibbetson) when he appeared at the Lyceum Theater in Rochester in the summer of 1926.[57] In addition to persuading her husband and children to sit for her, she also used her women friends as subjects.[58] Two of her former subjects confirmed to me that she did not work on commission, asking friends to sit for her with no expectation that they would buy the painting.[59] In addition to portraits, McEnery painted still lifes during her Rochester years.[60] This noncommercial relationship to her art practice no doubt contributed to the impression that she was "merely" an amateur artist, as the biographer of the local artist Carl Peters rather dismissively concluded.[61] There are obviously class issues involved here. As a wealthy married woman, McEnery had no need to support herself by selling her art. At the same time, her early involvement with the New York art world

[56] The location of the Vas portrait is unknown; it was exhibited at the Memorial Art Gallery in 1927 and is reproduced in a review in the *Democrat and Chronicle* dated December 5, 1926. The portraits of Murphy and Royce are in private collections in Oregon and California. There were at least two portraits of Goossens. The one illustrated here is at the Eastman School of Music; the location of the other portrait is unknown. The portrait of Lilian Rogers is in the Rochester Museum and Science Center (to which McEnery bequeathed her house on South Goodman Street).

[57] The portrait of Toto the clown is in a private collection. The location of the Hunter portrait is unknown, though it is recorded that Hunter purchased it himself at the time. *Democrat and Chronicle*, March 19, 1927. It was exhibited in the 1927 Memorial Art Gallery show.

[58] There are three portraits of Charlotte Whitney Allen by McEnery. One hangs in the library of the Memorial Art Gallery, another is in the mezzanine lounge of the Eastman Theatre, and a third, in the collection of the Rochester Institute of Technology, can be seen on their website at *www.rit.edu/~arton/paintprint/ mcemery_woman.html*. A portrait of Frank Cunningham is in a private collection, as are several portraits of her three children, Joan, Peter, and Michael.

[59] One was Elizabeth Holahan, long-time president of the Rochester Historical Society, who said that "Kathleen wouldn't take 'no' for an answer" (interview, February 21, 2001); the other subject was Ann Scoville, a sculptor who lived in Rochester in the 1940s. Although she declined to buy the painting, she says that McEnery gave it to her toward the end of her life (telephone interview, October 19, 2000).

[60] Apparently she no longer painted either nudes or outdoor scenes, as she had done in Spain and in Paris—none are listed in exhibition catalogues after 1914. However, in an interview with her in a local newspaper (probably from the late 1920s), it is reported that "she likes to paint landscapes and still life pictures" as well as portraits (undated newpaper clipping, family archive).

[61] See n. 37.

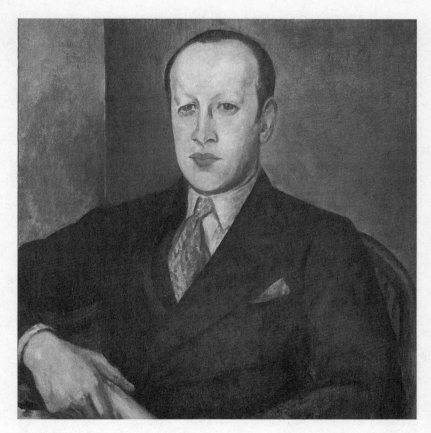

2.6 Kathleen McEnery: *Portrait of Eugene Goossens*, c. 1927 (Courtesy of the Sibley Music Library, Eastman School of Music, University of Rochester)

and her continuing connections with the national and international cultural elite (made possible by her privileged class position) ensured that she could still be taken seriously as an artist more than ten years after she left New York. Her 1926 exhibition at the Ferargil Galleries in New York was her first in that city since 1915, when she showed at the MacDowell Club. Commenting on the exhibition in a generally sympathetic review, the critic Forbes Watson weighed the advantages that might accrue from such an absence:

> Kathleen McEnery, who is holding an exhibition of portraits at the Ferargil Galleries . . . first came to the notice of the reviewers more than ten

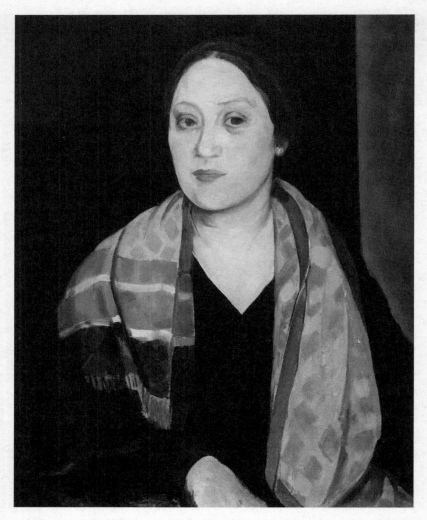

2.7 Kathleen McEnery: *Portrait of Lilian Rogers*, n.d. (Rochester Museum and Science Center, Rochester, N.Y.)

years ago at the Armory Exhibition and at the McDowell Club Exhibitions. Since those days she has held aloof from exhibitions, and the present display is the first in recent years. To judge by her present exhibition, she has not spent her time idling, and some quality has come into her work through the very fact that for so long a time she has made no effort to keep herself as an artist in the public eye. Living in Rochester, she has

worked without the distractions of the hurly-burly exhibition game. She has worked in her own way and developed a personal style.[62]

It was also because of her Rochester–New York connections that two of McEnery's paintings were reproduced in *The Dial* in 1928.[63] It is probable that Hildegarde Watson, the wife of *Dial* publisher James Sibley Watson and a good friend of McEnery's in Rochester, was instrumental here. In her memoir she says of her husband: "Sometimes he would send me—feeling much honored—to look for illustrations for *The Dial* at exhibitions of painting and sculpture."[64] McEnery's 1927 exhibition at the Memorial Art Gallery in Rochester included a *Portrait of the Artist's Daughter* and three paintings with the title *Still Life*; the paintings reproduced in *The Dial* are *Still Life* (lilies in a vase) and a portrait of McEnery's daughter, Joan (called simply *Portrait*), very likely seen at the MAG exhibition by Hildegarde Watson.

The waning of Kathleen McEnery's career following a period of high visibility and great promise in the years 1911 to 1915 is a complex affair. Although she was virtually the only woman painter in the McDowell Club exhibitions in New York, her gender does not explain the difference in career success between her and her coexhibitors.[65] Nor does the fact that she resisted radical modernism and continued to paint realist work, albeit in a style reflecting developments in European modern art. The same is true, for example, of Edward Hopper, whose work hung alongside hers at the MacDowell Club. (Andrew Dasburg and Stuart Davis were the exceptions in pursuing a truly modernist route.) Her Ashcan colleagues at the gallery, Henri, Luks, and Sloan could be said to be less forward-looking than McEnery in their work in the years that followed. Nevertheless, most of these

[62] Quoted (from the *New York World*, n.d.) in a local Rochester paper (newspaper clipping in family archive).

[63] *The Dial* 85 (July–December 1928): f. p. 28. The paintings are a still life (depicting a calla lily in a vase, private collection in Rochester), and a portrait of McEnery's daughter, Joan as a young girl (private collection in Virginia). Thanks to Lucy Curzon for discovering this journal issue, which can be read online at *http://virtual.clemson.edu/ groups/dial/dial85.htm*.

[64] Watson, *Edge of the Woods*, 91.

[65] One other woman painter included in the 1915 exhibition at the MacDowell Club (with McEnery and ten men) was Thalia W. Millett. In an exhibition at the Daniel Studio Gallery (whose date is uncertain), McEnery showed work with five men, including Ernest Lawson, Samuel Halpert, and George Luks.

artists have retained a place in the history of American art, even if generally perceived as inferior to that of the modernists (an assessment, as I suggested in my introduction, that has recently come under reconsideration). Since McEnery did not give up her painting career upon marrying, the remaining two factors one should consider are her move to a provincial city and her ambiguous role as amateur-professional artist. In an important way, of course, this circles back to questions of gender. In marrying a man with a successful business who belonged to a family long established in Rochester, she had to leave New York in 1914. Although she was able to continue her work for several decades and was also able to retain her connections to New York and beyond, the life of a wife and mother (and, as she is described in at least one local newspaper, socialite) competed in several important ways with her career. In a profile of her in a local paper in the 1930s (titled "Mrs. Cunningham: Real Artist and Real Wife and Mother") McEnery is described as "the kind of person who cannot be classified as 'so and so's wife.'" The reporter writes that "she makes it plainly understood that she takes her profession seriously," insisting that "to classify her painting as a hobby, or one of those thrilling avocations women are supposed to be enthused over, would be to minimize it. She is one of the rare women, who has successfully combined career, husband and the rearing of three children."[66] In the sense that she continued a highly productive life as an artist, exhibiting locally and occasionally outside Rochester, it is true that she did succeed in combining these strands.[67] Nevertheless, in leaving New York and forsaking the life of a full-time professional artist, McEnery also relinquished any possibility of capitalizing on her early success and securing a place alongside her contemporaries in the official histories of American art.

The received story of art is fundamentally a story of institutions. Success and visibility are the product of several factors: access to gal-

[66] *Rochester Journal*, n.d. (newspaper clipping in family archive).

[67] It is even possible that living in Rochester rather than a larger city may have been an advantage. A study of women artists in Boston in the period 1870 to 1940 shows that the existence of an art school in Boston—the school of the Museum of Fine Arts—ensured that locally produced art remained provincial and conservative, dedicated to the pursuit of beauty, and hostile to European and American modernism. See Erica E. Hirschler, *A Studio of Her Own: Women Artists in Boston, 1870–1940* (Boston: MFA Publications, 2001), 100–105. This book was published in conjunction with an exhibition with the same title.

leries and exhibitions; critical attention; museum purchase and continuing public display; and art-historical discussion and publication (essay, monograph, textbook). In an interview with a local newspaper probably dating to the late 1920s, McEnery deplored the lack of a dealer gallery in Rochester.[68] One with a strong New York connection would have served her even better, as would a continuing relationship with a New York gallery. Although the Ferargil Galleries, where she had an exhibition in 1926, remained in existence until 1955, she does not appear to have shown work there again. Far from New York, she also lacked access to the more informal institutions of art that inevitably play a part in the development of artists' careers, such as art clubs, parties, openings, and the unstructured social interactions of a local cultural milieu. Apart from the Memorial Art Gallery in Rochester and the Rochester Museum and Science Center, the only museum that owns one of her paintings (as far as I know) is the Smithsonian American Art Museum (and that painting—one of her two Armory show works—is in storage). Although there is little to be gained by erecting a hierarchy of exclusions (gender, geography, aesthetics, class), it is worth considering their intersections. As I have already suggested, the disappearance of McEnery is not a question of "hidden from history"—the earlier feminist critique of the obliteration of women artists from the history of art—nor is it simply explained by the privileging of modernism over realism and figurative work. The primary factor in her disappearance was her provincial location, though that, in turn, was an indirect product of gender inequalities. On the other hand, that other narrative about women artists who abandon their art practice when the demands of domestic life take over was more complicated in McEnery's case, where the privileges of class and wealth facilitated both the leisure and the travel that allowed her to continue to work as an artist.

With regard to the question of aesthetics and visual style, the work of Kathleen McEnery complicates any simple dichotomy of modernism/realism. In her own time she was considered a "modern" artist in New York as well as in Rochester. If one looks at her portraits and still life paintings from the 1920s and 1930s, it is clear that she has moved a long way from the realism of the Ashcan style of painting in

[68] "Art and Her Children Mrs. Cunningham's Delight" (newspaper clipping in family archive).

which she was originally trained. What was said in 1930 about the Art Deco artist Tamara de Lempicka could apply equally to McEnery: "She could be called realistic if the term were enlarged."[69] McEnery's work was what one might perhaps call "modern realism"; though not modernist (post-Cubist) painting, it is work strongly indebted to early-twentieth-century experiments in color and form, distancing it decidedly from academic style, American impressionism, and the social realism of the Ashcan school. Lempicka's biographer concludes her study by raising challenging questions about situating someone who simply doesn't fit:

> What are the boundaries of Modernism . . .? What do we do with a first-rate painter whose creations defy the characteristics that give Modernism its meaning? Why has such a painter been left out of virtually all written accounts of Modernism, even those seeking to reclaim women who'd been omitted from earlier official accounts? If we deem Tamara's talent worthy of serious attention, do we expand the term "Modernism," making it capacious enough to include her?[70]

In the end, one could conclude that the categories themselves are unhelpful. But from the point of view of the central theme of this book, namely, the marginalization of nonmodernist work, Kathleen McEnery would have been firmly situated by the dominant narrative of twentieth-century art on the side of the secondary, the retrograde, the inferior—in other words, the realist tradition. It is a narrative that is now seriously being called into question. A review of the work of Boston women artists makes the optimistic claim that thanks to postmodernism's abandonment of a progressive, linear view of art, "the works of these women can once again be valued on their own terms."[71] One should bear in mind, though, that this statement makes two rather problematic assumptions: that rediscovery will, in fact, engender a wider acceptance and that, having abandoned the discredited aesthetics of "the canon," one therefore has access to other, more convincing, criteria of judgment.

[69] Quoted in Laura Claridge, *Tamara de Lempicka: A Life of Deco and Decadence* (New York: Clarkson Potter, 1999), 175.
[70] Claridge, *Tamara de Lempicka*, 373.
[71] Deborah Weisgall, "Women Who Took Up Art When Most Women Didn't," *New York Times*, August 26, 2001. See n. 67.

If disappearance is a complex matter, so is discovery. The year 1987 marked a moment of discovery for Kathleen McEnery: two works in a major national exhibition; an endorsement by a well-known feminist art historian (Eleanor Tufts); and a complimentary notice by an art critic.[72] However, this did not lead to any lasting recognition. My later more or less accidental rediscovery of her work may prove to be just as ephemeral.[73] As in the case of the Whitney women, the question of aesthetic evaluation is merely raised and not answered by the critical questioning of the canon and its exclusions, and although I would be prepared to argue the qualities and skill of McEnery's work, its circulation in public opens the way for a more general debate as to its value. Griselda Pollock has proposed that one "excavate a feminist genealogy of twentieth-century artists who are women, creating . . . chains of association and dialogues across time and space that frame and examine the contradictions of sexual difference and cultural positioning" in order to "*see* artists and work that had been made invisible, illegible, irrelevant."[74] My belief is that exploring the life and work of Kathleen McEnery, particularly the vicissitudes of her reputation during her lifetime and following her death, will illuminate many of the issues involved in canon-formation and aesthetic hierarchies—gender, class, and aesthetics—as well as providing an opportunity to look at some marvelous paintings by a woman artist who was once in the forefront of the New York art world.

[72] "That [canvas] of Kathleen McEnery's, *Breakfast Still Life*, could, in both color and pattern, stand comparison with some of the best of Matisse." Raymond J. Steiner, "The National Museum of Women in the Arts," *Art Times* 3 (May 1987): 11.

[73] As this book goes to press, however, an exhibition of McEnery's work is planned at the Hartnett Gallery, University of Rochester, March 17 through April 26, 2003. There will be a catalogue to accompany the exhibition.

[74] Griselda Pollock, "Inscriptions in the Feminine," in *Inside the Visible: An Elliptical Traverse of 20th Century Art in, of, and from the Feminine,* ed. M. Catherine de Zegher (Cambridge: MIT Press, 1994), 69.

Gender and the Haunting of Cities

Or, the Retirement of the Flâneur

There has been a good deal of discussion in the past fifteen years on the topic of the *flâneuse*, the female version of modernity's urban stroller. Was there such a person, or did the ideology of separate spheres, combined with the architecture and organization of public space, render female *flânerie* impossible? Did the expansion of the public sphere and the birth of new activities—shopping and moviegoing are usually cited—create the conditions in the late nineteenth century for the *flâneuse* to make an appearance? Or, to approach the question from a different angle, is the problem not so much women's lack of access to the street but rather the distortions of cultural theory and social history, which foreground certain (male) activities and render women invisible? I want to consider the figure of the *flâneuse* in terms of three separate but related issues: women's access to urban space in the early twentieth century; the ways in which the *language* of modernity introduces gender biases; and alternatives posed by feminist historians for rethinking the public/private divide in order to describe a modernity in which women are no longer invisible. Although these are important matters, I also believe that new work in architectural and urban theory suggests a more profitable approach. Here the emphasis is on the *provisional* nature of the built environment and of the urban community, a perspective which—instead of focusing on obstacles and exclusions—permits one to consider the ways in which women actually negotiate the city in everyday life. In the end, after all the discussion about women's access to the practice of *flânerie*, one may sympathize with the rather

rhetorical question asked by James Donald: "Why on earth should any woman *want* to be a *flâneur*?"[1]

The *flâneur*—the French term is always used in English and German contexts—is the person who strolls aimlessly in the modern city, observing people and events, perhaps (if the *flâneur* also happens to be a writer or an artist) with a view to recording these observations in word or image. Although this particular figure has a prehistory in eighteenth-century thought, it is generally agreed that its prominence in the literature of modernity dates from Baudelaire's mid-nineteenth-century essays on modern life, particularly his 1859 essay "The Painter of Modern Life." Here the *flâneur* appears as the "modern hero"—the person whose experience epitomizes the fragmented and anonymous nature of life in the modern city, observing the fleeting and ephemeral aspects of urban existence (changing fashions, brief encounters). The theme was taken up half a century later by the German critic Walter Benjamin, for whom Baudelaire was the poet of modernity and the arcades of Paris the essential space of *flânerie*: "Strolling could hardly have assumed the importance it did without the arcades. . . . It is in this world that the *flâneur* is at home. . . . The arcades were a cross between a street and an *intérieur*. . . . The street becomes a dwelling for the *flâneur*; he is as much at home among the façades of houses as a citizen is in his four walls."[2]

The *flâneur* is not the only figure invoked as the epitome of the modern experience—Baudelaire and Benjamin also offer the dandy, the ragpicker (*le chiffonnier*), and the prostitute as emblematic modern urban types.[3] All of these have their origins in the radically new conjunction of the rise of commodity culture and the expansion of major metropolitan centers. This characterization of modernity has a good deal in common with descriptions by sociologists at the turn of the century, notably Georg Simmel, whose 1903 essay "The Metropolis and Mental Life" explored the subjective aspects of urban existence,

[1] James Donald, *Imagining the Modern City* (Minneapolis: University of Minnesota Press, 1999), 112.

[2] Walter Benjamin, *Charles Baudelaire: A Lyric Poet in the Era of High Capitalism*, trans. Harry Zohn (London: New Left Books, 1973), 36–37.

[3] Deborah Parsons suggests that the ragpicker is a more appropriate metaphor than the *flâneur* to characterize the fragmentary, commodity-driven modern city, one which, according to her, allots women their place in the modern city. "*Flâneur* or *flâneuse*? Mythologies of Modernity," *New Formations* 38 (1999): 91–100.

in particular its increased tempo, greater impersonality, and cultiva-
tion of a detached (blasé) attitude. The typical urban dweller is accus-
tomed to a state of anonymity unknown in the close-knit communi-
ties of rural society, or even of small-city life. The *flâneur* emerges both
as a possibility created by such conditions and as the prime exponent
of urban living.

The *flâneur*, however, is necessarily male. The privilege of passing
unnoticed in the city—particularly in the mid-nineteenth to early
twentieth centuries, the period in which the *flâneur* flourished—was
not accorded to women, whose presence on the streets would cer-
tainly be noticed. As many historians of the period have pointed out,
women in public—especially those apparently wandering without
aim—were considered "nonrespectable." It is no accident that the
prostitute appears as the central female trope in the discourse of
modernity. The problem for women was their automatic identifica-
tion with this "streetwalker" image whenever they walked in the
street. Discussing London in the 1870s, Deborah Nord identifies the
problem for middle-class women: "When they ventured onto the city
streets under the conditions necessary to urban strolling and observa-
tion, they took on the persona of the fallen woman."[4] Since the *flâneur*,
the central figure of modernity, was inherently gendered male, the ac-
count of urban experience, now seen through the eyes of the *flâneur*
and his cohorts, necessarily renders women invisible or marginal.[5] It
is therefore not surprising that since the mid-1980s—at the very time
that *flânerie* took center stage in the sociological discourse of modern-
ity—feminist critics have challenged this way of conceptualizing
modernity. It is not a matter of objecting to women's actual exclusion
but rather of suggesting that this exclusion is compounded by late-
twentieth-century approaches, which gave priority to the street and
the public arena in the very definition of modernity.

There have been a number of different responses to the recognition
of this privileging of male experience in the literature of modernity.
Some writers insist that women's absence from the public sphere has
been overstated—indeed, that there have always been women in the

[4] Deborah E. Nord, "The Urban Peripatetic: Spectator, Streetwalker, Woman
Writer," *Nineteenth-Century Literature* 46, no. 3 (1991): 365.
[5] See my essay "The Invisible *Flâneuse*: Women and the Literature of Modernity,"
in my *Feminine Sentences: Essays on Women and Culture* (Berkeley: University of Cali-
fornia Press, 1990), 34–50.

urban arena, and increasingly so toward the end of the nineteenth century. Such writers rightly object to any implication that women's place was solely in the private sphere of the home. As Leonore Davidoff and Catherine Hall have shown, the public and private arenas have never been separate and discrete but have always intersected—through family networks and marriage ties in relation to economic structure, in women's contribution to enterprise, and in men's own relationship to the domestic scene.[6] Mica Nava has pointed out that "women's appropriation of public spaces, in both symbolic and material ways, was growing rapidly" in the late nineteenth and early twentieth centuries. This is confirmed by Peter Fritzsche's study of Berlin in 1900, by Judith Walkowitz's discussion of the new spaces available for women in a redefined public domain in London in the 1880s, and by Kathy Peiss's study of working-class women's culture in turn-of-the-century New York.[7] Others have argued that not only do women appear in the urban landscape but also they do so in the later period in the very role of *flâneuse*. Here the emphasis has been on the two particular activities whose characteristics, it is argued, are those of *flânerie*, namely, shopping and moviegoing. Anne Friedberg's well-known discussion of what she calls "les *flâneurs* du mal (l)," with its double reference—back to Baudelaire's *Les Fleurs du mal* and forward to the newest type of shopping locale—focuses on these new opportunities for women in public: "As the department store supplanted the arcade, the mobilized gaze entered the service of consumption, and space opened for a female *flâneur*—a *flâneuse*—whose gendered gaze became a key element of consumer address."[8] Fried-

6 Leonore Davidoff and Catherine Hall, *Family Fortunes: Men and Women of the English Middle Class, 1780–1850* (Chicago: University of Chicago Press, 1987).

7 Mica Nava, "Modernity's Disavowal: Women, the City and the Department Store," in *Modern Times: Reflections on a Century of English Modernity*, ed. Mica Nava and Alan O'Shea (London: Routledge, 1996), 40; Peter Fritzsche, *Reading Berlin 1900* (Cambridge: Harvard University Press, 1996), 63–66; Judith Walkowitz, *City of Dreadful Delight: Narratives of Sexual Danger in Late-Victorian London* (Chicago: University of Chicago Press, 1992), 9; and Kathy Peiss, *Cheap Amusements: Working Women and Leisure in Turn-of-the-Century New York* (Philadelphia: Temple University Press, 1986).

8 Anne Friedberg, "Les *Flâneurs du Mal(l)*: Cinema and the Postmodern Condition," *PMLA* 106, no. 3 (1991): 420. See also her book *Window Shopping: Cinema and the Postmodern* (Berkeley: University of California Press, 1993). Ruth E. Iskin's essay "Selling, Seduction, and Soliciting the Eye: Manet's *Bar at the Folies-Bergère*," *Art Bulletin* 77, no. 1 (1995): 25–44, a study of the department store and consumer display in France in the late nineteenth century, insists on the visibility of women in at least this public arena (see esp. p. 35, and fn. 50).

berg perceives the cinema as the contemporary, postmodern culmination of this extension of the place of *flânerie*, situated as it often is within the shopping mall. In her case, the logic of extension is a dual one—first, having to do with the kind of public space the cinema occupies (one in which women can move freely and without suspicion) and, second, depending on a historical connection between cinema and arcade (the original space of *flânerie*). As she sees it, "the cinema was born out of the social and psychic transformations that the arcades produced," through the earlier, protocinematic devices of the panorama and the diorama.[9] Here the freedom to wander is no longer about the literal movement of bodies in space but rather the mobility of the gaze, confronted by the moving image. Similar arguments have been made by other film historians, substituting the virtual *flânerie* of movie viewing for the physical wandering of the urban stroller. For example, Giuliana Bruno has proposed that

> the cinematic situation made it possible for the female to experience a form of *flânerie*, as film, triggered by a desire for loitering, offered the joy of watching while traveling. The "spectatrix" could thus enter the world of the *flâneur* and derive its pleasure through filmic motions. We may see film spectatorship as providing access to the erotics of darkness and (urban) wandering denied to the female subject.[10]

Anke Gleber makes something of the same case in her discussion of film and *flânerie* in Weimar Germany, though the connection she wants to make between urban strolling and film viewing is more in the nature of parallels and similarities than the stronger claim of moviegoing as itself the new *flânerie*.[11]

[9] Friedberg, "Les Flâneurs du Mal (I)," 423.

[10] Giuliana Bruno, *Streetwalking on a Ruined Map: Cultural Theory and the City Films of Elvira Notari* (Princeton: Princeton University Press, 1993), 51.

[11] According to Gleber, "The cinema releases the female spectator from her exclusion from the world, and also her reduction to a passive image. The sites of female flanerie have been inscribed into the filmic medium from its earliest times." *The Art of Taking a Walk: Flanerie, Literature, and Film in Weimar Culture* (Princeton: Princeton University Press, 1999), 186. The logical extension of this transposition of *flânerie* from the streets to the cinema can be found in Mike Featherstone's discussion of the "virtual *flâneur*" who engages with computer, hypertext, and the Internet in "The *Flâneur*, the City and Virtual Public Life," *Urban Studies* 35, nos. 5–6 (1998): 909–25. Maren Hartmann has also introduced the notion of the "cyber*flâneur/se*," which is cited by Graeme Gilloch in " 'The Return of the *Flâneur*': The Afterlife of an Allegory," *New Formations* 38 (1999): 106–7.

I am, of course, sympathetic, to the desire to recover (and rediscover) women's place in modernity, and to counter those stories which render women quite invisible. It is important to emphasize women's continuing role in the public sphere—whether as shoppers, philanthropists, or workers (professional, clerical, and working-class)—and the great value of much feminist history has been to examine and describe these activities.[12] However, it is equally important to keep in mind the actual constraints, exclusions, and dangers faced by women in the urban environment, which is why I want to insist that the role of *flâneuse* remained impossible despite the expansion of women's public activities, and despite the newer activities of shopping and moviegoing. Central to the definition of the *flâneur* are both the *aimlessness* of the strolling, and the *reflectiveness* of the gaze. Benjamin himself believed that the decline of the Paris arcades, brought about by the Haussmannization of the city, signaled the end of *flânerie*, the department store itself epitomizing this transformation.[13] The experience which had once been neither public nor private (the arcade representing a kind of liminal space) and which had been fundamentally without aim became instead both an activity removed from the street and one with a very specific aim, namely, shopping and consumption. As Priscilla Ferguson puts it:

> When *flânerie* moves into the private realm of the department store, feminization alters this urban practice almost beyond recognition. . . . By abolishing the distance between the individual and the commodity, the feminization of *flânerie* redefines it out of existence. The *flâneur*'s dispassionate gaze dissipates under pressure from the shoppers' passionate engagement in the world of things to be purchased and possessed. The *flâneur* ends up going shopping after all.[14]

The department store cannot be the scene of urban strolling, not merely because it is an enclosed and circumscribed space but, more

[12] Deborah Nord, among others, has discussed women's public role as philanthropists and social investigators in her *Walking the Victorian Streets: Women, Representation, and the City* (Ithaca: Cornell University Press, 1995); see esp. part 3, "New Women," 181–236.

[13] Benjamin has written, "If the arcade is the classical form of the *intérieur*, which is how the *flâneur* sees the street, the department store is the form of the *intérieur*'s decay. The bazaar is the last hangout of the *flâneur*." *Charles Baudelaire*, 54.

[14] Priscilla P. Ferguson, "The *Flâneur* on and off the Streets of Paris," in *The Flâneur*, ed. Keith Tester (London: Routledge, 1994), 23, 35.

important, because shopping is a predefined and purposeful activity. In the case of moviegoing, feminists have made much of both women's freedom to attend this semipublic place—"legitimized public pleasure" for women, as one critic has called it[15]—and women's access to a new kind of looking, the gaze previously associated with the urban *flâneur*. Here is how Anke Gleber describes this activity of the female spectator: "The darkened space of the cinema removes her from the gaze of others, while at the same time allowing her own gaze unrestricted, extended access to all the shocks and impressions of modernity, approximating and even exceeding the experience of the street. This onset of the cinema finally gives women the right to indulge their scopic desires."[16] But here, too, it seems to me that it is stretching the meaning of the concept of the *flâneur* too far to describe the female movie spectator as a *flâneuse*. Like the department store, the movie theater (particularly in the suburban mall, which is Anne Friedberg's focus) can hardly be understood as public space. Women's relatively unproblematic admission to the movie theater was, in the early days, a long way from gaining general access to urban life. In addition, there is something a little strange about considering the "mobilized gaze" of film spectatorship as on a par with the look of the urban stroller. The spectator sits quite still, faces forward, and confronts a prearranged sequence of moving images which, to be sure, she can interpret freely—even glancing away, scanning the screen, and so on—but which ultimately offer nothing in the way of self-determined direction of the gaze or, indeed, possibilities of reflective response to the parade of images. In general, I see no real advantage in these attempts to recuperate the discourse of *flânerie* for women by means of a simple change of locale. For women in the city—negotiating the geography and architecture of public space in the early twentieth century—the role of *flâneuse* remained unavailable. In 1929 Walter Benjamin's friend and colleague Franz Hessel published one of the first sustained discussions of urban strolling entitled *Spazieren in Berlin* (later reprinted as *Ein Flaneur in Berlin*).[17] Rather surprisingly,

[15] Bruno, *Streetwalking on a Ruined Map*, 51.

[16] Gleber, *The Art of Taking a Walk*, 187. Miriam Hansen also discusses the mobilization of the active female gaze in cinema in *Babel and Babylon: Spectatorship in American Silent Film* (Cambridge, Massachusetts: Harvard University Press, 1991), 122.

[17] Franz Hessel, *Spazieren in Berlin* (Munich: Rogner & Bernhard, 1968). For a detailed discussion of Hessel and his importance to Benjamin, see chapter 4 of Gleber's *Art of Taking a Walk*, 63–83.

the first essay in this book of short impressions is entitled "The Suspect" ("Der Verdächtige"), and Hessel here reveals that as a *flâneur* in Berlin, he is always the subject of suspicious looks.[18] This does not accord with the "classical" notion of the *flâneur*, who is assumed to pass unchallenged and in virtual anonymity. For Benjamin, who reviewed the book in 1929, this only confirmed his view that the conditions of urban strolling, present in the Paris of the arcades, are never really reproduced in other cities or in later periods.[19] Women, of course, were almost invariably regarded with suspicion as they traversed the streets of the modern city. It is only with the extended view of *flânerie* (one might call it the "nonclassical" concept of the *flâneur*, like Hessel as Berlin wanderer) that one might—in acknowledging the advent of "the new woman" and the expansion of women's public presence—be willing to admit the existence of the *flâneuse*.

The question remains: Why *should* we do this? Here one might choose to address the question of women in the city from a different point of view. As has often been pointed out, the invisibility of women in the literature of modernity has little to do with women's actual lives during the period. Rather, it is a product of the *discourse* of modernity itself. In choosing to focus on the public sphere—the street and the urban space—and in privileging the figure of the *flâneur*, historians and sociologists have produced a quite biased view of modern life, one privileging the roles and experiences of men at the expense of women.[20] As Rob Shields states:

> Without attention to gender there is a tendency to represent the city as a generally public space, that is to focus on its street life, leaving out the home life within the tenements, flats, dwellings and backyards in which family life takes place. . . . The domestic remains *invisible* in representa-

[18] "Ich bekomme immer mißtrauische Blicke ab, wenn ich versuche, zwischen den Geschäftigen zu flanieren." *Spazieren in Berlin*, 9.

[19] Walter Benjamin, "The Return of the *Flâneur*," in *Walter Benjamin: Selected Writings*, vol. 2, *1927–1934*, ed. Michael W. Jennings, Howard Eiland, and Gary Smith, trans. Rodney Livingstone et al. (Cambridge: Harvard University Press, 1999), 265.

[20] This point is made by Elizabeth Wilson in "The Invisible Flâneur," *New Left Review* 191 (1992): 90–110, and in *The Sphinx in the City: Urban Life, the Control of Disorder, and Women* (Berkeley: University of California Press, 1991); by Nava in "Modernity's Disavowal"; and by Griselda Pollock in "Modernity and the Spaces of Femininity," in her *Vision and Difference: Femininity, Feminism and Histories of Art* (London: Routledge, 1988), 50–90. See also Wolff, "The Invisible *Flâneuse*."

tions of the city as a public "space" which is thought of as merely the built analogue or architectural concretisation of the public "sphere."[21]

The point here is that for the most part it was male sociologists and cultural critics who identified the features of modern city life in the early years of the last century, and that this story has been taken up since then by other male writers, including sociologists, urban geographers, and architectural historians. Until the 1970s and the advent of feminist critiques, the lives observed and described (and, perhaps, empathized with) were mainly those of men. Accordingly, we have inherited a very partial view of modernity and of urban life, one which marginalizes other experiences. The suggestion, then, has been to reconceptualize "modernity," to take account of the intersections of public and private and of the particular experiences of women (and, for that matter, of other "invisible" denizens of the city marginalized by class or ethnicity). Very likely shopping would figure more prominently—though not in order to discover any possibility of female *flânerie*. Such a story of modernity from the point of view of women would be illuminating in other ways, too. Deborah Nord notes that even though it was true that any woman stroller was seen as a prostitute in turn-of-the-century London, the divide between respectable and nonrespectable was sometimes less clear for women themselves. Particularly in the case of middle-class women reformers, working with and on behalf of prostitutes to oppose the repressive Contagious Diseases Act, a certain "necessary if ambivalent identification with the woman of the streets" emerged.[22] The strict divide of "respectability"—which was, in any case, always a product of male anxieties and the male psyche, though inevitably having real consequences for the lives of women—proves to be something rather different from the point of view of women "on the street."[23] In another context Marsha

[21] Rob Shields, "A Guide to Urban Representation and What to Do about It: Alternative Traditions of Urban Theory," in *Re-Presenting the City: Ethnicity, Capital and Culture in the 21st-Century Metropolis*, ed. Anthony D. King (New York: New York University Press, 1996), 236.

[22] Nord, "Urban Peripatetic," 364. Nord bases her comments on the work of Judith Walkowitz (*City of Dreadful Delight*) and Lynda Nead; see the latter's *Myths of Sexuality: Representations of Women in Victorian Britain* (Oxford: Blackwell, 1988).

[23] Patrice Petro has expressed this succinctly: "The presence of women in places they had never been before (notably, in industry and in the cinema) explains the perceived threat of woman registered in various discourses during the Weimar years. And while it would be a mistake to assume that either the workplace or the cinema

Meskimmon has shown the striking difference in the visual arts be-
tween the portrayal of prostitutes by male artists in Weimar Germany
(for example, the well-known paintings of Otto Dix and Georg Grosz)
and paintings by women artists, whose representations of prostitutes
"posed alternatives to the simplistic rendering of the 'bad' woman out
in public and, indeed, to the 'mother/whore' binary."[24] Such a work
by the artist Gerta Overbeck is described by Meskimmon as follows:

> In her sketch, the prostitute is shown as but one type of woman
> worker. . . . In Overbeck's work, the banality of the daytime shop setting
> is in stark contrast to the more usual conventions of placing the prosti-
> tute on the street, in the brothel or the bedroom, to emphasise the seduc-
> tion, decadence and desire. Overbeck's prostitute is not "seducing" the
> viewer and we are not placed as the empowered consumer, choosing to
> "purchase" the goods. . . . We are located with the female figure, we
> enter into a relation of comparability with this figure through the banal
> specificity of the representation. We encounter the prostitute as an ordi-
> nary working woman . . . much in the way Overbeck herself encoun-
> tered the sex workers in her locality.[25]

Such a reorientation of point of view produces quite a different con-
ceptual framework for the exploration of modernity and its urban fig-
ures. This shift of focus, privileging the perspective of women in the
city, brings into view experiences and connections generally obscured
by the dominant tropes and theories of modern life. It is not so much
a question of substituting one kind of subject-position for another but
rather of opening up the possibility of seeing women's complex nego-
tiations of city life, real obstacles and constraints, and ideological con-
structions which attempt to delimit and constrain them.

It is not difficult to explain why theories of modernity have privi-
leged the *flâneur*. When one considers that a crucial aspect of this

was entirely liberating for women, it would also be wrong to confuse male percep-
tions of woman with women's perception, for to do so would be to mistake male de-
sire for female subjectivity." *Joyless Streets: Women and Melodramatic Representation in
Weimar Germany* (Princeton: Princeton University Press, 1989), 71.

[24] Marsha Meskimmon, *We Weren't Modern Enough: Women Artists and the Limits of
German Modernism* (Berkeley: University of California Press, 1999), 42. She discusses
the work of the artists Gerta Overbeck, Elsa Haensgen-Dingkuhn, and Elfriede Lohse-
Wächtler, among others.

[25] Meskimmon, *We Weren't Modern Enough*, 24–25.

uniquely modern practice is the *reflectiveness* entailed in urban obser-
vation, it becomes clear that the critic, for whom this figure looms so
large, identifies strongly with him. The *flâneur is*, in fact, the critic—
writer, artist, sociologist—whose detached observations might well
be reported in literary or visual texts. For Baudelaire the illustrator
Constantin Guys was the archetypal *flâneur*. For Benjamin Baudelaire
himself was the *flâneur* of the nineteenth century. In general, a crucial
aspect of urban wandering is the "reading" of the urban environment
and the production of texts—precisely the task of the social theorist
and the urban ethnographer.[26] In other words, the importance of the
flâneur is, among other things, the *self*-importance of the sociologist of
modernity, for whom this poetic figure serves as prototype. He has
proven himself an attractive and suggestive figure, one conveying the
peculiar features of life in the metropolis—fragmentation, anonymity,
speed. I want to suggest that it will be no great loss to ask the *flâneur*
to cede his central position and instead to occupy a more marginal po-
sition as merely one of the city's inhabitants. Certainly a newly femi-
nized urban theory will achieve this displacement—without hard
feelings and with a lingering sympathy for the aimless stroller, who,
after all, might not have had such an easy time of it himself, given the
particular demands on masculine identity. Elizabeth Wilson has sug-
gested that the masculinity of the *flâneur* is itself in question, in his
failure to annihilate the threatening figure of woman with his gaze,
and one could also observe that neither the aimless wandering nor the
translation of observations of city life into literary and artistic texts ac-
cords well with the ideology of masculinity as purposive, focused,
and productive.[27] Under these circumstances, it is understandable
why James Donald would question why any woman would even
want to be a *flâneur*.

What I am suggesting is that instead of either bemoaning women's
lack of access to *flânerie* and to the public sphere more generally, or
taking to task theories of modernity and the city which privilege the
male experience, one should adopt the rather different aim of explor-
ing women's (and men's) actual lives in the modern city. This is

[26] See David Frisby, "The *Flâneur* in Social Theory," 81–110, and Bruce Mazlish,
"The *Flâneur*: From Spectator to Representation," 43–60, both in Tester, ed., *The
Flâneur*.
[27] Wilson, "The Invisible Flâneur," 109.

Meskimmon's strategy in her study of women artists in Weimar Germany, whose lives (and art) reflect a complex negotiation of the structures and ideologies of gender in that period. Here women move center stage in the modern metropolis, whether as prostitute, housewife, mother, "new woman," or androgyne (the "garçonne" of the 1920s and early 1930s). Seen anew in the context of their actual lives, and as represented in paintings by women artists, these figures offer a striking contrast to their more familiar prototypes in the art of men and in the dominant ideologies of gender—ideologies of the "good" and "bad" woman (angel/whore, virgin/fallen woman). This strategy of bypassing those ideologies and their narratives of women's place permits one to consider the "multidimensional and contradictory manifestations" of the modern,[28] which have always given space to women, who, as Elizabeth Wilson has put it, "have survived and flourished in the interstices of the city, negotiating the contradictions of the city in their own particular way."[29] It is a strategy already well known in another context not usually associated with gender and modernity, namely, the influential work of Michel de Certeau, in particular the essays collected in his book *The Practice of Everyday Life*, a study, as he states in his introduction, of "the ways in which users . . . operate."[30] The much-quoted essay "Walking in the City" draws a distinction between what de Certeau calls the "concept-city" of urban discourse and the specific spatial practices of city inhabitants. The former—the imaginary totalization of urban planners and social theorists—cannot account for or even perceive the actual movements in the streets (the "pedestrian speech acts" of urban dwellers). What he calls "the rhetoric of walking" describes the ways in which walking in practice manipulates the formal codes of city space, both using and transgressing them in ways disallowed—rendered invisible—by the concept-city. De Certeau's interest is in the trajectories of everyday life—the ways in which people negotiate the street, the city, and, indeed, the social world in general. The linguistic metaphor employed—the concept-city as the formal rules of language, and the urban practices as individual speech acts—provides a way of under-

[28] Rita Felski, *The Gender of Modernity* (Cambridge: Harvard University Press, 1995), 211.

[29] Wilson, *The Sphinx in the City*, 8.

[30] Michel de Certeau, *The Practice of Everyday Life*, trans. Steven Rendall (Berkeley: University of California Press, 1984), xi.

standing the relationship between structures and actions, one which is also useful in looking at women in the modern city. Without denying or ignoring the dominant physical and institutional structures of urban life (buildings, streets, officially sanctioned practices) and the gender ideologies in force (of men's and women's "proper" place), one can simultaneously switch from the bird's-eye view to ground level (the image is de Certeau's) and observe the "rhetorics of everyday life" for women in the early-twentieth-century metropolis.

But by now the city itself seems to have evaporated—its structure and organization exposed as a fiction, and even its physical attributes seen as quite secondary to the practices and discourses in which they are made visible. In James Donald's radical expression of this perspective, the city is an "imagined environment."[31] Indeed, the central purpose of his book is to investigate the discourses of the modern city, resisting throughout any notion of some underlying "real" city, unmediated by the languages of planning, literature, cinema, and other forms of representation. Even though he once claimed that "there is no such thing as the city,"[32] Donald proceeds with care in his formulation of the city-as-text:

> Of course, cities are not only mental constructs. Of course, there are real cities. . . . But why reduce the reality of cities to their thinginess, or their thinginess to a question of bricks and mortar? States of mind have material consequences. They make things happen. . . . What particularly interests me is the power of *the city* as a category of thought. *The city* is an abstraction, which claims to identify what, if anything, is common to all cities. . . . The city we do experience—the city as state of mind—is always already symbolised and metaphorised.[33]

This is not quite de Certeau's point, though Donald cites him frequently. We have slightly shifted the focus away from those rhetorics of walking (and other everyday practices) which traverse, negotiate,

[31] Donald, *Imagining the Modern City*, 8.

[32] James Donald, "Metropolis: The City as Text," in *Social and Cultural Forms of Modernity*, ed. Robert Bocock and Kenneth Thompson (Oxford: Polity /Open University, 1992), 442. See also Janet Wolff, "The Real City, the Discursive City, the Disappearing City: Postmodernism and Urban Sociology," *Theory and Society* 21, no. 4 (1992): 553–60.

[33] Donald, *Imagining the Modern City*, 8, 17.

and transgress the official structures and ideologies of the social world and toward a conception of the city as an imagined environment—that is, a real, physical environment always perceived through the prevailing discourses *about* the city. In one case our attention is drawn to the contingencies of mundane urban life, which do not always accord with the official narratives about the city. In the other the emphasis is on the operation of those narratives themselves and the ways in which they constitute "the city." In both cases, however, one can see the possibility of a new feminist urban theory, no longer constrained by assumptions of unwelcoming streets, multiple exclusions, and rigid patriarchal structures. Instead, those urban practices of negotiating public space (and gender ideology) become visible, naturally including the lives and peregrinations of women in the city. None of this is meant to suggest that one ignore the actual existence either of cities or of specific urban facts (architecture, physical layout, dangers for women in public). But the recognition of both the discursive and the provisional nature of those facts—seeing them as ultimately the product of past and present social interactions—enables the construction of *other* urban discourses, particularly discourses of "the feminine" (and of woman) in public space.

I conclude with a discussion of ghosts and the haunting of cities. In 1927 Virginia Woolf wrote an essay entitled "Street Haunting," a lighthearted fantasy about a woman's walk through London, ostensibly on a mission to buy a new pencil.[34] It is an essay often invoked by feminist critics, delighted to discover evidence of women's passage in the streets of the metropolis. For the same reason attention is also paid to Woolf's Mrs. Dalloway, who spends a good deal of time walking in London to buy flowers for her party.[35] Like the images produced by

[34] Virginia Woolf, "Street Haunting: A London Adventure," in *The Essays of Virginia Woolf*, vol. 4, *1925–1928*, ed. Andrew McNeillie (London: Hogarth Press, 1994), 480–91.

[35] Virginia Woolf, *Mrs. Dalloway* (London: Harcourt Brace Jovanovich, 1925). See, e.g., Rachel Bowlby, "Walking, Women and Writing: Virginia Woolf as *Flâneuse*," in *Still Crazy After All These Years* (London: Routledge, 1992), 26–47. See also Nord, "Urban Peripatetic," 374–75; and Jane Beckett and Deborah Cherry, "Modern Women, Modern Spaces: Women, Metropolitan Culture and Vorticism," in *Women Artists and Modernism*, ed. Katy Deepwell (Manchester: Manchester University Press, 1998), 44–45.

the German women artists discussed by Meskimmon, Woolf's heroines provide that rare thing: access to women's experience of the public in the early twentieth century. From this point of entry one can undertake the task of rewriting the modern city. For Woolf the notion of "haunting" has no particular connotations of ghosts or spirits; it merely carries its secondary definition of "frequenting."[36] However, I have been struck by the recurrent use of the language of ghosts and haunting in literature about the city and urban space. James Donald refers to "the haunted spaces of the city."[37] Rob Shields talks about "the dark silences of urban constructions"; and Rosalyn Deutsche has suggested the value of the concept of *prosopopoeia* (giving voice to the dead) for urban theory.[38] In her study of architecture and modernity, Hilde Heynen has proposed Daniel Libeskind's Berlin Jewish Museum as the ideal design for the necessary rewriting of modernity in the arena of architectural design, its voids and spaces invoking the absent and the dead in a manner she considers appropriate to our late-modern times.[39] Heynen's argument is that architecture must confront the failures and contradictions of modernity and not offer a false celebration of harmony. Invoking Freud's notion of the uncanny, she explains that "architecture is capable of making us feel something of that which is repressed, that which exists beyond the normal and expected."[40] The uncanny is also identified by James Donald as the "darkened spaces" which return "to haunt the City of Light."[41] It serves as the central organizing theme and metaphor in Anthony Vidler's major study of issues in contemporary architecture.[42]

This apparently supernatural turn in urban and architectural theory is actually part of a critical strategy to show how our discourses and narratives not only illuminate but also create the object of study

[36] In *The American Heritage Dictionary* this is given as the secondary meaning of "haunt," the first being "to visit or appear to as a ghost or spirit."

[37] Donald, *Imagining the Modern City*, 24.

[38] Shields, "A Guide to Urban Representation and What to Do About It," 231; Rosalyn Deutsche, "Reasonable Urbanism," in *Giving Ground: The Politics of Propinquity*, ed. Joan Copjec and Michael Sorkin (New York: Verso, 1999), 183.

[39] Hilde Heynen, *Architecture and Modernity: A Critique* (Cambridge: MIT Press, 1999), 200–208, 222.

[40] Heynen, *Architecture and Modernity*, 223.

[41] Donald, *Imagining the Modern City*, 73.

[42] Anthony Vidler, *The Architectural Uncanny: Essays in the Modern Unhomely* (Cambridge: MIT Press, 1992).

(the city, the public sphere), and also how those same discourses and narratives render invisible (make ghosts of) those practices and figures not given a name. For the same reason the sociologist Avery Gordon has insisted that haunting is essential to the sociological imagination:

> Haunting is a constituent element of modern social life. It is neither premodern superstition nor individual psychosis; it is a generalizable social phenomenon of great import. To study social life one must confront the ghostly aspects of it. . . . The ghost is not simply a dead or a missing person, but a social figure, and investigating it can lead to that dense site where history and subjectivity make social life. The ghost or the apparition is one form by which something lost, or barely visible, or seemingly not there to our supposedly well-trained eye, makes itself known or apparent to us, in its own way, of course.[43]

This exploration of the uncanny, the repressed, and the ghostly need not (though it can) be undertaken in psychoanalytic terms.[44] At the level of discourse, and at its simplest, it reminds us that narratives exclude and obscure at the same time as they define and highlight. The lives of women in the modern city—in private as well as in public (the sociology of modernity has paid little attention to the domestic sphere)—are thus, as Gordon puts it, "barely visible, or seemingly not there."[45] As a result, they haunt the discourse and the city itself—uncanny because not admitted to language and thought. Both James Donald and Rosalyn Deutsche are making a more radical point about discourse, however, one which will prove useful in rethinking women's place in the early-twentieth-century city. For these writers the very vocabulary of urban history and urban theory constrains our understanding of the problems and possibilities of city life. As Deutsche explains—her own interest is in the politics of the contem-

[43] Avery F. Gordon, *Ghostly Matters: Haunting and the Sociological Imagination* (Minneapolis: University of Minnesota Press, 1997), 7–8.

[44] For a brilliant analysis of the uncanny in modernity, which combines sociohistorical and psychoanalytic methods, see Peter Stallybrass and Allon White, *The Politics and Poetics of Transgression* (London: Methuen, 1986).

[45] Gordon, *Ghostly Matters*, 8.

porary city—an approach that begins by complaining about which groups do not have access to the public arena (women, minorities, working-class people) makes the mistake of simply accepting "the public" as given. Rather, she says, "the public" is itself a political term, one which defines its opposite ("the private") and thereby already locates men and women in particular places. She insists on rejecting a vision of a unified public sphere in favor of acknowledging "the openness and indeterminacy of the democratic public."[46] This means recognizing the fundamental instability and provisionality of social categories, as well as the role of representation in producing entities like "the public." Similarly, Donald advocates a "negotiative approach" to the city, one which can incorporate within its view moments of contradiction and confrontation.[47] This reconceptualization of the modern city thus permits us to abandon the kind of corrective analytic that notes women's absence from the city streets and leaps at any opportunity to find women who actually traverse the public arena—shoppers, workers, moviegoers. Instead, it becomes possible—indeed, essential—to explore the micropractices of urban living and the very specific ways in which women negotiate the modern city.

Of course, there *is* a city and there *are* public and private spaces. In the modern city of the early twentieth century these spaces were, in many ways, gendered. But what I have been suggesting is that if one takes "the city" or "the public sphere" as already given, clearly identifiable social facts, one is doomed to the depressing (and ultimately rather boring) point of view that perceives only exclusions and absences. If, instead, one understands "the city" as itself a discursive construct, and "the public" (and "private") as a narrative device, one may begin to entertain counternarratives—to confront the "shadows and obscurities," the dark silences, and the ghosts.[48] For these are not sinister and threatening presences but only the figures obscured by narratives of fixity. I have already suggested that one relegate the *flâneur* to a position of less importance, and this demotion is rein-

[46] Rosalyn Deutsche, "Agoraphobia," in her *Evictions: Art and Spatial Politics* (Cambridge: MIT Press, 1996), 325. On this basis, the discourse of ghosts is reversed, as Deutsche, to some extent following Bruce Robbins's lead, identifies "the public sphere" itself as the phantom—that is, as being imaginary. See Bruce Robbins, ed., *The Phantom Public Sphere* (Minneapolis: University of Minnesota Press, 1993).

[47] Donald, *Imagining the Modern City*, 144, 167.

[48] Ibid., 96.

forced by the disarticulation of the "public," that is, of the natural habitat of the *flâneur*.[49] In the process, the question of female *flânerie* loses all importance and, at the same time, women become entirely visible in their own particular practices and experiences in the modern city.

[49] The insistent presence of the *flâneur* in the literature on gender and modernity is itself perceived as a kind of ghost story by James Donald, who wonders: "Why does the spectral presence of the *flâneuse* haunt the discussion" of public space? *Imagining the Modern City*, 112.

❖ CHAPTER FOUR ❖

The Feminine in Modern Art

Benjamin, Simmel, and the Gender of Modernity

Perhaps it seems odd to embark on an exploration of "the feminine" in modern art. After all, the term has operated consistently as a strategy for the segregation and denigration of women's work. Tamar Garb has shown how the concept of "l'art féminin" was used in late-nineteenth-century France both by critics of women's art and by women artists themselves in their negotiation of the contradictions of the prevailing discourse of separate spheres, allowing them to practice as serious professional artists without in any way posing a challenge to the values of family, domesticity, and women's proper place.[1] In her study of women artists and the Parisian avant-garde in the early twentieth century, Gill Perry cites a number of critics and art historians who explain the difference—and inferiority—of women's art in terms of women's "feminine" characteristics (sensibility, softness, refinement, lack of creativity).[2] Such examples could be multiplied beyond the modern period. One notorious example of this kind of gendered criticism is Charles Sterling's 1951 argument for the reattribution of a painting previously thought to be by David to Constance-Marie Charpentier: "The notion that our portrait may have been painted by a woman is, let us confess, an attractive idea. Its po-

[1] Tamar Garb, "'L'Art féminin': The Formation of a Critical Category in Late-Nineteenth-Century France," in *The Expanding Discourse: Feminism and Art History*, ed. Norma Broude and Mary D. Garrard (New York: HarperCollins, 1992), 207–29. Garb also points out (p. 226, n. 22) that the denigration by critics of Impressionism in the same period was sometimes achieved by calling it a "feminine art."

[2] Gill Perry, *Women Artists and the Parisian Avant-Garde* (Manchester: Manchester University Press, 1995), 5–10.

86

etry is literary rather than plastic, its very evident charms, and its cleverly concealed weaknesses, its ensemble made up from a thousand subtle artifices, all seem to reveal the feminine spirit."[3] The notion of "the feminine" has a solid history as the basis for the confirmation of the distinct, innate, and inferior characteristics of women and their work. Not surprisingly, a primary task of feminist art criticism has been to challenge the ideologies and discourses which underlie the concept. For the past twenty-five years or so a good deal of the focus of feminist art historians has been on the triple arena of women's marginalization from both art practice and art history: the gendered nature of access to cultural production; questions of representation and gender; and the differential treatment of men's and women's art by critics, galleries, museums, and art historians. The multiple successes of this work have included: the rediscovery and reappraisal of women artists formerly "hidden from history"; the analysis of the historically varied but more or less pervasive exclusionary mechanisms involved in the institutions and practices of art-making; the understanding and critique of the role of representation in the construction of gender ideologies; the possibilities—and choices—for a feminist cultural practice; and, of course, the demolition of the conservative notion of the "essential feminine" in art and in general.

My apparently perverse desire to resurrect the concept of "the feminine" is best explained by characterizing this earlier feminist work as informed by a politics of *correction*. That is, it has generally been motivated by the imperative to challenge and contest an androcentric universe, to correct its one-sided terms and assertions, to fill its gaps, and to modify its canon. Without in any way intending to detract from the importance of this work, I want to propose the value of a different project here—what one might call a politics of *interrogation*. That is to say, if modernism is gendered male, rather than identify bias, insert women artists, and counter an antipatriarchal discourse (visual or critical) to the received tradition and its texts, one would do well to in-

[3] Cited by Rozsika Parker and Griselda Pollock in *Old Mistresses: Women, Art and Ideology* (London: Routledge & Kegan Paul, 1981), 106. The work in question is Charpentier's *Charlotte du Val d'Ognes*, c.1800, bequeathed to the Metropolitan Museum of Art in 1917. See also Thomas B. Hess, "Great Women Artists," in *Art and Sexual Politics: Why Have There Been No Great Women Artists?*, ed. Thomas B. Hess and Elizabeth Baker (New York: Macmillan, 1973), 44–48.

vestigate that dominant discourse in order to explore—and perhaps explode—its strategies and its contradictions. One should not be surprised to learn that the "masculinism" of modernism is by no means monolithic. Not only that—"the feminine" now appears differently, not just as the discrete and fantasized Other produced in ideology but as an integral aspect of the complex identity and subjectivity of modern culture. In another context Griselda Pollock has proposed something along these lines, arguing that "feminism has needed to develop forms of analysis that can confront the difference of women as *other* than what is *other* to this masculine order while exposing the sexual politics of dominant discourses and institutions."[4] Suggesting that the "overfeminization" of women's art in nineteenth-century discourses of gender, which insist on radical gender difference, has only been supplanted by a certain "underfeminization" in the critical work of feminist art historians contesting this difference, she convincingly argues the case for a feminist practice which abjures this stark opposition, at the same time opening the way for the critical recuperation of the notion of "the feminine":

> The repoliticization of gender is a historically new set of theorizations of sexual difference. The aim is to work beyond the opposition—to use a *tactical* insistence on sexual difference in order *strategically* to rupture the power systems that operate upon this explicit, sometimes latent, use of gender as an axis of hierarchy and power. The aim is to seek ways in which the difference of the feminine might function not merely as an alternative but as the dialectical spring to release us from the binary trap represented by sex/gender.[5]

Pollock suggests that we "read for the feminine against the grain of cultural modes that render it blankness"[6]—that we learn to decipher what she calls "inscriptions in the feminine." It is worth stressing that although the context of her essay is the catalogue to an exhibition of work by women,[7] such inscriptions are also to be found in the work of

[4] Griselda Pollock, "Inscriptions in the Feminine," in *Inside the Visible: An Elliptical Traverse of 20th Century Art in, of, and from the Feminine*, ed. M. Catherine de Zegher (Cambridge: MIT Press, 1996), 67–87, 71.

[5] Pollock, "Inscriptions in the Feminine," 70.

[6] Ibid., 82.

[7] The exhibition, "Inside the Visible," was held at the Institute of Contemporary Art, Boston, in 1996.

male artists.[8] "The feminine" is that which is discursively—and, in Pollock's account, psychically—produced as "other" to Western male subjectivity, and which, accordingly, lives a subterranean existence, for men and for women, within the culture. The decipherment of its "inscriptions," here specifically in works of art, is the feminist project that Pollock proposes and that I want to pursue. Toward the end of this chapter I make this more concrete by discussing particular works. Before doing so I make a detour of sorts involving a shift of focus from the gender of *modernism* to the gender of *modernity*. I want to suggest that in this case art history can benefit from sociology—that the issue of "the feminine" in art can be approached by looking first at the parallel (and, as I argue, related) debate among sociologists and critical theorists on the question of "the feminine" in modern society.

Thanks to the work of feminist revisionist art historians, we now know a good deal more about women modernists than we did a couple of decades ago. Surveys, monographs, and exhibitions have rendered quite familiar women Impressionists, Expressionists, Constructivists, Vorticists, and Surrealists.[9] In a number of crucial respects, this is in the context of the perception of modernism as itself gendered male. First and most obviously, the modernist canon has consisted predominantly of male artists. This has been both the result of the (usual) processes of exclusion and marginalization of women artists and a product of the discursive construction *of* the modernist artist as the heroic, asocial, masculine figure. Michael Leja has shown how this ideology continued to operate in the postwar period in the guise of the "Modern Man" of Abstract Expressionism.[10] As Griselda

[8] Indeed, as is well known, Julia Kristeva—whose own comment on this issue stands as an epigraph to the book/catalogue ("I would call 'feminine' the moment of rupture and negativity which conditions the newness of any practice")—identified such moments in the work of certain male avant-garde writers. See her *Revolution in Poetic Language*, trans. Margaret Waller (New York: Columbia University Press, 1984).

[9] See, e.g., Anne Higonnet, *Berthe Morisot's Images of Women* (Cambridge: Harvard University Press, 1992); Whitney Chadwick, *Women Artists and the Surrealist Movement* (New York: Thames and Hudson, 1985); Shulamith Behr, *Women Expressionists* (Oxford: Phaidon, 1988); Magdalena Dabrowski, *Liubov Popova* (New York: Museum of Modern Art, 1991); Gretchen H. Gerzina, *Carrington: A Life* (New York: Norton, 1989); and Jane Beckett and Deborah Cherry, "Modern Women, Modern Spaces: Women, Metropolitan Culture and Vorticism," in *Women Artists and Modernism*, ed. Katy Deepwell (Manchester: Manchester University Press, 1998), 36–54.

[10] Michael Leja, *Reframing Abstract Expressionism: Subjectivity and Painting in the 1940s* (New Haven: Yale University Press, 1993).

Pollock, Carol Duncan, and Maria Tatar have shown, the gender of modernism has also consisted in its typical subject matter—in particular the female nude, male virility and misogyny, and recurrent crises in masculinity.[11] The identification of the androcentric nature of modernism is now common in literary studies,[12] and in Andreas Huyssen's account the field of modernism in general is gendered male, in contrast to the feminized realm of mass culture.[13] The politics of correction, as I term it, has been concerned not only to rediscover women modernists but also to rethink modernism in order to see how the field has been reconfigured as a result of the acknowledgment of women's contributions.[14] Examples of this might be Pollock's discussion of the "spaces of femininity"—the garden, the interior, the box at the opera—in the work of Impressionists Mary Cassatt and Berthe Morisot; or Rosemary Betterton's reading of Suzanne Valadon's female nudes as both self-contained and disruptive of the dominant tradition of the representation of women as passive object of the gaze.[15] But here one is still within the framework of the feminine as alternative (to go back to Pollock's own formulation). Given the fundamentally gendered nature of modernist art practice, such interventions only serve to modify the discourse in minor ways, leaving it essentially unchallenged. Instead of tinkering with the gender of modernism by addition (either of names or of new subject matter), a more

[11] Griselda Pollock, "Modernity and the Spaces of Femininity," in her *Vision and Difference: Femininity, Feminism and the Histories of Art* (London: Routledge, 1988), 50–90; Carol Duncan, "Virility and Domination in Early Twentieth-Century Vanguard Painting," in her *Aesthetics of Power: Essays in Critical Art History* (Cambridge: Cambridge University Press, 1993), 81–108; Maria Tatar, *Lustmord: Sexual Murder in Weimar Germany* (Princeton: Princeton University Press: 1995); and Lisa Tickner, "Men's Work? Masculinity and Modernism," in *Visual Culture: Images and Interpretations*, ed. Norman Bryson, Michael Ann Holly, and Keith Moxey (Hanover: University Press of New England, 1994), 42–82.

[12] See, e.g., Bonnie Kime Scott, ed., *The Gender of Modernism: A Critical Anthology* (Bloomington: Indiana University Press, 1990), as well as collections which address both literature and art, such as Gabriele Griffin, ed., *Difference in View: Women and Modernism* (London: Taylor & Francis, 1994) and Bridget Elliott and Jo-Ann Wallace, eds., *Women Artists and Writers: Modernist (Im)positionings* (London: Routledge, 1994).

[13] Andreas Huyssen, "Mass Culture as Woman: Modernism's Other," in his *After the Great Divide: Modernism, Mass Culture, Postmodernism* (Bloomington: Indiana University Press, 1986), 44–62.

[14] Elliott and Wallace, eds., *Women Artists and Writers*, 12.

[15] Pollock, "Modernity and the Spaces of Femininity"; Rosemary Betterton, "How Do Women Look? The Female Nude in the Work Of Suzanne Valadon," in *Looking On: Images of Femininity in the Visual Arts and Media*, ed. Rosemary Betterton (London: Pandora, 1987), 217–34.

radical feminist practice must challenge the very construction of that gendering. This means, for example, a masculinity which turns back on itself and becomes self-reflexive, or an art practice which incorporates, and can be read in terms of, moments of stress in the construction and maintenance of such an identity.

In order to approach this possibility and to see what it might mean in practice, I want to look at the related debate about the gender of modernity and the invocation of "the feminine" in that rather different arena. Let me start by clarifying some terms. Where "modernism" refers to cultural practice (and its associated ideologies and institutions), "modernity" refers to a sociohistorical moment, usually defined as the period from the mid-nineteenth century to the First World War.[16] Its characterization has generally been embedded in a complex of economic, technological, sociological, and experiential terms, broadly perceived as the consequences of the rise of industrial (as opposed to mercantile) capitalism, the factory system and the associated division of labor, the bureaucratization of service and other white-collar occupations, urbanization, and the consequent "decline of community."[17] These sociohistorical developments, in turn, are seen as manifestations of the logic of instrumental reason and the project of the Enlightenment, and are understood even by their critics as a form of progress.[18] Their existential coordinates, identified and celebrated (or sometimes condemned) by poets, critics, and humanist sociologists, are the anonymity of city life, the fleeting and ephemeral nature of social contacts, and the sense of constant change and impermanence. This is the context of the rise of modernism in the arts, whether one dates this (as Baudelaire did in 1859) from the sketches of Constantin Guys or, like T. J. Clark, from the work of the Impressionists or, as is more common, from the turn of the century, particularly Cubism, Futurism, and Fauvism.[19] Although I think one has to be careful

[16] I am aware, of course, that other disciplines date "the modern" much earlier, and also that what counts *as* "modern" varies from one discourse to another. But here I am following the conventionally accepted sociological characterization of the particular period and its characteristics.

[17] The main figures here are Karl Marx, Emile Durkheim, Max Weber, and Ferdinand Tönnies.

[18] For Marx, the preeminent critic of capitalist society, this was an advance on previous forms of social and economic organization and a necessary stage on the way to communism.

[19] Charles Baudelaire, "The Painter of Modern Life" [1863] in *The Painter of Modern Life and Other Essays*, trans. and ed. Jonathan Mayne (Oxford: Phaidon, 1964), 1–40;

about a cavalier assumption of modernism as "the painting of modern life" (the phrase is both Baudelaire's and Clark's) since the actual relationship between social forms and visual representations is too often assumed rather than theorized, there is no doubt that modernity is the historical condition of the rise of modernism. For this reason I take it as axiomatic that questions of gender in the field of modern art may be usefully explored in the broader arena of modernity itself. My assumption here is that the critical analysis of the gender of modernity will prove helpful in looking at the possibilities for, and nature of, the kind of feminist interventions in visual representation I have begun to suggest.

Like modernism, modernity is gendered male.[20] Most theorists of the modern have focused on the public sphere of work, politics, and city life, an arena to which women had quite limited and problematic access. The key figures of modernity—the *flâneur*, the dandy, the stranger—were quintessentially male; any woman adopting these roles would likely have been taken for a prostitute or another "nonrespectable" female.[21] In addition, the focus on the public sphere has three important consequences for the question of gender and modernity. First, it excludes the bourgeois woman, who was confined, in ideology if not entirely in reality, to the home, the suburbs, and the domestic arena. Second, it somehow renders invisible the working-class women who traversed the city and participated fully in activities

T. J. Clark, *The Painting of Modern Life: Paris in the Art of Manet and His Followers* (New York: Knopf, 1985). In his latest book, however, Clark dates the advent of modernism from David and the French Revolution; see his *Farewell to an Idea: Episodes from a History of Modernism* (New Haven: Yale University Press, 1999).

[20] For this argument, see Barbara L. Marshall, *Engendering Modernity: Feminism, Social Theory and Social Change* (Boston: Northeastern University Press, 1994) and Rita Felski, *The Gender of Modernity* (Cambridge: Harvard University Press, 1995). For an interesting case study of a specific woman's relationship to modernity, see Biddy Martin, *Woman and Modernity: The (Life)Styles of Lou Andreas-Salomé* (Ithaca: Cornell University Press, 1991).

[21] Janet Wolff, "The Invisible *Flâneuse*: Women and the Literature of Modernity," in her *Feminine Sentences: Essays on Women and Culture* (Cambridge: Polity: 1990), 34–50. See also Elizabeth Wilson, *The Sphinx in the City: Urban Life, the Control of Disorder, and Women* (London: Virago, 1991). Although the figures of the prostitute, the lesbian, and the widow feature as tropes of the modern for Baudelaire and Benjamin, among others, these operate discursively as aspects of male desire and male identity, not as points of access to women's experience of modernity and social life.

outside the home.[22] Third, it obscures the integral and complex relations *between* the public and the private spheres—for men and for women.[23] Feminist historians and sociologists have therefore embarked on the reconceptualization of the condition of modernity. Barbara Marshall, whose book critiques classical sociological theories of modernity, puts it like this:

> The exclusion of women from the heart of the classical project has resulted in a skewed picture of social life, of the very subject matter of sociology. The changes associated with modernity—such as the separation of the family from wider kinship groups, the separation of the household and economy (which entailed the radical transformation of both), and the emergence of the modern state—are all *gendered* processes. The roles which emerged alongside the differentiation of the economy and the state from the household—worker, citizen—were (are) *gendered* roles.[24]

Rita Felski, who is more interested in the literary texts of modernity, announces her project as "a desire to reread the modern through the lens of feminist theory," which she does through the problematization of the public/private divide and the exploration of the figures of female desire in sociological theory, fiction, and sexological discourses.[25] For neither Marshall nor Felski is this simply a question of discovering women's point of view, of making visible those obscured by a masculinist view of modernity, or of promoting the hidden features of a "feminine sensibility" in modern life—the strategy of correction or supplementation. Rather, they undertake a critical analysis of the discourses of modernity in order to confront directly their constructions of masculinity. Following their lead, and in line with what I said earlier about the feminist critique of modernism, I will pursue this with particular reference to the work of Georg Simmel and Walter Benjamin.

Simmel's concept of "female culture" and Benjamin's identification

[22] See Christine Stansell, *City of Women: Sex and Class in New York, 1789–1860* (Chicago: University of Illinois Press, 1987).

[23] See Leonore Davidoff and Catherine Hall, *Family Fortunes: Men and Women of the English Middle Class, 1780–1850* (London: Hutchinson, 1987).

[24] Marshall, *Engendering Modernity*, 9.

[25] Felski, *Gender of Modernity*, 10.

of "the feminine" as (according to Christine Buci-Glucksmann) allegory of modernity[26] are both responses to long-standing problems in the project of modernity—problems which have not, however, usually been formulated in terms of gender. The negative aspects of modernization and its social coordinates have been discussed ever since the theory of modernity itself was first formulated. I am not referring to the conservative and Romantic critiques of industrialization and the "decline of community" but rather to those writers (like Marx and Engels) whose progressive view of capitalist modernity was premised on the prediction of its eventual overthrow, and also to the pained ambivalence of many of those fundamentally committed to the logic of material and economic progress under capitalism. In the early twentieth century Max Weber had already perceived the numbing and constraining effects of advanced rationalization, encapsulated in his two evocative phrases "the disenchantment of the world" and "the iron cage of bureaucracy." Theodor Adorno, Max Horkheimer, and their Frankfurt School colleagues demonstrated the self-destructive and contradictory aspects of modern capitalist society, a perspective taken up later by Jürgen Habermas in the analysis of the irrational foundations and tendencies of bureaucratic rationality.[27] Zygmunt Bauman's influential study of modernity follows the logic of this argument to its extreme, seeing the Holocaust not as an aberration against reason but as an outcome of the Enlightenment project itself, its scientific principle of value-freedom, and the associated perfection of technological skills and bureaucratic organization.[28] What is new is the tendency to cast these issues in terms of gender. There have been a number of fem-

[26] Christine Buci-Glucksmann, "Catastophic Utopia: The Feminine as Allegory of the Modern," in *The Making of the Modern Body: Sexuality and Society in the Nineteenth Century*, ed. Catherine Gallagher and Thomas Laqueur (Berkeley: University of California Press, 1987), 220–29. See also her *Walter Benjamin und die Utopie des Weiblichen* (Hamburg: VSA, 1984) and *Baroque Reason: The Aesthetics of Modernity* (London: Sage, 1994), which is (more or less) a revision and translation of the former.

[27] This prospect was foreseen by Weber in his distinction between *Wertrationalität* and *Zweckrationalität* (value-rationality and means-rationality). See Max Weber, "The Nature of Social Action" [1922] in *Weber: Selections in Translation*, ed. W. G. Runciman and trans. Eric Matthews (Cambridge: Cambridge University Press: 1978), 28; Max Horkheimer and Theodor W. Adorno, *Dialectic of Enlightenment* [1944], trans. John Cumming (London: Allen Lane, 1973); Jürgen Habermas, "Knowledge and Human Interests: A General Perspective," appendix to *Knowledge and Human Interests* (London: Heinemann, 1972) 301–17, and his *Toward a Rational Society: Student Protest, Science, and Politics*, trans. Jeremy J. Shapiro (Boston: Beacon, 1970).

[28] Zygmunt Bauman, *Modernity and the Holocaust* (Cambridge: Polity, 1989).

inist critiques of both classical sociology and its Frankfurt School variants.[29] Later scholars have suggested that the Frankfurt School's own critiques coincide with the intellectual and political interests of feminism.[30] One finds discussions of a "feminine dialectic of Enlightenment" or a "female dialectic of Enlightenment," variously proposing that the perception by the critical theorists of women's marginal place in modern culture provides the starting point for the interrogation and transformation *of* that culture.[31] Sigrid Weigel's argument, for example, is that the recognition by Adorno and Horkheimer of "the siting of the feminine on the reverse side of enlightenment" opens the possibility for "the *female*" variant of a dialectic of enlightenment, in addition to reason and its Other," introducing a "*third position*" into the dialectic, a move which necessitates the introduction of a polyperspectival and topographical dimension to dialectical thinking in place of a single analysis.[32] This feminist reappropriation of insights of the critical theorists has been accompanied by a renewal of interest in the work of Georg Simmel, one of the founding fathers of European sociology. Until recently seen as rather marginal to the discipline—perhaps because of his essayistic, often impressionistic style and his tendency to cross disciplines by moving from sociology to economics, aesthetics, and ethics—he has (often for the very same reasons) been brought back into circulation, with updated translations of his work and books and essays devoted to his life and publications.[33] The feminist interest

[29] See, e.g., Seyla Benhabib and Drucilla Cornell, *Feminism as Critique: On the Politics of Gender* (Minneapolis: University of Minnesota Press, 1987).

[30] See, e.g., Maggie O'Neill, ed., *Adorno: Culture and Feminism* (London: Sage, 1999).

[31] Andrew Hewitt, "A Feminine Dialectic of Enlightenment," *New German Critique* 56 (1992): 143–70; Sigrid Weigel, "Towards a Female Dialectic of Enlightenment: Julia Kristeva and Walter Benjamin," in her *Body- and Image-Space: Re-reading Walter Benjamin* (London: Routledge, 1996), 63–79. See also her "'Leib und Bildraum' (Benjamin): Zur Problematik und Darstellbarkeit einer weiblichen Dialektik der Aufklärung," in *Topographien der Geschlechter: Kulturgeschichtliche Studien zur Literatur* (Hamburg: Rowohlts Enzyklopädie, 1990), 18–42.

[32] Weigel, "Toward a Female Dialectic Of Enlightenment," 67, 68.

[33] Though earlier collections of his work were available in English—notably Kurt Wolff, ed., *The Sociology of Georg Simmel* (Glencoe: Free Press, 1950)—what is striking is the proliferation of newer collections: Georg Simmel, *Essays on Interpretation in Social Science* (Manchester: Manchester University Press, 1980); David Frisby and Mike Featherstone, eds., *Simmel on Culture: Selected Writings* (London: Sage, 1997); Georg Simmel, *The Philosophy of Money*, 2d ed. (London: Routledge, 1990). Individual essays continue to appear in translation for the first time, including Simmel's "Bridge and Door" [1909] and "The Picture Frame" [1902] in *Theory, Culture & Society* 11, no. 1

in his work is centered on two essays of 1911: "Female Culture" and "The Relative and the Absolute in the Problem of the Sexes."[34]

Simmel's own version of the late-nineteenth-century thesis of modernity and the rationalization of society depends on the notion of the *objectification* of culture. Across a wide range of topics, from his major study of the philosophy of money to his well-known and frequently anthologized essay on the metropolis and mental life, a central theme remains the transformation of modern society in the direction of an increased division of labor and an associated separation of the *forms* of association from the lived experience of social encounters.[35] This is how he puts it in an early essay on money in modern culture:

> If sociology wished to capture in a formula the contrast between the modern era and the Middle Ages, it could try the following. In the Middle Ages a person was a member bound to a community or an estate, to a feudal association or a guild. His personality was merged with real or local interest groups, and the latter in turn drew their character from the people who directly supported them. This uniformity was destroyed by modernity. On the one hand, it left the personality to itself and gave it an incomparable mental and physical freedom of movement. On the other hand, it conferred an unrivalled objectivity on the practical content of life. Through technology, in organizations of all kinds, in factories and in the professions, the inherent laws of things are becoming increasingly dominant and are being freed from any colouration by indi-

(1994): 5–10, 11–17; and "On the Sociology of the Family" [1885], *Theory, Culture & Society* 15, nos. 3–4 (1998): 283–93. Texts about Simmel include: David Frisby, *Georg Simmel* (London: Tavistock, 1984); idem, *Sociological Impressionism: A Reassessment of Georg Simmel's Social Theory* (London: Heinemann, 1981); and *Theory, Culture & Society* (special issue on Simmel) 8, no. 3 (1991).

34 Both are included in *Georg Simmel: On Women, Sexuality, and Love*, ed. Guy Oakes (New Haven: Yale University Press, 1984). "Female Culture" is also included (in a shortened version) in Frisby and Featherstone, eds., *Simmel on Culture*, 46–54. A discussion of Simmel's work on women and gender issues can be found in Suzanne Vromen's "Georg Simmel and the Cultural Dilemma of Women," *History of European Ideas* 8, nos. 4–5 (1987): 563–79; Felski, "On Nostalgia: The Prehistoric Woman," in her *Gender of Modernity* 8, 35–60; and Lieteke van Vucht Tijssen, "Woman and Objective Culture: Georg Simmel and Marianne Weber," *Theory, Culture & Society* 8, no. 3 (1991): 203–18. An early recognition of Simmel's contribution to gender studies can be found in Lewis A. Coser, "Georg Simmel's Neglected Contributions to the Sociology of Women," *Signs* 2, no. 4 (1977): 869–76.

35 Georg Simmel, *The Philosophy of Money* [1900] (London: Routledge & Kegan Paul, 1978); "The Metropolis and Mental Life" [1902–3], in Wolff, ed., *Sociology of Georg Simmel*, 409–24.

vidual personalities. . . . Thus modernity has made subject and object mutually independent, so that each can more purely and completely find its own development.[36]

Unlike his contemporaries, in the essays on women Simmel equates the tendency toward objectification and differentiation with the male character. For one thing, "the division of labor is incomparably more congruent with the male nature than with the female."[37] More generally, he claims that

> it is important at the outset to affirm the fact that human culture, even as regards its purely objective contents, is not asexual. As a result of its objectivity, there is no sense in which culture exists in a domain that lies beyond men and women. It is rather the case that, with the exception of a very few areas, our objective culture is thoroughly male. It is men who have created art and industry, science and commerce, the state and religion.[38]

The solution he proposes for the excessive objectification of modern culture and the damaging fragmentation of aspects of the personality—both subjective and objective—among men is the reintegration of the female resistance to such a division. In his view this would address the problems of the women's movement and enable women's participation in the public life of work and politics in a newly constituted social realm. The terms of this solution remain vague, but the importance of Simmel's perception (as early as 1911) of the gendered nature of modernity is beyond question. However, even his most devoted followers are forced to admit that there is an uneasy mix in these essays of a brilliant analytical critique of the social construction of gender difference in modern culture and a more problematic assumption of the metaphysical character of "female culture" and women's nature.[39] Simmel himself sometimes claims a certain agnosticism about innate fe-

[36] Georg Simmel, "Money in Modern Culture" [1896], *Theory, Culture & Society* 8, no. 3 (1991): 17–31.

[37] Simmel, "Female Culture," 70.

[38] Ibid., 67.

[39] This is addressed by Guy Oakes in his introduction to *Georg Simmel*; Felski, *Gender of Modernity*; Vromen, "Georg Simmel and the Cultural Dilemma of Women"; van Vucht Tijssen, "Women and Objective Culture"; and Coser, "Simmel's Neglected Contributions to the Sociology of Women."

male characteristics,[40] but it is clear that in the end his view of women's nondifferentiated personality is both essentialist and culture-bound. As Lewis Coser has stated, "His diagnosis was resplendently modern, his cure was Wilhelminian."[41] Although it is disappointing to read Simmel's conclusion that "on the whole . . . the home remains the supreme cultural achievement of women,"[42] I suggest that the incorporation of a feminist critique into the sociology of modernity—specifically in relation to its foundational features of rationalization, social division, and objectification—opens the possibility for a *non*essentialist conception of "the feminine" as a contrast and challenge to the modern.[43]

Such a possibility has also been identified in the work of Walter Benjamin by a number of feminist scholars who are enthusiastic about the critical potential of Benjamin's always elliptical writings on modernity but who nevertheless disagree about the site and meaning of "the feminine" in these texts. I will consider briefly the contributions of Christine Buci-Glucksmann, Angelika Rauch, and Eva Geulen to this debate, in order to assess the actual possibilities for "regendering" modernity in Benjamin's work. I do this, of course, because I suspect that such potential does reside in at least some of the essays, though I must confess that in the past I have been inclined to include Benjamin among those whose characterizations of "the modern"—including the depiction of women—have been the major culprits in the masculinization of modernity.[44] As with Simmel, one needs to separate the critical-analytical perceptions about gender from

[40] "At this point, I shall not consider the issue of whether this masculine character of the objective elements of our culture is a result of the inner nature of the sexes or is a consequence of male dominance." Simmel, "Female Culture," 67.

[41] Coser, "Simmel's Neglected Contributions to the Sociology of Women," 876. Coser takes the view that the second should not invalidate the first: "None of his often extremely naïve excursions into the psychology of women should detract from his major contributions to an understanding of women's dilemmas in male cultures" (875).

[42] Simmel, "Female Culture," 97.

[43] Felski suggests that although "Simmel's often subtle and complex engagements with the contradictory dimensions of modernity gives way in the context of his account of femininity to a view of a static and unchanging female nature," nevertheless the nostalgia for an idealized, nonalienated "feminine" at work here may be productively employed as a focus of mobilization for criticism (*Gender of Modernity,* 57, 59).

[44] See my essay "The Invisible *Flâneuse*." More recently, I have considered the particular appeal of Benjamin's writing (and his persona) to cultural studies and feminism, which I believe has a great deal to do with the memoiristic and "micrological" tendencies in his work; see my "Memoirs and Micrologies: Walter Benjamin, Feminism and Cultural Analysis," in my *Resident Alien: Feminist Cultural Criticism* (New Haven: Yale University Press, 1995), 41–58.

those figures of women which appear as idealized and essentialized while remaining entirely culture-bound. Benjamin's approach is very different from Simmel's—though they share the preference for the essay form and the method of the intellectual *flâneur*[45] (what David Frisby has called "sociological impressionism").[46] Benjamin's interest is not in the objectification of modern society and therefore not in the gendered basis of this tendency. More in the tradition of Baudelaire, he focuses on the experience of modernity, one he is convinced is quite devalued in comparison with the premodern period.[47] This theme persists throughout his work, from the early metaphysical approach to the more materialist studies of the late 1930s. The loss of the wholeness and integrity of a prelapsarian concept of experience (*Erlebnis*) and its replacement by the modern pragmatic, linguistically-mediated contemporary experience (*Erfahrung*) is not, of course, the fault of industrial capitalism; the lost possibility is, in fact, a prehistoric, prelinguistic phenomenon. But for Benjamin the specific circumstances of modern capitalist society exacerbate this fundamental gap. According to Richard Wolin:

> The problem of the rationalization of social life and the concomitant diminution of the capacity for qualitative experience became a paramount concern in the work of the later Benjamin. He recognized the decline of traditional life forms which this process of rationalization entailed as an irreparable *loss*: for the meaning potentials objectified in the cultural products of traditional societies contain a promise of transcendence; they are the objects in which past ages have deposited their collective dreams and longings, their aspirations for a better life[48]

[45] Deena Weinstein and Michael A. Weinstein prefer to see Simmel as a *bricoleur*. See their article "Georg Simmel: Sociological ~~flâneur~~ bricoleur," *Theory, Culture & Society*, 8, no. 3 (1991): 151–68.

[46] Frisby, *Sociological Impressionism*.

[47] For a discussion of this aspect of Benjamin's thought, see Howard Caygill, *Walter Benjamin: The Colour of Experience* (London: Routledge, 1998); Martin Jay, "Experience without a Subject: Walter Benjamin and the Novel," in *The Actuality of Walter Benjamin*, ed. Laura Marcus and Lynda Nead (London: Lawrence & Wishart, 1998), 194–211; Richard Wolin, "Experience and Materialism in Benjamin's *Passagenwerk*," in *Benjamin: Philosophy, Aesthetics, History*, ed. Gary Smith (Chicago: University of Chicago Press, 1989), 210–27 (as well as Smith's introduction "Thinking through Benjamin," vii–xlii); Michael W. Jennings, "Profane Illuminations: Benjamin's Theory of Experience and Philosophy of Language," in *Dialectical Images: Walter Benjamin's Theory of Literary Criticism* (Ithaca: Cornell University Press, 1987), 82–120.

[48] Richard Wolin, *Walter Benjamin: An Aesthetic of Redemption* (New York: Columbia University Press, 1982), 217.

As is well known, Benjamin looked for moments of redemption—working against or subverting the rationalizing tendency—in modern society, particularly in its aesthetic forms (for example, in his essays on Surrealism and on the mechanical reproduction of art).

Christine Buci-Glucksmann has argued that the feminine, which operates as allegory of the modern in Benjamin's writing, can also act as the locus of transgression, as a protest *against* modernity. As she puts it, "The 'feminine' could delineate certain scenes of modernity, certain of its negative or positive utopias, which appear close to the spaces of the baroque with their multiple entrances and doubled, ambiguous spaces."[49] Central here is the discussion of what she calls "catastrophic utopia," which she defines as "the destructive tendency toward appearance and false totality, where the feminine body is an allegory of modernity"[50]—the allegorical nature of woman residing in "the great Baudelairean images (prostitute, barren woman, lesbian, androgyne)."[51] In this sense the figures of women epitomize the modern, especially the prostitute, in whose person are combined the promise of a lost union and wholeness and the nature of the commodity.[52] Benjamin's own references to these figures are typically elusive. For example, Buci-Glucksmann uses the following three quotations as epigraphs: "The lesbian is the heroine of modernism," "Baudelaire's heroic ideal is androgynous," and "Love directed towards prostitutes is the apotheosis of empathy for the commodity."[53] She explores two other "utopian" moments associated with the feminine—namely, "anthropological utopia" and "transgressive utopia"—in which the figures of the androgyne and the lesbian, providing a "subterranean" history of the nineteenth century, pose a challenge to modernity through its own "visual unconscious."[54] According to her, "the lesbian is the sister of the prostitute, in that she protests against the dominant interiority of the family scene, the reduction of love to family and pregnancy. But she is also an exactly opposite figure: she embodies 'a protest against the technological revolution' and a *'heroic archetype* of

[49] Buci-Glucksmann, "Catastrophic Utopia," 221.
[50] Ibid.
[51] Ibid., 220.
[52] On this point see Angelika Rauch, "The *Trauerspiel* of the Prostituted Body, or Women as Allegory of Modernity," *Cultural Critique* 10 (1988): 77–88.
[53] Quoted by Buci-Glucksmann, *Baroque Reason*, 91.
[54] Ibid., 94.

modernity.' "[55] The potential for the critique of modernity through the tropes of gender and femininity is summarized by her as follows:

> Woman's power over images, the staging of female bodies in the imaginaries of allegory or the protest against modernity, rediscovery of a bisexuality of writing, radical anthropological experience in the various utopianisms and modes of transgressing the normative division between feminine and masculine: all these new territories foreign to the "historicist" reason of progress, all these "primal historical forms" recaptured by "dialectical images" which bridge the past and now-time. . . . The "utopia" of the feminine, in all its interpretative excess, might represent this intertwining of time, images and bodies in profane illumination.[56]

Not surprisingly, other feminist readers of Benjamin have distanced themselves from some aspects of this interpretation, especially from what they see as an essentialist valorizing of "the feminine" in Buci-Glucksmann's notion of a utopian moment within modernity. Angelika Rauch's objection is that Buci-Glucksmann takes Benjamin's formulations too literally: "The author misses the point of Benjamin's critique of representation and modernity. His formulation of allegory, for example, contains a deconstruction of cultural and aesthetic significance and in this case, the deconstruction of the representation of femininity. Feminine sexuality, in the prostitute, acts as *appearance*, not as essence."[57] The point of woman-as-allegory for Rauch is that in the context of the avant-garde and the destruction of the institution of art, which "exposes the appearance of femininity as a projection of the male subject," modernity's dependence on and denial of a myth of wholeness is made clear.[58] This reading of Benjamin—in my opin-

[55] Ibid., 106.
[56] Ibid., 113–14.
[57] Rauch, "*Trauerspiel* of the Prostituted Body," 88, n. 21.
[58] Sigrid Weigel, also resistant to Buci-Glucksmann's discovery of a "utopia of the female" in Benjamin, sees in the analogies between Benjamin's and Kristeva's theories the articulation of a position within and also counter to modernity, one aligned with the feminine/female; see "Towards a Female Dialectic of Enlightenment." In another essay Weigel traces the particular figures of woman—mother, aunt, market woman, whore—in Benjamin's city writings, suggesting that Benjamin practices "a deconstructive form of writing in regard to myths of femininity"; see "Reading/Writing the Feminine City: Calvino, Hessel, Benjamin," in *"With the Sharpened Axe of Reason": Approaches to Walter Benjamin*, ed. Gerhard Fischer (Oxford: Berg, 1996), 85–98, 96.

ion the more profitable approach and one similar to my own exploration of "the feminine" in modern art—is developed in a rather different way by Eva Geulen. As she points out, "a general reconstruction of gender and gendering in Benjamin can be derived from virtually any of his texts, for all of them are saturated with the imagery of gendered eroticism."[59] Instead of looking at the figures of woman (allegorical or otherwise) in modernity, Geulen turns to the more fundamental question of gender as a central and constitutive category of Benjamin's philosophical approach. A "genealogy of gender" in Benjamin, she argues, must go back to his earliest writings on language and philosophy, in which a persistent theme of ambivalence in his work—creative/noncreative, organic/nonorganic, production/waste—is revealed to be fundamentally sexual.[60] The figure of the hermaphrodite, alluded to frequently throughout Benjamin's writings, registers this ambivalence as well as the impossibility of its reduction into two clear opposites. According to Geulen, even the early essays on language and on the youth movement are founded on a profoundly gendered understanding of the oppositions and historical transformations at work in those arenas. At the risk of oversimplifying Geulen's argument, what strikes me as critical is the proposition that gender operates as a constitutive category in Benjamin's thought. That is, the very analysis of modernity is necessarily premised on issues of masculinity and femininity. Like Rauch, Geulen demonstrates the possibility for a feminist critique of modernity which does not hypostatize a notion of "the essential feminine" but rather invites the analysis of its own terms.[61] On the basis of this suggested possibility, I conclude by returning to the question of gender and modernism in the visual arts.

Earlier I argued that it is no real solution to the problem of a "masculinized" modernism simply to rediscover women modernists or to identify new gender-specific themes in painting. The most interesting

[59] Eva Geulen, "Toward a Genealogy of Gender in Walter Benjamin's writing," *German Quarterly* 69, no. 2 (1996): 161–80, 162.

[60] Geulen, "Toward a Genealogy of Gender," 166.

[61] The question of the relationship between the genealogy of gender in Benjamin's oeuvre and the progress of this structure of thought through his historical and materialist studies of the nineteenth and early twentieth centuries still remains to be explored since it is not something that Geulen pursues.

and challenging work—by men as well as women modern artists—has engaged critically *with* issues of gender, sometimes exposing the construction of gender ideologies, sometimes showing the strains in an otherwise monolithic and seamless set of identities. To that end, I have spent some time discussing the related debate about gender and modernity for two reasons. First, I think that the critical investigation of the gendered discourses of modern life is—or should be—central to the art-critical analysis of gender in visual discourses. Second, modern art is, despite everything, the "painting of modern life" (though not in any sense of simple equivalence or straightforward expression). My exploration of the visual construction of masculinity and femininity in art is thus already premised on an understanding of the complex intersections of text and social experience, of art and modern life.

How might one explore the signs of femininity (or, for that matter, of the troubling of masculinity) in modern art? Art historians have already begun this work. Linda Nochlin has suggested that certain family portraits by Degas, while ostensibly contributing to the genre of celebration of family, in fact manifest the fragmentation and centrifugality often involved in particular familial relations.[62] Her reading of his portraits of the Bellelli family identifies tensions within the group which subvert the "official" story of domestic integrity. Similarly "reading against the grain" of dominant interpretations (including some feminist ones), Carol Armstrong focuses on the counter and the mirror in Manet's *Bar at the Folies-Bergère* to propose that in the space between the public, consumer zone (the objects on the counter) and the private, psychic zone (the mirror and its implications of opticality and illusion), the barmaid herself, in her "interruptive" position, "both divides and bridges the gendered worlds of the subject and object, the self and the other, demonstrating how joined—rather than opposed—they are, how twinned they are, too."[63] Griselda Pollock has followed her own earlier advice to investigate "inscriptions of the

[62] Linda Nochlin, "A House Is Not a Home: Degas and the Subversion of the Family," in *Dealing with Degas: Representations of Women and the Politics of Vision*, ed. Richard Kendall and Griselda Pollock (New York: Universe, 1992), 43–65.

[63] Carol Armstrong, "Counter, Mirror, Maid: Some Infra-Thin Notes on *A Bar at the Folies-Bergère*," in *12 Views of Manet's Bar*, ed. Bradford R. Collins (Princeton: Princeton University Press, 1996), 25–46, 43.

feminine" in modern art, finding these in the complex and contested meanings of paintings by men as well as women.[64] Dealing with a somewhat later period, Ernst van Alphen reads Francis Bacon's portraits and figures—obvious examples of the literal deconstruction of the pictured body—as thereby also engaged in the deconstruction of masculinity itself.[65] To these I wish to add two brief suggestions of possible "inscriptions in the feminine" which work in this interrogative way.

The first is the work of the English artist Gwen John, who lived and worked in Paris for most of her life until her death in 1939. John has become a favorite of feminist critics, who have been taken with her representations of women and characteristic images of domestic interiors—the spaces of femininity. I think one could also read her paintings of rooms *without* figures (women or men) as images which, though not quite still lifes and not the usual domestic scene, ask questions about the absence of people and encourage us to reflect on our own expectations about who *ought* to be in the scene and what that person might be doing. In *The Teapot*, dating from around 1915–16 (fig. 4.1), John creates a simple but highly evocative scene. The painting is not just a still life, since the objects themselves speak of the brief and temporary absence of the human figure—the book, the single cup and saucer, the teapot itself. The invitation to acknowledge the missing figure is, I would suggest, also an invitation to reflect on our assumptions about gender, particularly in the context of the history of such representations (for example, Victorian images of the domestic scene, in which the association of women and the serving of afternoon tea is entirely clear.)[66] The effect of the absence is the dislocation of what is taken for granted. It thus provides an opportunity for the exploration of constructions of femininity in the visual field.

My second example relates to my study of the realist artists of the Whitney Studio Club in the decades leading up to the founding of the

[64] Griselda Pollock, *Differencing the Canon: Feminist Desire and the Writing of Art's Histories* (London: Routledge, 1999). She devotes individual chapters to van Gogh, Toulouse-Lautrec, and Mary Cassatt, among others.

[65] Ernst van Alphen, "Masculinity," *Francis Bacon and the Loss of Self* (London: Reaktion, 1992). He also points out that Bacon's few female nudes are quite unavailable for the male gaze, resisting objectification and challenging the viewer and male desire itself.

[66] Consider, e.g., William Holman Hunt's *Children's Holiday* (1864–65) or William Hicks's *Woman: Companion of Manhood* (1863).

4.1 Gwen John: *The Teapot (Interior: Second Version)*, c. 1915–16 (Yale University Art Gallery)

Whitney Museum of American Art in 1931 (see chapter 1). In the course of my research, I came to understand the marginalization of realism in postwar art history as itself a gendered practice in which realism figures as "feminine" against modernism's masculinity. The relative invisibility of American figurative art of the early twentieth century—particularly after the consolidation of the "MoMA narrative" (the privileging of post-Cubist and abstract art associated with and maintained by the Museum of Modern Art in New York) after the Second World War—did not discriminate between work by men and women. The question of gender instead operated on another level in the discursive production of modernism as masculine and of realism as feminine. This meant, of course, the feminization of figurative (nonmodernist) work by men and not just of work by women. Here I suggest this as another opportunity for critical inquiry. The project in this case is less the discovery of inscriptions of the feminine in modern art (an approach more suited to the dominant, modernist tradition) than the analysis of what is already constituted as "feminine." I think that one could then look differently at the work of artists like Guy Pène du Bois (fig. 4.2) and Yasuo Kuniyoshi (fig. 4.3), not because they depict women or "feminine" spaces but because their discursive construction as feminine—the basis for their absence from the primary canon of twentieth-century art—can help us to understand how the masculinity of modernism operates. This would involve a consideration of how modernism was constructed as masculine, a project proposed as early as 1973 by Carol Duncan, and rereading the nonmodernist work of du Bois and Kuniyoshi in this context—a study both of images themselves and of critical discourses surrounding those images.

These are merely preliminary suggestions for what such an exploration of the feminine in modern art might look like. I hope that my detour through Simmel and Benjamin, the theorists of modernity, has supported my argument that the task for feminist criticism is not so much a filling in of gaps in the story of the modern but rather the analytics of a sympathetic but critical engagement with that story. Within what is primarily an art-historical task, I want to make the case for the sociohistorical interpretation of what constitutes "the feminine" (either in the figure of women, as in Benjamin's essays, or in the contradictions and exclusions of "masculinity"). For the same reason, I am not persuaded by some versions of the approach I have been re-

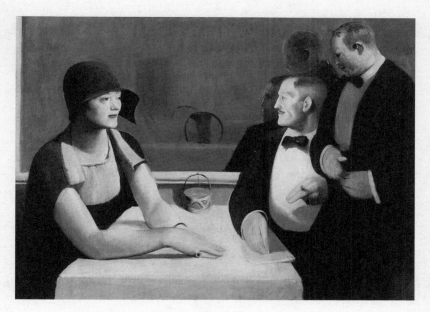

4.2 Guy Pène du Bois: *Mr. and Mrs. Chester Dale Dine Out*, 1924 (The Metropolitan Museum of Art, gift of Chester Dale, 1963 [63.138.1])

4.3 Yasuo Kuniyoshi: *Weathervane and Sofa*, 1933 (Santa Barbara Museum of Art, gift of Wright S. Ludington)

viewing, such as Weigel's attempt to link Benjamin with Kristeva's notion of the "semiotic" or Pollock's enthusiastic endorsement of the notion of the "matrixial," which she adopts from the artist and psychoanalyst Bracha Lichtenberg Ettinger.[67] These seem to me to come too close to those essentializing notions of femininity and of woman I have attempted to avoid. I am, however, in total agreement that one can retrieve the concept of "the feminine" from its role in the service of the denigration of women's work and instead consider how it operates interrogatively in the discourses and histories of both modernism and modernity.

[67] See Weigel, "Toward A Female Dialectic of Enlightenment"; Pollock, "Inscriptions in the Feminine," 77–85.

The Failure of a Hard Sponge

Class, Ethnicity, and the Art of Mark Gertler

Looking at the work of the English artist Mark Gertler, it is easy to view 1912—the year he finished his studies at the Slade School of Art and moved out of his parents' home into his own studio, as well as the year of the second Post-Impressionist exhibition in London—as a turning point in his visual style. The switch from the more traditional "Slade" style of painting to work influenced by Cézanne and Picasso is evident when one compares an earlier portrait of his family dating from 1910–11 (fig. 5.1) with a 1913 painting entitled *Family Group* (fig. 5.2), or two portraits of his mother, the first painted in 1911 and the second in 1913 (figs. 5.3 and 5.4). Gertler's biographer, John Woodeson, maintains that despite his ambivalence about modern art, he was, in fact, one of the leaders of the modern movement in England after the autumn of 1912, that is, after the second Post-Impressionist show.[1] One can certainly read these paintings as representing a progression from the more traditional visual language of the first of each pair[2] to the angular, geometric, formalized representation in the second, a development marked by Gertler's encounters with the work of Picasso and other post-Cézanne artists. Woodeson has identified elements in Gertler's style around 1913 "which place him beyond Post-

[1] John Woodeson, *Mark Gertler: Biography of a Painter, 1891–1939* (Toronto: University of Toronto Press, 1973), 126.
[2] Juliet Steyn describes the 1911 portrait of Gertler's mother as "a competent Edwardian portrait. Its language has a debt to Slade painting." See her essay "Mythical Edges of Assimilation" in *Mark Gertler: Paintings and Drawings* (exh. cat.) (Camden, Eng.: Camden Arts Center, 1992), 11.

5.1 Mark Gertler: *The Artist's Family: A Playful Scene*, c. 1910–11 (Birmingham Museums and Art Gallery)

Impressionism and in twentieth-century art."[3] His best-known work, *Merry-Go-Round* of 1916 (fig. 5.5), is an antiwar painting created, as Gertler wrote to the artist Dora Carrington, when "the whole horror of war has come freshly upon me."[4] It clearly has affinities with aspects of Futurism—for instance, the machinelike character of the figures on the carousel and the emphasis on war (though in Gertler's case, unlike the Futurists' or the Vorticists,' the emphasis is negative). By this date Gertler was certainly well aware of the work of the more avant-garde artists in London. He visited the studio of David Bomberg, was a friend of Henri Gaudier-Brzeska, and was familiar with the work of Jacob Epstein.

However, the story of Gertler's relationship to modernist movements in art is more complex. Unlike Bomberg, Wyndham Lewis, and other artists, he did not pursue the possibilities of Cubism, Futurism, and other new movements. After 1916 he returned to the pre-Cubist moment of Post-Impressionism as his inspiration—and, even earlier,

[3] Woodeson, *Mark Gertler*, 339.
[4] Ibid., 225–26.

5.2 Mark Gertler: *Family Group*, 1913 (Southampton City Art Gallery, Hampshire, U.K./Bridgeman Art Library)

5.3 Mark Gertler: *The Artist's Mother*, 1911 (Tate Gallery, London/Art Resource, N.Y.)

to a new passion for Renoir. The 1922 painting *Queen of Sheba* (Tate Gallery) illustrates this well. Many of his later paintings were still lifes, such as *The Basket of Fruit* of 1925 (also in the Tate Gallery), and although there is still a certain flattening out of forms evident in the latter that recalls Cubist arrangements, the moment of his more radical experimentation had passed.[5] In the last year of his life he described his aim in painting: "What my forms represent is of secondary

[5] One exception is *Cubist Still Life*, painted in 1938 (private collection).

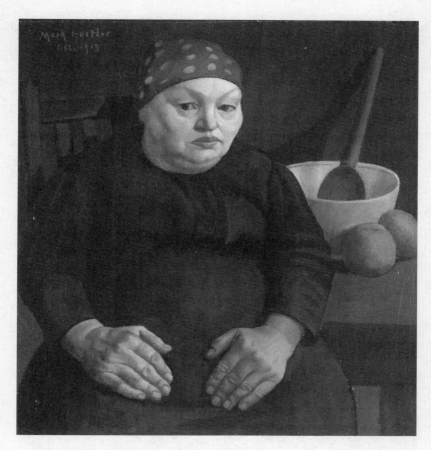

5.4 Mark Gertler: *The Artist's Mother*, 1913 (City and County of Swansea: Glynn Vivian Art Gallery Collection)

importance. . . . I am a classical painter. . . . Studying nature is necessary but most important is to study the great paintings of the past."[6]

In fact, Gertler's own view on the difference between the two portraits of his mother has little to do with formal innovation. For him the later painting (the more "modernist" work) was simply more *realistic*, and hence more true to his heritage and to his mother's life. In a letter dated July 1913 he wrote: "I am painting a portrait of my mother. She sits bent on a chair, deep in thought. Her large hands are lying heavily and wearily on her lap. The whole suggests suffering

[6] Quoted in Woodeson, *Mark Gertler*, 352.

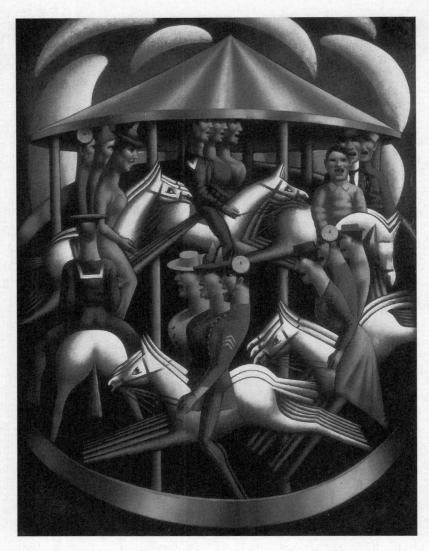

5.5 Mark Gertler: *Merry-Go-Round*, 1916 (Tate Gallery, London/Art Resource, N.Y.)

and a life that has known hardship. It is barbaric and symbolic."[7] It is clear from a letter dated December 1913 to Carrington that he does not believe there is anything new about the work :

> My picture is now finished. . . . I've got the character of the woman and that's a good deal. I know it is not new, and our revolutionists would say of it that was academic. I don't care. Newness doesn't concern me. I just want to express *myself* and be personal. . . . As for realism—my work is real and I wanted to be real. The more I see of life, the more I get to think that realism is necessary. . . . I don't want to be abstract and cater for a few hyper-intellectual maniacs. An over-intellectual man is as dangerous as an over-sexed man. The artists of today have thought so much about newness and revolution that they have forgotten art.[8]

In April 1920, while on a trip to Paris, he wrote to Carrington: "Renoir has made an enormous impression on me. In fact I am not sure that I do not like him best!"[9] It is clear that even at the moment of his most radical experimentation in painting, he remained ambivalent with regard to modern art. The following is from an interview conducted by the *Jewish Chronicle* in February 1912:

> What are your views, then, on modern art?" asked a reporter.
> "Decided and not flattering. I have no 'parrot' veneration for the old masters, but I say this, that until we begin to paint in the same sincere spirit that they did, we have no chance of approaching them as painters."[10]

In January 1915 he commented: "An artist who has come back from Paris with all the 'Latest Fashions' is to my mind the most dreadful of all living creatures."[11] And in a letter dated August 1919 to S. S. Koteliansky: "Do you know what a Jew says to a 'shatchan' when the proposed bride is unsuitable? He says, 'Very nice, very fine, but not

[7] Letter to the Hon. Dorothy Brett, in *Mark Gertler: Selected Letters*, ed. Noel Carrington (London: Rupert Hart-Davis, 1965), 55.

[8] Carrington, ed., *Mark Gertler: Selected Letters*, 60.

[9] Ibid., 179.

[10] Quoted in Woodeson, *Mark Gertler*, 336. See also letter to Carrington dated March 14, 1921, in Carrington, ed., *Mark Gertler: Selected Letters*, 199.

[11] Quoted in Woodeson, *Mark Gertler*, 118.

for me.' That's what I feel about the French pictures."[12] In February 1928 he told Marjorie Hodgkinson (whom he was to marry two years later): "As for Surrealism, I don't know anything about it, but I am becoming more and more suspicious of 'movements,' with intricate and *startling* ways of painting and writing etc. I am more and more convinced that the best methods are after all the simplest and the traditional."[13]

I suggest that one can understand Mark Gertler's ambivalent relationship to the avant-garde only by considering him and his work in the context of class relations, intellectual life, and modernism in England in the first decades of the twentieth century. In particular, two extra-aesthetic factors are at work which, I believe, ultimately manifest themselves in his work. The first is his complex, agonized relationship with Bloomsbury. The second is his equally conflicted attitude to his immigrant origins and his Jewish identity. Ironically, his work is at its most radical—and here I do not mean politically radical—the more he distances himself from the orthodoxies of Fry and the Bloomsbury group and retains his connection with his origins. In January 1915 he finally left the East End of London for a studio in Hampstead, near his middle-class and upper-class friends. As he wrote at the time, "I am *immensely* relieved to leave the East End and even my parents, although I like them. There I shall be free and detached—shall belong to no parents. I shall be neither Jew nor Christian and shall belong to no class."[14] Within a couple of years following this move, he had abandoned his commitment, which was always provisional, to stylistic and visual experimentation practiced by the European avant-garde. Woodeson poses the following rhetorical question: "Was it true, as some critics maintained, that while his powers of expression and skill at design had increased as he tried to make his art become more cosmopolitan, moving nearer to the mainstream of European painting, the vitality and intensity of his earlier work had been lost?"[15]—with "cosmopolitan" and "mainstream" signifying a pre-Cubist modernism.

[12] Carrington, ed., *Mark Gertler: Selected Letters*, 176.

[13] Ibid., 225.

[14] Letter to Carrington, dated January 1915, in Carrington, ed., *Mark Gertler: Selected Letters*, 80–81.

[15] Woodeson, *Mark Gertler*, 329. Charles Spencer talks of Gertler's "East End masterpieces and his later decline" in "Anglo-Jewish Artists: The Migrant Generations,"

This apparent paradox only makes sense if one understands two things about the connections between modernism and conservatism. First, there was a strongly conservative streak in what was ostensibly the most avant-garde tendency in England, namely, the Bloomsbury circle. Second, the more radically "modernist" work was—is—produced from the apparently conservative inclination to work from a given social situation (though I would add that this "situation" is usually one of marginalization and displacement). It is worth adding that the connection between aesthetic, social, and political values is more complex than I present it here; it is clear, for example, that members of the Bloomsbury group were far more progressive politically and in terms of sexual politics than Gertler and Lewis, among others.

Bloomsbury and the Avant-Garde

Although Virginia Woolf's much-quoted claim that "on or about December 1910 human character changed" accurately records the impact of Roger Fry's first Post-Impressionist exhibition, which opened in November of that year at the Grafton Galleries in London, it completely ignores the fact that the avant-garde on display there, which so shocked audiences and critics, was already quite out of date. The major figures at the exhibition were Cézanne, van Gogh, and Gauguin. Three years after Picasso painted *Les Demoiselles d'Avignon*, there was no hint in this exhibition of the revolution of Cubism; the few Picassos on display were early works, and even the Cézannes were works predating those which had typically inspired Cubism.[16] In the same year as Filippo Marinetti's first visit to England and the publication in Milan of the "Manifesto of Futurist Painting"[17] no Futurist work was included in the Grafton Galleries show. Five years after the Expressionist group Die Brücke was formed in Dresden, and in the same year as the founding of Der Blaue Reiter, Fry and his colleagues did not include any Expressionist works. In 1910 Wassily

in *Immigrant Generations: Jewish Artists in Britain, 1900–1945* (New York: Jewish Museum, 1982), 34.

[16] Ian Dunlop, *The Shock of the New* (New York: American Heritage Press/McGraw-Hill, 1972), 137.

[17] Charles Harrison, *English Art and Modernism, 1900–1939* (London: Allen Lane, 1981), 86.

Kandinsky painted the early abstract work *Battle* (now in the Tate Gallery),[18] but he was also not represented in the show. There were, however, three paintings by Matisse and some by Fauve artists Maurice Vlaminck and André Derain.[19] Two years later, at the second Post-Impressionist exhibition, Matisse and Picasso were the key figures. Fry again chose not to show Italian Futurist painters even though the English section of the exhibition included works by Wyndham Lewis which already showed the influence of Futurism.[20]

Nevertheless, in the context of British parochialism (what Ian Dunlop has referred to as the "provincialism" of the English, based on "a misplaced enthusiasm for the native school"[21]) the reaction to the first exhibition was one of shock. The reviews were uniformly critical, ranging from the familiar argument that "the drawing is on the level of that of an untaught child of seven or eight years old . . . the method that of a schoolboy who wipes his fingers on a slate after spitting on them"[22] to outraged descriptions of the paintings as similar to a rat plague and as a source of infection.[23] British collectors at the time were mainly buying nineteenth-century British art. Among artists, the New English Art Club (founded in 1886) was the main radical group opposed to the academy and influenced by French Impressionism. The more advanced of these artists (Walter Sickert, Harold Gilman, Spencer Gore, Lucien Pissarro) had met regularly since 1907 as the Fitzroy Street Group, later (in 1911) to become the Camden Town Group.[24] Unlike other members of the New English Art Club, these artists followed developments in French art, particularly Neo-Impressionist and Post-Impressionist painting. Much of their work displayed a new interest in light and color. Particularly "modern" in the context of English art at that time was the choice of subject matter, with a focus on scenes of everyday life. Charles Marriot, an art historian writing in 1920, commended Sickert's application of French styles of painting to English subjects, saying of him that "he translates

[18] Rosemary Lambert, *The Twentieth Century* (New York: Cambridge University Press, 1981), 28.

[19] Harrison, *English Art and Modernism*, 45.

[20] Ibid., 87, 62f., 67; Frances Spalding, *British Art Since 1900* (London: Thames and Hudson, 1986), 38–39.

[21] Dunlop, *Shock of the New*, 127.

[22] Wilfred Blunt, *Diaries*, quoted in Dunlop, *Shock of the New*, 144.

[23] Robert Ross, *Morning Post*, quoted in Dunlop, *Shock of the New*, 133.

[24] Dunlop, *Shock of the New*, 124; Harrison, *English Art and Modernism*, 28, 36.

absinthe into beer."[25] Despite the highly innovative themes of these paintings and the radically new treatment inspired by recent French art, compared to contemporary developments in Europe this work was in no sense avant-garde.

The significance of 1910 lies in the ascendancy of a new aesthetic, namely, the Bloomsbury orthodoxy of Clive Bell and Roger Fry, with its insistence on "significant form" (Bell) and "imagination" (Fry),[26] and on the emancipation of art from its dependence on morality, illustration, and the faithful depiction of the world of appearances. For the visual artists in this circle—notably Duncan Grant and Vanessa Bell, sister of Virginia Woolf—the increasing focus on the formal characteristics of art manifested itself in art-as-decoration; indeed, with the formation of Fry's Omega Workshops in July 1913, much of their energy was devoted to designing fabrics and furniture and decorating pottery). The influence of the avant-garde movements elsewhere in Europe was nonexistent here—and not only in 1910 but throughout the painting careers of the Bloomsbury artists. Though one could argue that judging English art by French or Continental standards constitutes a certain Eurocentric prejudice that ignores the specificity and uniqueness of the English and British traditions,[27] my twofold claim is that Fry and his associates believed they were in the vanguard of European art on *its* terms, and that much of the work they produced did lack originality on any terms.

A more radical group of artists working in England before and during the First World War was inspired and excited by developments on the Continent—particularly Cubism and Futurism. The most important of these was the writer and painter Wyndham Lewis. He had been a member of the Fitzroy Street Group and was a founding member of the Camden Town Group. But by 1911 he was already influenced by Cubism, and in 1913 he was in the vanguard of those English artists receptive to Futurism.[28] His associates involved in the short-lived magazine *Blast*, which he edited in 1914 and 1915, and in the radical group calling itself the "Vorticists" included the poet Ezra Pound and artists Henri Gaudier-Brzeska, William Roberts, Edward Wadsworth, and Helen Saunders, all of whom were committed to a

[25] Quoted in Harrison, *English Art and Modernism*, 32.
[26] Ibid., 54.
[27] I wish to thank Keith Bell for this important point.
[28] Harrison, *English Art and Modernism*, 36, 90.

version of Futurism. C. R. W. Nevinson, though not a member of the Vorticists, was also a "confirmed disciple" of Italian Futurism[29] who showed his work in Futurist exhibitions with Lewis and the others. Though some of these artists continued to produce important work, after 1918 the prewar energy had dissipated. Art in England reverted to its accustomed state of insularity and provincialism, with the 1920s and 1930s characterized by the continued hegemony of Bloomsbury and the rise of a new school of still-life and landscape artists (Nash, Nicholson, Hitchens). The next important avant-garde movement to have an impact in Britain was Surrealism—which included such notable English Surrealist artists and writers as Leonora Carrington, Eileen Agar, Julian Trevelyan, Herbert Read, Roland Penrose, and Humphrey Jennings. But it was not until 1936, when the International Surrealist Exhibition was held in London, that these developments occurred. The first Surrealist manifesto was published in 1924; Surrealist activities had already begun in Belgium in 1924, in Catalonia in 1925, in Rumania in 1928, in the Canary Islands in 1932, and in Egypt in 1934.[30] As usual, the English were a little late.

I believe that the failure of the avant-garde in England can only be understood in connection with the particular class basis of the intelligentsia in the first decades of the last century. In October 1913 (a year after the second Post-Impressionist exhibition), a group of artists, led by Lewis, that included Wadsworth, Nevinson, and Frederick Etchells broke away from Fry's Omega Workshops, setting up the Rebel Art Centre a few months later.[31] As Charles Harrison has pointed out, the consequent split between the English Post-Impressionists, on the one hand, and the more "militantly modernist" artists, on the other, must be seen in relation to the structures of class difference.[32] For the most part, the rebel artists were from working-class, lower-middle-class, immigrant, or nouveau-riche backgrounds. In his book-length study of Lewis's novels, Fredric Jameson situates his radical aesthetic and his reactionary politics in the context of the "shifting class alliances" of prewar Europe and of the marginalization of the

[29] Ibid., 88.
[30] Michael Remy, "Surrealism's Vertiginous Descent on Britain," in *Surrealism in Britain in the Thirties* (Leeds: Leeds City Art Galleries, 1986), 19.
[31] Harrison, *English Art and Modernism*, 74.
[32] Ibid., 88.

middle and lower middle class.[33] In other metropolitan centers of western Europe, it was precisely the vision and culture of these groups which was in the ascendancy, resulting in the success of the avant-garde—which, like all avant-gardes, was later to be assimilated into the mainstream. This is the classic operation of cultural capital, in which an emergent social group employs education and taste in the threefold project of securing class privilege not based on economic capital, legitimating that privilege through the prestige of culture, and differentiating itself from lower strata whose lack of appreciation of high culture confirms and naturalizes their inferior position. As Pierre Bourdieu has suggested, the art of the avant-garde lends itself particularly well to such exclusionary strategies, since its apprehension involves not only the knowledge of the "codes" of high art but also the "successful mastery of the code of codes" which comes into play when modernism self-consciously suspends existing codes.[34] The ability to participate in the game of appreciating classical, romantic, or realist art depends on education and familiarity; the more complicated game of knowing and then subverting this traditional aesthetic requires a more sophisticated kind of learning. In that respect, vanguard art is ideally suited to serve the professional middle classes as cultural capital.

To some extent, this was the case in England. In *Vision and Design* (1920) Roger Fry identified an educated upper class as resistant to the radical endeavor of English modernism:

> I found among the cultured who had hitherto been my most eager listeners the most inveterate and exasperated enemies of the new movement. . . . I now see that my crime had been to strike at the vested interests. These people felt instinctively that their special culture was one of their social assets. That to be able to speak glibly of Tang and Ming, of Amico di Sandro and Baldovinetti, gave them a social standing and a distinctive cachet. . . . It was felt that one could only appreciate Amico di Sandro when one had acquired a certain considerable mass of erudition

[33] Fredric Jameson, *Fables of Aggression: Wyndham Lewis, the Modernist as Fascist* (Berkeley: University of California Press, 1979), 15, 128.

[34] Pierre Bourdieu and Alain Darbel, *The Love of Art*, trans. Caroline Beattie and Nick Merriman (Cambridge: Polity, Cambridge, 1991), 44. See also Bourdieu's "Outline of a Sociological Theory of Art Perception," *International Social Science Journal* 20, no. 4 (1968): 600–601.

and given a great deal of time and attention, but to admire a Matisse required only a certain sensibility.[35]

The implication was that Fry's group represented a quite separate social stratum which constituted a challenge to the dominant culture. However, this split has been overstated, in a country in which the modernizers were not the dispossessed. The notion of cultural capital is usually premised on the existence of a certain distance between the professional middle class and the politically and economically dominant group. Culture works within this gap to guarantee a parallel system of prestige and social power. Cultural capital also depends upon a recognition by the ruling class of the authority of high culture, even though, as Bourdieu has shown, the audiences for the most advanced cultural forms have tended to be professionals rather than capitalists and corporate executives.[36] There is a long-running debate among social historians, starting with a fierce disagreement between Perry Anderson and E. P. Thompson in the 1960s, about the lasting effects of the civil war in England in the seventeenth century and the social consequences of industrialization in the late eighteenth and nineteenth centuries. According to Anderson, there was never a fully successful bourgeois revolution in England but rather an accommodation with the aristocracy and landed gentry, which produced a new ruling class characterized by traditional aristocratic values. This has been much contested not only by Thompson but also by later social historians, who have insisted on the decidedly bourgeois character of England after the mid-nineteenth century, the House of Lords and the monarchy notwithstanding.[37] On both sides, though, there is agreement on the nature of the English intelligentsia before the First World War. In particular, the close integration of this group into the composite ruling class has been well documented. For Anderson this is evidence of the persistence of aristocratic rule, since the aristocracy "produced its own intelligentsia by flooding Eton, Winchester, and Oxbridge with

[35] Quoted in Dunlop, *Shock of the New*, 159–60.
[36] Pierre Bourdieu, *Distinction: A Social Critique of the Judgement of Taste*, trans. Richard Nice (London: Routledge & Kegan Paul, 1984).
[37] See, e.g., Simon Gunn, "The 'Failure' of the Victorian Middle Class: A Critique," in *The Culture of Capital: Art, Power and the Nineteenth-Century Middle Class*, ed. Janet Wolff and John Seed (Manchester: Manchester University Press, 1988), 17–43; and E. P. Thompson, "The Peculiarities of the English" [1965], rpt. in his *Poverty of Theory and Other Essays* (London: Merlin, 1978), 35–91.

its sons. . . . Thus a peculiarity of English history has been the tradition of a body of intellectuals which was *at once homogeneous and cohesive and yet not a true intelligentsia.* The reason for this was that the unity of the group was mediated not through ideas but through kinship."[38] This analysis is borne out by Noel Annan's classic study of what he called "the intellectual aristocracy," in which he traced the links of marriage and kinship across the dominant figures in English intellectual life in the late nineteenth and early twentieth centuries. In addition to the crucial social connections, he demonstrated the importance of public school and, especially, Cambridge in the formation of this group, as well as the tendency of its members to work in government in the Indian and Home civil service and to dominate intellectual periodicals.[39] For Annan this is not the old upper class (more likely to be found in the diplomatic service, for example) nor the capitalist class but rather a new aristocracy which was able to remain closed and to perpetuate itself through kinship and educational institutions. The tendency to work through existing institutions in this way produced "the paradox of an intelligentsia which appears to conform rather than rebel against the rest of society."[40] His conclusion about this intelligentsia is highly relevant to the progress of the avantgarde in England:

> Here is an aristocracy, secure, established and, like the rest of English society, accustomed to responsible and judicious utterance and sceptical of iconoclastic speculation. As a corollary it is also often contended that they exert a stultifying effect upon English intellectual life by monopolising important posts and thus excluding a new class who, unbeneficed and indignant, eat out their hearts in the wilderness.[41]

Bloomsbury names figure prominently in Annan's family networks—Strachey, Huxley, Trevelyan, Keynes, Stephen—and, as

[38] Perry Anderson, "Origins of the Present Crisis," *New Left Review* 23 (1964): 42–43.
[39] Noel G. Annan, "The Intellectual Aristocracy," in *Studies in Social History*, ed. J. H. Plumb (London: Longmans, Green, 1955), 243–87.
[40] Annan, "Intellectual Aristocracy," 285.
[41] Ibid., 285–86. See also T. W. Heyck, *The Transformation of Intellectual Life in Victorian England* (London: Croom Helm, 1982); Heyck similarly concludes that the intellectuals were "separate from the ruling class in some ways, but very much a part of it in others" (237).

Annan says, "if we recollect that Mr. E. M. Forster is a great-grandson of Henry Thornton and that Mr. Duncan Grant is a first cousin of the children of Sir Richard Strachey, all the members of the original Bloomsbury circle except Mr. Saxon Sydney-Turner and H. T. J. Norton, Fellow of Trinity, have already appeared in the families which we have examined."[42] Raymond Williams has no hesitation in describing the Bloomsbury circle as "a true *fraction* of the existing English upper class,"[43] a group with more liberal values than those of the dominant sector of its class (and of its own Victorian and Edwardian forebears) but one nevertheless structurally and ideologically tied to the ruling class and hence the status quo. In the context of this particular intelligentsia, one both radical and deeply conservative, one should examine not so much the operation of cultural capital—which may not be a very helpful term in this case—but rather the particular *economy of prestige* in effect in the realm of culture.[44] David Morgan has shown how the social relations of the Bloomsbury group operated to exclude nonmembers.[45] Taking Leonard Woolf's own list of members of the group (never a carefully defined one),[46] Morgan has examined the ways in which this friendship network also worked as a system of patronage and brokerage, in which the friends reviewed one another's books, served as editors for each other's work on journals (notably *The New Statesman* and *The Nation*), and published (through the Woolfs' Hogarth Press) each other's books. These informal intersections of social relations and systems of cultural production resulted in a relatively closed system with considerable power and influence in the intellectual and cultural life of the period. Stressing the "common social and academic antecedents (professional, upper-middle class and Cambridge)" of the members of the group, Morgan also suggests that these tight interconnections at the level of work and social relations produced and

42 Annan, "Intellectual aristocracy," 279–80.

43 Raymond Williams, "The Bloomsbury Fraction," in his *Problems in Materialism and Culture* (London: Verso, 1980), 156.

44 The term occurs in the special issue *Cultural Critique* 12 (1989) entitled "Discursive Strategies and the Economy of Prestige."

45 David Morgan, "Cultural Work and Friendship Work: The Case of 'Bloomsbury,'" *Media, Culture and Society* 4 (1982): 19–32.

46 It included the Bells, the Woolfs, Adrian Stephen (brother of Vanessa Bell and Virginia Woolf), Lytton Strachey, Maynard Keynes, Duncan Grant, E. M. Forster, Saxon Sydney Turner, Roger Fry, and Desmond and Molly MacCarthy.

sustained a "relatively coherent world-view."[47] The other side of this, of course, is the exclusion of those not of that class, social network, or worldview.

Mark Gertler and Bloomsbury

The shift from the large-scale sociohistorical perspective to the particular discussion of one individual and his connections raises many problems common to such cultural histories. In selecting Gertler (a quite unique and, in many ways, eccentric figure) as somehow "typical" of a moment in social history, I am also taking the risk that what I am presenting might be a misreading of the social relations and aesthetic values at play in this period. The broader generalizations, however, are only tested at the level of particular events and relationships. At the same time, observations of these events may often be the basis for a provisional theory of the larger social context. I offer this discussion of Mark Gertler in the belief that from a reading of his life and work one can indeed understand a good deal about cultural ideas and social relations of class and ethnicity at the macro level in England between 1910 and 1940.

Gertler was born in 1891 and grew up in Whitechapel, in the East End of London, the home of poor Jewish immigrants from Eastern Europe. His own parents came from Galicia, a Polish province of Austria-Hungary, first emigrated to England in 1890, returned to Galicia a few months later, and moved back to London again in 1896 when Mark (who had been born during the first short stay in England) was five. He studied at the Slade School of Art, where he met the artist Dora Carrington, the object of his infatuation for a number of years. Carrington represented one of his links with Bloomsbury when she, in turn, fell in love with Lytton Strachey, with whom she lived from 1917 until his death and her subsequent suicide in 1932. (Gertler himself committed suicide in 1939.) He also came into contact with the Woolfs and Bells and other "Bloomsberries" from the summer of 1915 at Garsington Manor, the country home of Lady Ottoline Morrell, where, as pacificists, they were officially engaged in

[47] Morgan, "Cultural Work and Friendship," 31.

agricultural work to assist in the war effort.[48] At one point Roger Fry took an interest in Gertler's work, invited him home for a weekend in October 1917, bought one of his drawings the following year, and included him in an exhibition of the Omega Workshops in December 1918.[49] Clive Bell was less enthusiastic. In one review he wrote that "Gertler's artistic gift, one inclines to suppose, is precisely that irreducible minimum of talent without which an artist cannot exist. . . . He has only two or three notes and they are neither 'rich nor rare.' "[50] Virginia Woolf kept her distance. In June 1919 Gertler wrote from Garsington Manor to a correspondent "Virginia received me rather coldly."[51] Her own diaries make "coldness" seem something of an understatement. A real distaste is apparent in her comment from June 24, 1918: "Gertler is a plump white young man, got up for the occasion very sprucely in sponge bag trousers. His face is a little tight & pinched; but the word he would wish one to use of him is evidently 'powerful.' There is something condensed in all Jews. His mind certainly has a powerful spring to it. He is also evidently an immense egoist."[52] I will come back to Woolf's reference to "all Jews" shortly. It is worth pointing out here that although this, like many other references in her diaries and letters, has something of an antisemitic ring to it, one cannot simply assume an uncomplicated hostility here. The tone is characteristic of many of her rather acid comments about people mentioned in the diaries. She was, of course, also married to a Jew. Even when talking about Leonard Woolf's family, her diary entries include comments like "I do not like the Jewish voice; I do not like the Jewish laugh"[53] and "I think Jewesses are somehow discontented."[54]

A few months later she records: "We have been talking about Gertler to Gertler for some 30 hours," adding, "I suspect the truth to be that he is very anxious for the good opinion of people like ourselves."[55] (Leonard Woolf, in a letter to Lytton Strachey on the same

[48] Harrison, *English Art and Modernism*, 145.
[49] Woodeson, *Mark Gertler*, 251f.
[50] Ibid., 266.
[51] Quoted in Carrington, ed., *Mark Gertler: Selected Letters*, 172.
[52] Quoted in *The Diary of Virginia Woolf*, vol. 1, *1915–1919*, ed. Anne Olivier Bell (New York: Harcourt Brace Jovanovich, 1977), 158.
[53] Ibid., 6.
[54] Ibid., 29.
[55] Ibid., 198.

occasion, says, "Now Gertler is here talking about Gertler," which conjures up a picture of the couple cosily coming to joint verdicts on their guests each evening.)[56] By December 1921 she is describing Gertler and a couple of others as having "grease in their texture." Gertler "has grown fat; his hair stands upright; he has the same tightly buttoned face as of old—little eyes—hard cheeks—something small & concentrated about him which makes me repeat, however foolhardily, that I don't believe he can paint a picture."[57] About another unfavored acquaintance she writes the following month: "And he lives in the pigsty—by which I mean the Murrys, the Sullivans & the Gertler."[58] Only after his death does she allow herself a different tone: "Talk at Nessa's last night. Much about Gertler's suicide. Nessa and Duncan said his last show, just over, was a great advance & very remarkable. . . . A most resolute serious man: intellectual; fanatical about painting, even if a fanatical egotist. And he seemed established. . . . Poor of course, & forced to teach."[59] Gertler's attitude toward Bloomsbury was hardly any friendlier, and there is little evidence that, as Virginia Woolf supposed, he cared much about their "good opinion." However, it is clear that from the time of his first encounters with members of this social circle until his death, he sustained a real ambivalence toward its members. While he was at the Slade, he wrote to William Rothenstein, his benefactor, about his "nice friends among the upper class."[60] But for the most part his letters reflect a real discomfort in the company of such people. In a letter dated June 1913 to the Hon. Dorothy Brett, he described a visit to the theater: "Evening dress! I felt so awkward! Everybody in the theatre looked at me. I felt ashamed. I feel so uncomfortable in evening dress, especially as my friend wore a monocle! My face looks so dirty in comparison with those well-washed gentry. I must use that hard sponge again that I bought."[61] On one occasion he wrote to Carring-

[56] Letter to Lytton Strachey dated September 22, 1918, quoted in *Letters of Leonard Woolf*, ed. Frederic Spotts (New York: Harcourt Brace Jovanovich, 1989), 279.

[57] Quoted in *The Diary of Virginia Woolf*, vol. 2, *1920–1924*, ed. Anne Olivier Bell (New York: Harcourt Brace Jovanovich, 1978), 149, 195. Nobody else ever seems to describe Gertler as fat. In fact, on this occasion he had just left a sanatorium, where he had spent six months (November 1920 to May 1921) with tuberculosis.

[58] Ibid., 158.

[59] Quoted in *The Diary of Virginia Woolf*, vol. 5, *1936–41*, ed. Anne Olivier Bell (New York: Harcourt Brace Jovanovich, 1984), 221.

[60] Quoted in Woodeson, *Mark Gertler*, 49.

[61] Quoted in Carrington, ed., *Mark Gertler: Selected Letters*, 54.

ton: "You are the *Lady* and I am the East End boy."[62] A year later (December 1913), he told her: "I feel that I should like to excite all the working classes to, one night, break into these theatres and *destroy* all those rich *pleasure seekers*."[63] At other times, though, he asserted that it was unfortunate to be born of the lower class, and that "a modern artist must have an income."[64] Throughout these agonized reflections he remained on the fringes of the Bloomsbury group, retaining close friendships with a number of upper-middle-class members of that wider circle: the Morrells, John Middleton Murry and Katharine Mansfield, D. H. Lawrence, and Eddie Marsh. His ambivalence about "upper class friends" was played out very explicitly in his reflections on art and aesthetics. The following passage from a letter to Carrington, written after his visit to the 1912 Post-Impressionist exhibition, is, I think, very telling:

> I remembered my childhood in Austria. The great *poverty*. No bread and my poor striving mother—my father was in America at the time. Then I remembered my school days in London with my little urchin friends. They now sell newspapers at the Mansion House. Then came my Polytechnic days. Then I worked in a designing firm for *a year*! which nearly broke my heart. Then the Slade and that awful ghost Tonks,[65] and here I am now an artist—supposed to be—yes, I thought to myself, "Be a tailor, anything, my dear boy," but not an artist. By this time the room was in gloom and my pictures all looked like mocking spectres that were there to laugh at me. I could stand it no longer. So I went out and saw more unfortunate artists. I looked at them talking art, Ancient art, Modern art, Impressionism, Post-Impressionism, Neo-Impressionism, Cubists, Spottists, Futurists, Cave-dwelling, Wyndham Lewis, Duncan Grant, Etchells, Roger Fry! I looked on and laughed to myself saying "Give me the *Baker*, the *Baker*," and I walked home disgusted with them *all*, was glad to find my dear simple mother waiting for me with a nice roll, that she knows I like, and a cup of hot coffee. Dear mother, the same mother of all my life, *twenty years*. You, dear mother, I thought, are the only *modern artist*.[66]

[62] Ibid., 47.
[63] Ibid., 60.
[64] Ibid., 56.
[65] A drawing teacher at the Slade.
[66] Quoted in Carrington, ed., *Mark Gertler: Selected Letters*, 47.

After his visit to Paris in 1920, he again wrote to Carrington: "Yesterday I saw [John Middleton] Murry. We talked of my Paris trip and of Cézanne and Renoir. I told him *my* way of understanding these great men and how terribly misled one has been all along by the 'wizards' and intellectuals' ' interpretations of them. I mean Roger Fry & Co."[67] Paradoxically, at the same time as he was rejecting the rhetoric and critical evaluation of the "new" expressed by Fry and his colleagues, Gertler was—for a brief period dating from around 1912 to 1916—producing more "modern" works than any by Vanessa Bell or Duncan Grant.

If 1912 proved a significant year for Gertler—he finished his studies at the Slade and finally moved out of his parents' home—his decision in 1915 to leave the East End and move into a studio in Hampstead was to have greater consequences for his work. Now detached from his roots in the family and the community, he became closely associated with the artistic and intellectual life of the Carline circle, which met at the home of the brothers Sydney and Richard and their sister Hilda Carline, all of whom were artists. Other artists included Stanley Spencer, Paul Nash, Henry Lamb, Charles Ginner, C. R. W. Nevinson, and William Roberts.[68] Many of these artists had, like Gertler, trained at the Slade, including all three Carlines, and represented a wide range of attitudes to contemporary European developments in art, from resistance to Cézanne to interest in Kandinsky and abstraction.[69] Removed from the orthodoxies of Bloomsbury, this informal group nevertheless provided Gertler with a cultural environment remote from his class and ethic background. In addition, unlike most of the other members of the Carline circle, through Carrington, Ottoline Morrell, and even Fry he retained some connection with the Bloomsbury group.

Mark Gertler and Jewish Identity

"I shall be neither Jew nor Christian," Gertler had announced upon leaving the East End of London. Virginia Woolf's comment (quoted above) suggests that in the view of others he didn't have much choice

[67] Ibid., 180.
[68] See Keith Bell, *Stanley Spencer* (London: Phaidon, 1992), 47.
[69] Ibid.

about this. D. H. Lawrence, on seeing Gertler's *Merry-Go-Round*, wrote to him: "It is the best *modern* picture I have seen. . . . It would take a Jew to paint this picture."[70] Charles Spencer has said that Gertler's work—"some of the finest paintings in Britain this century"—"could only have derived from a uniquely Jewish experience."[71] Charles Harrison claims that "Gertler's Polish-Jewish origins account to a considerable extent for the distinctiveness of the mood established in his works."[72] Apart from the fact that some of Gertler's early paintings took as their subject matter scenes from the lives of East End Jews, what could these statements mean? To understand this, one needs to consider the situation of Jews in England in the early twentieth century, as well as the persistent assumptions about the links between Jews and modernism, assumptions which have sometimes exposed the antisemitism behind antimodernism.

As social historians of the period have pointed out, the decades around the turn of the century saw the production of a notion of "Englishness"—a definition which necessarily involved discursive practices which produced certain others as non-English.[73] This construction of the idea of Englishness had real implications for immigrants, particularly Jews from eastern Europe. As David Feldman has shown, the Aliens Act of 1905, which was specifically intended to reduce the level of Jewish immigration, should be seen not only as a legal and political measure but also as "symptomatic of a new formulation of the idea of the nation."[74] Anti-alien opinion deployed the vocabulary of "home" and "nation" in objecting to the "invasion" of such foreigners. It is important to recall, however, that the previously established Jewish community was equally worried about uncontrolled immigration, and that its organizations were involved in the repatriation of many Jews back to eastern Europe.[75] For those Jews attempting to achieve an assimilated status in British society, the influx of poor, less well educated, "foreign" Jews into the country threat-

[70] Letter to Mark Gertler dated October 9, 1916, rpt. in *Mark Gertler: Paintings and Drawings* (exh. cat.) (Camden, Eng.: Camden Arts Center, 1922), 40.

[71] Spencer, "Anglo-Jewish Artists," 34.

[72] Harrison, *English Art and Modernism*, 152.

[73] See the essays in *Englishness: Politics and Culture, 1880–1920*, ed. Robert Colls and Philip Dodd (London: Croom Helm, 1986).

[74] David Feldman, "The Importance of Being English: Jewish Immigration and the Decay of Liberal England," in *Metropolis-London: Histories and Representations Since 1800*, ed. David Feldman and Gareth S. Jones (London: Routledge, 1989), 57–58.

[75] Feldman, "Importance of Being English," 63.

ened to destabilize their position. Juliet Steyn has explored these tensions in connection with the organization of the 1906 Whitechapel Art Gallery exhibition "Jewish Art and Antiquities," in which the "Jewishness" portrayed and described was a western European tradition—predominantly Dutch, German, or Sephardic—that ignored the Ashkanazi tradition of eastern Europe.[76] She, too, records the ambivalence of relatively assimilated Jews to the new immigrants—for example, in evidence given to the Royal Commission on Alien Immigration (whose work culminated in the 1905 Act) by Jews who stressed the importance of assimilation for these people. (It is tempting to read Gertler's relationship to Bloomsbury in these terms—Leonard Woolf, the educated, assimilated Jew resisting the threat of a more foreign, un-English Jewishness in Gertler.) What is clear from these debates is the marginalization and occasional demonization of the east European Jew in the early decades of the twentieth century in relation to the definition of what was "English."

It is within this context that one can make sense of some of the otherwise strange connections made between modernism and Jewishness. The view that there was a particularly strong relationship between Jews and modernism was pervasive. (It was still evident in 1951 when Herbert Read, writing about the work of Jacob Epstein, claimed that as early as 1914 he had concluded that Expressionism "was the characteristic style of the Jews.")[77] With regard to Jewish artists in New York in the same period, Milton Brown offers the following explanation for the tendency of immigrant artists to turn to the avant-garde:

> It was only toward the turn of the century that Jewish artists began to surface, and they were all East European in origin: Maurice Sterne, Max Weber, Abraham Walkowitz, Samuel Halpert, William Zorach and Leon Kroll. It seems nearly impossible, when one's origins are in the urbanized ghetto or the *shtetl* of Eastern Europe, to make the quantum leap to cosmopolitan art, as these men did. This phenomenon is more understandable when we acknowledge that many of these immigrants, especially the younger ones, and certainly the intellectuals, were not domi-

[76] Juliet Steyn, "The Complexities of Assimilation in the 1906 Whitechapel Art Gallery Exhibition 'Jewish Art and Antiquities'," *Oxford Art Journal* 13, no. 2 (1990): 44–50.
[77] Quoted by Spencer, "Anglo-Jewish Artists," 28.

nated by the *shtetl* or conservative mentality, but had already been eman-
cipated; touched by European enlightenment, they had become secular-
ized and radicalized. The migration might have been daunting, but a
new world and a new age beckoned, and they seemed somehow to have
been prepared for the challenge.[78]

However, he goes on to say that one cannot identify a specifically
"Jewish art," a point reinforced by Avram Kampf, who traces the
wide range of styles employed by Jewish artists in the early twentieth
century.[79] Given the actual diversity of the art practices of Jewish
artists (as well as the fact that many avant-garde painters were *not*
Jews), where does the equation of Jews with modernism come from?

Juliet Steyn's careful reading of the reception of the 1914 exhibition
"Twentieth Century Art" held at the Whitechapel Art Gallery exposes
the ideological (and antisemitic) bases of this assumption.[80] This exhi-
bition, which included a separate room devoted to the work of Jewish
artists curated by David Bomberg, displayed nearly five hundred
works by British artists. Although, according to Steyn, at most thir-
teen of these works could be described as Cubist or Futurist, the show
was perceived by many critics as an aggressively modern exhibition.
The reviewers, moreover, were overwhelmingly hostile to modernism
and to the "foreign" influences on English art. They tended to identify
the Jewish artists' work as Cubist or Futurist, though only one of the
artists (David Bomberg) could be described this way. (Mark Gertler
was one of the fifteen Jewish artists included in this section of the ex-
hibition.) One reviewer, decrying the new tendency in Duncan
Grant's work, called it "cabalistic." In a familiar dismissal of modern
art *The Daily Telegraph* review said of the Jewish section: "The small
room contains a good collection from the brushes of Jewish painters.
There are also a great many subjects that will appeal to children."[81] In

[78] Milton W. Brown, "An Explosion of Creativity: Jews and American Art in the
Twentieth Century," in *Painting a Place in America: Jewish Artists in New York,
1900–1945*, ed. Norman L. Kleeblatt and Susan Chevlowe (New York: Jewish Mu-
seum, 1991), 25.

[79] Avram Kampf, *Chagall to Kitaj: Jewish Experience in 20th Century Art* (London:
Barbican Art Gallery, 1990).

[80] Juliet Steyn, "Inside-Out: Assumptions of 'English' Modernism in the
Whitechapel Art Gallery, London, 1914," in *Art Apart: Art Institutions and Ideology
Across England and North America*, ed. Marcia Pointon (Manchester: Manchester Uni-
versity Press, 1994), 212–30.

[81] Quoted in Steyn, "Inside-Out," 225.

general, the reaction to modernism was hostile, and in that reaction there was a persistent assumption that modernism and Jewishness were equated or at least intimately related. As Steyn demonstrates, this equation had its origins in the ideological commitment to expel the "foreign" in all its forms from the conception of the ideal (however historically recent) of Englishness and of English art.

As Peter Gay has pointed out with regard to Jews in Germany, there is no particular reason why English Jews should be modernists.[82] However, if one accepts Fredric Jameson's argument (in his discussion of Wyndham Lewis) about the sociology of modernism —that social displacement and marginality enables the more radical vision of an avant-garde aesthetic and a radical (in Lewis's case, right-wing) politics—then this also applies to the work of Jewish artists from immigrant backgrounds, like Bomberg and Gertler. It is not so much their *Jewishness* as their consequent social (and class) placement which is relevant. Now it becomes possible to understand, on the one hand, the ultimately conservative tendencies of the "modernism" of members of the Bloomsbury Group, securely embedded as they were in the upper middle class and in a position of social power; and, on the other hand, the more innovative practices of those who, like Gertler, were marginalized by virtue of class, education, and ethnicity. It also permits one to see a little more clearly why Gertler's ambivalence about the upper classes, his continuing, albeit conflicted, relationship with its members, and his abandonment of his own heritage produced a crisis, personal as well as artistic, which can be read in his work after 1916.

Gertler, who was excluded from the Bloomsbury circle and its satellites as much by his own intermittent hostility to its lifestyle as by its own systems of closure, nevertheless spent much of his life in its orbit. His artistic career can be viewed—and thus far has been seen, as with most artists whose lives end in suicide—as a purely personal narrative. Alternatively, it can be viewed as a textual history, related in terms of training, influence, style, and subject matter. I suggest that there is another, more sociological narrative which makes sense of his work, one involving class relations, ethnic identification, and visual representation in early-twentieth-century England.

[82] Peter Gay, *Freud, Jews and Other Germans: Masters and Victims in Modernist Culture* (Oxford: Oxford University Press, 1978), 101.

The "Jewish Mark" in English Painting

Cultural Identity and Modern Art

In her memoirs Lady Ottoline Morrell recalls visiting Mark Gertler's studio in 1914 and seeing his paintings: "In those early days there was still the Jewish tradition, the Jewish mark, which gave them a fine, intense, almost archaic quality."[1] The notion that some Jewish quality could be detected in a work was quite widespread in England in the early twentieth century and could also be found among Jewish writers on art. In this chapter I explore the question of "Jewishness" in art in relation to debates about the construction of "Englishness" in the same period. As several scholars have recently shown, "Englishness" is defined negatively in relation to its exclusions.[2] Social historians have demonstrated the centrality of Jews and Jewish identity in the production of this national ideology in the period before the First World War, suggesting that to be English was, among other things, to be "not Jewish." My intention is to examine the manifestation of this discursive strategy in the visual arts, in particular in the texts of art criticism. For the most part, discussion of the construction of "Englishness" has been restricted to the disciplines of history and literary criticism; the "Englishness" of visual art is only now being taken as a topic of analysis (though it has a kind of prehistory in Nikolaus Pevs-

[1] Robert Gathorne-Hardy, ed., *Ottoline: The Early Memoirs of Lady Ottoline Morrell* (London: Faber and Faber, 1963), 253. Thanks to Ben Harvey for bringing this text to my attention.
[2] See, e.g., Philip Dodd, "Englishness and the National Culture," in *Englishness: Politics and Culture, 1880–1920*, ed. Robert Colls and Philip Dodd (London: Croom Helm, 1986), 1–28.

ner's 1955 Reith Lectures and book published the following year.)[3]
Here I consider examples of the work of certain Jewish artists (Mark
Gertler, Jacob Kramer, Jacob Epstein, and David Bomberg) in the pe-
riod 1910–1920, as well as the critical response to their work, in order
to assess how much the "Englishness" of modern art was dependent
on the identification—and exclusion—of "non-English" ("Jewish")
visual style. I suggest that although it is important to understand this
attribution as ideologically and discursively produced, there is also a
sense in which one may still want to consider the relevance of ethnic-
ity in relation to these works, in terms of their subject matter, style,
and social conditions of production.

The premise of Robert Colls and Philip Dodd's seminal book on
Englishness is that the period 1880–1920 was a crucial one in the for-
mation of a new and important conception of "Englishness," one
which redefined the nation and its cultural attributes in specific ways
which have had implications for twentieth-century Britain and up to
the present moment.[4] Starting from the acknowledgment that there is
no fixed meaning of "Englishness" but rather that "Englishness has
had to be made and re-made in and through history, within available
practices and relationships, and existing symbols and ideas,"[5] they
focus on this crucial forty-year period at the turn of the nineteenth
century in order to examine the radical transformation of the concep-
tion of national identity associated with modernity, industrialization,
and related changes in social and political relations (mainly domestic
relations of class and gender and, to a lesser extent, international rela-
tions of colonialism).[6] Contributors to the volume explore aspects of
politics, literature, music, the Irish, and the discovery of rural England
in relation to the central theme. As early as 1978 the relevance of liter-
ature to the formation of a national identity at this particular histori-
cal moment was made clear in an important article by Tony Davies, in
which he demonstrated the interconnectedness in late-nineteenth-
century England of literary criticism, literary ideology, a particular

3 Nikolaus Pevsner, *The Englishness of English Art*, 2d ed. (London: Penguin, 1993).
4 Colls and Dodd, eds., *Englishness*.
5 Ibid., "Preface," *Englishness*, n.p.
6 Bill Schwarz, in an otherwise sympathetic review, has faulted the book for its in-
adequate attention to this dimension, arguing that the "modern symbolic unities of
England can make no historical sense unless the imperial determinations are
painstakingly reconstructed"; see his "Englishness and the Paradox of Modernity,"
New Formations 1 (1987): 149.

definition of English literature, and a national language known as "standard English."[7] Davies reads this composite set of standardization practices as ideological responses to, and the imaginary resolution of, the social divisions of class and gender that were created and exacerbated by the progress of industrial capitalism in England in that period. Thus, standard English—and English literature—operated as ideological constructs which produced unity in the face of division and, of course, potential antagonism. The identification of a specific moment in the history of "Englishness," however, does not imply uniqueness. Another major collection of essays dating from the late 1980s addresses "the making and unmaking of British national identity" across three centuries, tracking the changing meaning of the term in different circumstances.[8] The editor, Raphael Samuel, pays particular attention to Britain in the interwar years and in the period after the Second World War, moving forward to his central concern (and the motivating factor behind the publication of the three-volume collection), namely, the currency of new conceptions of "Englishness" and "Britishness" during the Thatcher administration. Contributions also cover the seventeenth, eighteenth, and nineteenth centuries, collectively establishing the fact that, as one reviewer put it, "since the eighteenth century the terrain of Englishness has been continually redefined."[9] In the context of this acknowledgment of the always contingent nature of Englishness, I focus (like Colls and Dodd) on the critical period at the turn of the century in which the contemporary national ideology was first articulated.

It is interesting, in fact, that the *content* of the ideology of Englishness is not often specified. Davies stresses the emphasis on unity (as against class and other divisions). Samuel and others describe the interwar version of the ideology known as "Little Englandism," whose key features included the English countryside, the rise of gardening, rural and small-town life, the charisma of authority, and an active

[7] Tony Davies, "Education, Ideology and Literature" [1978], in *Culture, Ideology and Social Process*, ed. Tony Bennett et al. (London: Open University Press, 1981), 251–60.

[8] See Raphael Samuel, ed., *Patriotism: The Making and Unmaking of British National Identity*, 3 vols. (London: Routledge, 1989).

[9] Stephen Daniels, "Envisioning England," *Journal of Historical Geography* 17, no. 1 (1991): 98. Actually, Daniels here means "terrain" rather literally, referring to the physical coordinates of "Englishness" at different moments—the village, the monument, parkland, the factory town—but makes clear throughout that this is only one aspect of the changing meaning of "Englishness" across time.

xenophobia directed at Europeans and Americans alike.[10] David Lowenthal traces English xenophobia back to the thirteenth century and its modern form to eighteenth-century anti-French sentiment.[11] Philip Dodd, discussing late-nineteenth-century English culture, considers the centrality of a particular conception of masculinity in that formation.[12] Apart from such abbreviated descriptions, "Englishness" is usually distinguished less by its inherent characteristics than by its *exclusions*. Two groups in particular are considered by Dodd, each marginalized by, and at the same time invited to participate in, the national culture: the working class and the Celts (Irish, Scots, Welsh). Their colonization is necessarily founded on an initial positioning of members of those groups as "other" to the dominant culture. This feature, namely, the discursive construction of a collective identity by processes of exclusion, is absolutely central to the case of the construction of Englishness. As Dodd says, "the definition of the English is inseparable from that of the non-English; Englishness is not so much a category as a relationship."[13] Samuel puts it thus: "Ideas of national character have typically been formed by processes of exclusion, where what it is to be British is defined in relations of opposition to enemies both without and within."[14] In the period under discussion, the excluded Other par excellence is the Jew.[15]

The 1905 Aliens Act was specifically designed to reduce the level of Jewish immigration. It was the first piece of legislation in nearly a century to limit free entry into the country. The impact of enormous numbers of Jewish immigrants from eastern Europe to Britain between 1880 and 1914 has been well documented by David Feldman and other social historians of the period, as have the complex and conflicted responses of the more assimilated Jews already living in

[10] Raphael Samuel, "Introduction: Exciting to Be English," in Samuel, ed., *Patriotism*, vol. 1, xxii–xxviii.

[11] Its persistence could be noted at the end of the twentieth century. As preparations for the World Cup soccer tournament were finalized in France, British tabloids referred to "France's slimy Continental ways," and carried headlines like "Frogs Need a Good Kicking." *New York Times*, June 3, 1998.

[12] Dodd, "Englishness and the National Culture."

[13] Ibid., 12.

[14] Raphael Samuel, "Introduction: The 'Little Platoons,'" in Samuel, ed., *Patriotism*, vol. 2, xviii.

[15] Discussing the fiction of the 1930s writer Mary Butts, Patrick Wright argues that here "the Jew is actively given a meaning which is culturally *necessary* to the valued England which he contaminates." *On Living in an Old Country: The National Past in Contemporary Britain* (London: Verso, 1985), 122.

London and other major cities.[16] Economic and other fears fueled the hostile reaction to this influx, which manifested itself in growing demands for immigration controls and, in some cases, repatriation. Among Jews themselves, the additional fear was that the more visible, less "respectable" Jews from villages and small towns in eastern Europe would threaten their own status as assimilated English people. Accordingly, Jewish organizations were actively involved in programs of Anglicization for the newcomers, as well as in schemes for repatriation. The "alienness" of the immigrants was all too apparent, and was a primary cause of the widespread and growing anti-alien agitation which led to the 1905 act. Feldman has asked, "In what sense and to what extent was it possible for Jews and Jewish immigrants to become English in the late Victorian and Edwardian years?"[17] His careful historical research of the debates of the period suggests an answer: if not for the new immigration, Jews might not so easily have served as the "necessary other" in the construction of Englishness—might, indeed, have passed for English—but the definition of "Jew" underwent a radical shift as a result of the particular historical circumstances, providing the ideal alien for the production of Englishness.[18]

As with most such phenomena, the discursive construction of "Jewishness" and "Englishness" was not confined to political and legislative debate. Through a close reading of the texts of Arnold, Trollope, George Eliot, T. S. Eliot, Joyce, and others, literary scholar Bryan Cheyette has shown how English literature participated in the construction of "the Jew" in the late nineteenth and early twentieth centuries. In his nuanced reading, the figure of the Jew is never fixed,

[16] David Feldman, "The Importance of Being English: Jewish Immigration and the Decay of Liberal England," in *Metropolis-London: Histories and Representations since 1800*, ed. David Feldman and Gareth Stedman Jones (London: Routledge, 1989), 56. The following discussion of anti-alienism is greatly indebted to this essay as well as to Feldman's book *Englishmen and Jews: Social Relations and Political Culture, 1840–1914* (New Haven: Yale University Press, 1994) and to his essay "Jews in London, 1880–1914," in Samuel, ed., *Patriotism*, vol. 2, 207–29

[17] Feldman, "Jews in London," 207.

[18] My discussion (and Feldman's) of this production of the non-English Other is obviously at the level of social history and in terms of discourses and social institutions. For a fascinating exploration of the same issues in psychoanalytic terms, see James Donald, "How English Is It? Popular Literature and National Culture," in *Space and Place: Theories of Identity and Location*, ed. Erica Carter, James Donald and Judith Squires (London: Lawrence & Wishart, 1993), 165–86.

manifesting what he calls a "protean instabililily" as a signifier.[19] This means that the relationship between "Englishness" and "Jewishness" is constantly in flux, alternating between inclusion and exclusion. Like Feldman, Cheyette is clear that in the period before and after the First World War the project of inclusion was secondary to that of exclusion. G. K. Chesterton, for example, "increasingly constructed 'the Jew' as the opposite of both a familial Englishness and a homogeneous European Christendom."[20] David Glover has discussed Joseph Conrad's *Secret Agent* in relation to British anti-alienism and the Aliens Act, seeing it as a text which both responds to and participates in the discourses on racialized identities (though in this case not explicitly with reference to Jews).[21] The literary representation of the Jew has its own prehistory, paralleling the history of the discourse of the Jew in general,[22] but my interest here is in its specific articulation in the early decades of this century. In an anthology of contemporary texts on "Englishness" in the period from 1900 to 1950—literature, political speeches, diaries, journalism—the editors have illuminated, in the very arrangement of the book, the complex ways in which a variety of discourses intersect (and often compete) in the cultural construction of a strategic category. They, too, stress the changing nature of the category of "Englishness" but focus on its regular dependence on discourses of exclusivity. Particularly suggestive is the inclusion in the list they provide of media and social practices through which this ideology is produced of one which has to date been little addressed: namely visual representations.[23] It is this aspect that I am pursuing in this chapter, in order to come back to Lady Ottoline's comment and to the question of what it might mean to talk about the "Jewishness" of

[19] Bryan Cheyette, *Constructions of "the Jew" in English Literature and Society: Racial Representations, 1875–1945* (Cambridge: Cambridge University Press, 1993), 8.

[20] Cheyette, *Constructions of "the Jew"*, 204.

[21] David Glover, "Aliens, Anarchists and Detectives: Legislating the Immigrant Body," *New Formations* 32 (1997): 22–33. Indeed, Glover points out the irony of Conrad's focus on Italians rather than Jews as figuring in the "phobic imaginary" of the anti-alien movement (30).

[22] See, for example, Mary Janell Metzger, "'Now by my hood, a gentle and no Jew': Jessica, *The Merchant of Venice*, and the discourse of early modern English identity," *Publications of the Modern Language Association of America* 113, no. 1 (1998): 52–63; and James Shapiro, *Shakespeare and the Jews* (New York: Columbia University Press, 1996).

[23] Judy Giles and Tim Middleton, introduction to *Writing Englishness, 1900–1950: An Introductory Sourcebook on National Identity*, ed. Judy Giles and Tim Middleton (London: Routledge, 1995), 6.

visual art. I am interested less in the question of the representation *of* Jews in art than in the art-critical discourse about Jewish artists and their work (whether or not the subject matter is the life and representation of Jews). It is not that the representation of Jews in this period is not of critical importance in relation to my main theme here—the Jew as non-English Other. Indeed, Kathleen Adler's interesting study of Sargent's portraits of the Wertheimer family provides clear evidence to the contrary.[24] But the "Jewish mark" is the presumed sign of work by Jews and is not to be found or sought in a painting by Sargent or any other non-Jewish artist. My focus is the narrower one of Jewish artists of the period and their work.

How is "Englishness" manifest in the discourse(s) of the visual? Until recently, the starting point for anyone attempting to address the question has been Pevsner's 1955 study,[25] which famously (or perhaps notoriously) identified both characteristics and cause. For him the essential characteristics of English art are naturalism, detachment, conservatism, linearity, the perpendicular and "longness" in portraits (the contrast being, implicitly where not explicitly, not only the French and the European in general but also the "other," Celtic, domestic aesthetic).[26] For Pevsner the explanation of these characteristics is to be found in climate and language. Twenty years after Pevsner, the analytic framework had not changed all that much. For example, in his introduction to a 1975 volume on the history of British painting, David Piper states: "Any account of the Englishness of English art must begin with geography, with the obvious fact that Britain is an island." He, too, stresses the linear rather than painterly qualities of English art, explaining these in terms of climate:

> The English climate, even when seeming crystal-clear to the natives, appears slightly hazy to those coming from, say, Italy. Mediterranean light has an extraordinary faculty of seeming to order, in the onlooker's eye, its component elements into interrelationships that have a visual logic, and inevitability, that is rarely glimpsed in England. And when Conti-

[24] Kathleen Adler, "John Singer Sargent's Portraits of the Wertheimer Family," in *The Jew in the Text: Modernity and the Construction of Identity*, ed. Linda Nochlin and Tamar Garb (London: Thames and Hudson, 1995), 83–96.

[25] Pevsner, *The Englishness of English Art*.

[26] See William Vaughan, "The Englishness of British Art," *Oxford Art Journal* 13, no. 2 (1990): 22–23.

nental originals in art, imported into Britain, are copied, or used as source for inspiration, their painterly and monumental qualities tend to be transposed into linear values.[27]

With regard to the lack of large-scale painting in England, he adds: "The English climate is here again partly to blame, for the island's persistent damp is noxious to large-scale painting, whether fresco or stretched on vast canvases."[28] As John Barrell has pointed out, the focus on climate in discussions of the peculiarities of English art pre-dated Pevsner by more than 150 years and can be traced back to the work of John Ruskin.[29] But since the mid-nineteenth century, the continuing interest in cause has been accompanied by a new definition of content, as the concept of "Englishness" itself has undergone transformation. One should, of course, expect to find the fluidity of political conceptions of national identity matched by equally mobile definitions of the "Englishness" of art since, as Philip Dodd points out, "The Englishness of English art . . . is not a 'given,' does not have a settled and continuous identity, but has been constituted and reconstituted at various historical moments—for very different purposes."[30] For roughly the past hundred years, however, the "Englishness" of art has been seen to consist in its landscape painting, its representation of a particular type of rural scene, and its essentially southern English character.[31] This particular visual imaginary has its grounding in the urban realities which initially produced it, as well as in the particular anxieties associated with the progress of modernity at the turn of the

[27] David Piper, *The Genius of British Painting* (London: Weidenfeld and Nicolson, 1975), 8.

[28] Piper, *The Genius of British Painting*, 9.

[29] John Barrell, "Sir Joshua Reynolds and the Englishness of English Art," in *Nation and Narration*, ed. Homi K. Bhabha (London: Routledge, 1990), 154–76. Barrell's argument is that for a brief period in the late eighteenth century there flourished (particularly in the writings of Sir Joshua Reynolds) a "discourse of custom," which focused on the local and ornamental, as opposed to the dominant discourse of civic humanism, whose focus was the universal. His suggestion is that the discourse of custom, which ultimately failed to establish itself in the Academy, might have opened the way for very different theories of art and culture in the nineteenth century.

[30] Philip Dodd, "An Open Letter from Philip Dodd: Art, History and Englishness," *Modern Painters* 1, no. 4 (1988–89): 41.

[31] For a detailed discussion of this visual ideology, see the following: Vaughan, "The Englishness of British Art," and his "Constable's Englishness," *Oxford Art Journal* 19, no. 2 (1996): 17–27; Tim Barringer, "Landscapes of Association," *Art History* 16, no. 4 (1993): 668–72; and David Lowenthal, "British National Identity and the English Landscape," *Rural History* 2, no. 2 (1991): 205–30.

century.[32] The work of "new historians" of art who read English landscape painting critically has met with fierce resistance by those for whom art—and, not coincidentally, this supremely "English" genre of art—transcends politics and ideology.[33] For the past decade the parameters in which one must understand the "Englishness" of English art have been mapped out in terms of an ideology of the rural scene, a visual ideology very much in accord with its equivalents in literature and political discourse.

As in other discourses of "Englishness," the discourse on visuality is entirely dependent on that process of exclusion which allows the national to emerge as a positive moment.[34] The discursive Other may be the French, the Celts, or the northern English. In the early twentieth century it was paradigmatically, as in literary and other fields, the Jew. The placing of Jews in art-critical discourse and in institutional practice manifests a combination of the hostile (antisemitic) and the benign. In both cases the apparently unquestioned identification of Jewish art and Jewish artists as separate and different from the main currents of English and British art is striking. This separation is justified either in terms of style or in terms of theme and subject matter. It is difficult to read—and read about—these cultural practices in the early twenty-first century without the unease which is founded in suspicion of antisemitism in the very identification of difference. However, it is important to recall that Jews as much as non-Jews colluded in this belief in ethnicity as a foundation for art-making. The effect of these discursive practices, as I hope I have shown with regard

[32] Barringer, in particular, makes this argument in "Landscapes of Association." It has its correlate in T. J. Clark's essay on the Impressionists' displacement of urban experience onto representations of apparently rural scenes which are, in fact, images of the suburbs whose traces of the city, though energetically marginalized, appear in attenuated form. See "The Environs of Paris" in his *Painting of Modern Life: Paris in the Art of Manet and His Followers* (New York: Knopf, 1985), 147–204.

[33] An early and famous example of this was Lawrence Gowing's response to John Berger's interpretation of a painting by Gainsborough; see the latter's *Ways of Seeing* (Harmondsworth: Penguin, 1992), 106. A decade later the critical response to David Solkin's reading of the landscapes of Richard Wilson replayed this ideological battle; see his *Richard Wilson: The Landscape of Reaction* (London: Tate Gallery, 1982). For the critical debate, see Neil McWilliam and Alex Potts, "The Landscape of Reaction: Richard Wilson (1713?–1782) and His Critics," *History Workshop Journal* 16 (1983): 171–75.

[34] "The definition of the Englishness of English art is always attended . . . by the definition of what was seen to be 'unenglish' and alien." Dodd, "An Open Letter from Philip Dodd," 40.

to the more general case of constructions of national identity, was to participate in the construction and maintenance of a conception of "Englishness" in the visual field. Three examples of Jewish participation in—or at least acceptance of—such practices come to mind. The first is David Bomberg's willingness to curate a special room devoted to the work of Jewish artists at the 1914 exhibition held at the Whitechapel Art Gallery in London.[35] The second is Mark Gertler's apparent acceptance of D. H. Lawrence's admiring statement ("It would take a Jew to paint this picture") about his 1916 painting *The Merry-Go-Round*.[36] The third is *The Jewish Chronicle*'s description of Jacob Epstein's sculpture as "entirely Hebraic,"[37] a characterization which is particularly problematic given the tendency, recorded by Elizabeth Barker, for non-Jewish critics at the time to employ precisely this strategy in the service of a clearly antisemitic ideology.[38] (It is worth noting that such unself-conscious reference to the "Jewishness" of art was still possible in the mid-1980s; in an exhibition catalogue on twentieth-century British art, Frederick Gore wrote: "Mark Gertler's early work is closely related to his family and has an emotional power associated with the striving of a Jewish émigré community to achieve modest prosperity.")[39]

My own interest here is in those texts which position the Jewish artist (and his work) as Other as part of the project of (negatively) producing an English identity. The other side of this, though, is the (positive) "quest for Jewish style," as it is referred to by Avram

[35] See Juliet Steyn, "Inside-Out: Assumptions of 'English' Modernism in the Whitechapel Art Gallery, London, 1914," in *Art Apart: Art Institutions and Ideology Across England and North America*, ed. Marcia Pointon (Manchester: Manchester University Press, 1994), 212–30.

[36] Letter to Gertler dated October 9, 1916; rpt. in *Mark Gertler: Paintings and Drawings* (exh. cat) (London: Camden Arts Center, 1992), 11. I have not come across any objection to the letter in Gertler's published correspondence and other commentary on his work and life. See my discussion in chapter 5.

[37] S. D., "Jacob Epstein's Sculptures: Some Impressions of a Layman," *Jewish Chronicle*, April 27, 1917.

[38] Elizabeth Barker, "The Primitive Within: The Question of Race in Epstein's Career, 1917–1929," in *Jacob Epstein: Sculpture and Drawings*, ed. Evelyn Silber (London: W. S. Maney and Son/Henry Moore Centre for the Study of Sculpture, 1989), 44–48. This served as the catalogue for a 1987 exhibition held at the Leeds City Art Galleries and the Whitechapel Art Gallery, London.

[39] Frederick Gore, "The Resilient Figure: Mark Gertler and Matthew Smith," in *British Art in the 20th Century: The Modern Movement*, ed. Susan Compton (London: Royal Academy of Arts, 1986), 172.

Kampf.[40] The context of Kampf's essay is the 1990 exhibition at the Barbican Art Gallery on the theme "Chagall to Kitaj: Jewish Experience in 20th Century Art." His discussion of the question of Jewish style (which serves as the introductory chapter to the catalogue) focuses on Russian writers in the nineteenth and early twentieth centuries, whose answer to the question shifted from a stress on aesthetic characteristics (for example, in the view of the nineteenth-century critic Vladimir Stassof it was the essential *realism* of Jewish art) to a focus on content, particularly the inclusion of Jewish folk themes in painting. Chagall, of course, epitomizes "Jewish" art of the latter type. An important 1919 essay on the theme cited by Kampf also considers the appearance of the Hebrew letter in art, as well as the preference by Jewish artists for "deep, dark tones" of gray and violet.[41] By the time of the Russian Revolution, the commitment to modernism and the avant-garde by Jewish artists as well as writers on Jewish art had displaced the earlier emphasis on realism. However, Kampf concludes that by 1922 the idea—and the possibility—of a national Jewish art had faded; in his long and comprehensive survey of Jewish art in other countries and later in the century, the notion of an essentially "Jewish" art does not recur. A study of the Soyer brothers—three immigrant Jewish American artists active in the interwar years—considers Irving Howe's suggestion that "some tonality of 'Jewishness'" inheres in a painting by Raphael Soyer and reviews the more general question of the "Jewishness" of the oeuvre of the brothers.[42] The authors' view is that one can only describe the work as Jewish in the particular sense that much of it contains themes related to Jewish life, including the complex representation of the artists' own ambivalence with regard to their heritage. I refer to these two essays, neither of which deals with British artists, because the idea of the "Jewish mark" is generally premised on some universal Jewish quality or qualities; that is, the ideology of "Jewishness" in English art is founded on a generic concept of Jewishness, so that the expectation is that what is "Hebraic"

[40] Avram Kampf, "The Quest for a Jewish Style," in his *Chagall to Kitaj: Jewish Experience in 20th Century Art* (London: Barbican Art Gallery/Lund Humphries, 1990), 15–43.

[41] Kampf, *Chagall to Kitaj*, 25. The authors of the essay he refers to are Issachar Ryback and Boris Aronson.

[42] Milly Heyd and Ezra Mendelsohn, "'Jewish' Art? The Case of the Soyer Brothers," *Jewish Art* 19–20 (1993–94): 196.

in New York, Russia, and London is more or less the same thing. Critical analysis soon deconstructs this ideology, however, insisting that one make particular, local inquiries into the supposed "Jewishness" of specific works. On that basis, I want to look a little more closely at the art-critical language employed in the case of Jewish artists in England in the 1910s.

The two major reasons for describing art as "Jewish" were its subject matter and its style; in the case of the latter, this was usually in terms of either a work's perceived "primitivism" or its formal characteristics (notably its identification as "modernist" and "foreign"). I think it is clear that the question of style, addressed in these terms, is highly problematic, and I will come back to examples of that discourse. The matter of content is both more straightforward and (at least ostensibly) less ideologically weighted. There is no question that many of the immigrant Jewish artists in England in the early twentieth century, or those whose parents were immigrants, though they themselves may have been born in Britain, took family life, and hence traditional Jewish themes, as their subject matter. Jacob Kramer (1892–1962) was born in the Ukraine and came to Britain at the age of eight. The family settled in Leeds, and Kramer was accepted as a student at the Slade School of Fine Art in London. Eventually he returned to work and teach in Leeds.[43] Much of his work, and not only in his early years, depicted Jewish life, including religious practices. One of his best-known paintings is *Day of Atonement* of 1919, now in the Leeds City Art Galleries (fig. 6.1). This image of men at prayer on the holiest day of the Jewish year achieves its striking effect by means of its simplicity and starkness of both form and color and its invocation of the rhythm of prayer in the repetition of the human figure. The work shows evidence of Kramer's involvement in modernist art practice in England, in particular the influence of Vorticism. Although, as we will see, some critics did equate modernism with Jewish art, the "Jewishness" of this particular painting clearly—and, I think, unproblematically—lies in its subject matter. The same can be said for most of Mark Gertler's (1891–1939) early work. Gertler was born in England of immigrant parents from eastern Europe. The family returned to Galicia after his birth and then settled in England when he was five.

[43] *The Immigrant Generations: Jewish Artists in Britain, 1900–1945* (New York: Jewish Museum, 1983), 60.

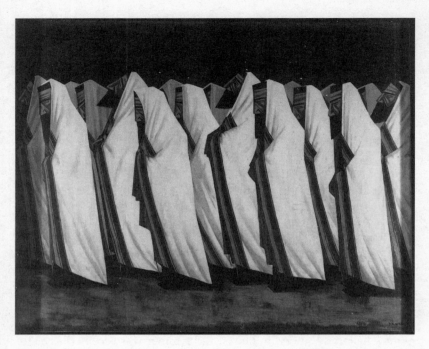

6.1 Jacob Kramer: *Day of Atonement*, 1919 (Leeds Museum and Galleries [City Art Gallery]; Michael R. Mitzman/The William Roberts Society; photograph: Photographic Survey, Courtauld Institute of Art)

Gertler grew up in the Jewish community in the East End of London. Like Kramer, he studied at the Slade. Although he later moved away from his family and abandoned his early interest in depicting traditional Jewish themes, his work in the period before the First World War was very much centered on those themes.[44] Lady Ottoline's comment about the "Jewish mark" in his painting was prompted—though in retrospect many years later—by a visit to his studio in 1914, at a time when she was might very well have seen works like *Jewish Family* of 1913 (fig. 6.2) and *The Rabbi and His Grandchild* of the same year (fig. 6.3).[45] One cannot be certain what she means by the "Jewish

[44] See chapter 5 for a discussion of Gertler's changing, conflicted relationship with his Jewish heritage and with the artists and intellectuals of the Bloomsbury group.

[45] She does not refer to these particular works, instead mentioning a work which she describes as "a fruit stall with pyramids of oranges and apples," and another depicting the birth of Eve, which is almost certainly *The Creation of Eve* of 1914, now in a private collection. Gathorne-Hardy, *Ottoline*, 253.

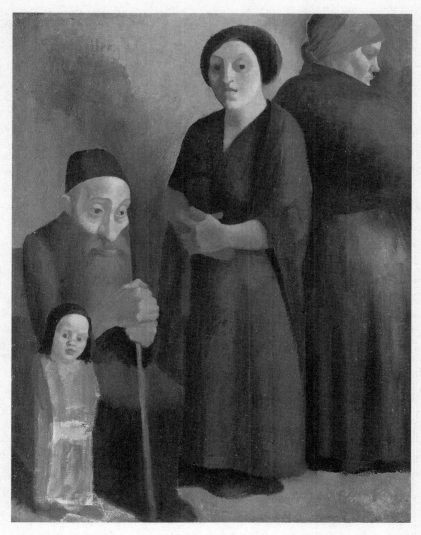

6.2 Mark Gertler: *Jewish Family*, 1913 (Tate Gallery, London/Art Resource, N.Y.)

mark," and her comment that this "gave them a fine, intense, almost archaic quality" does support the reading that she was talking about style as much as content. Nevertheless, his studio in 1914 would very likely have contained several paintings with subject matter drawn from Jewish life. It was only in the following year that he more or less abandoned these themes.

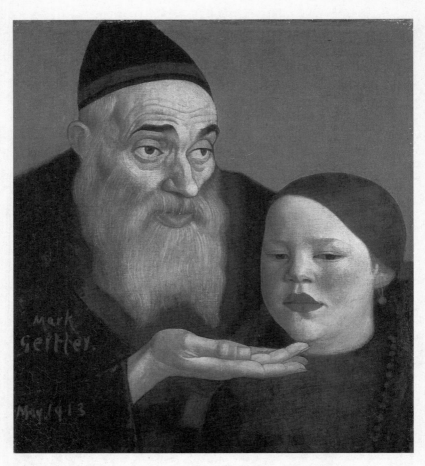

6.3 Mark Gertler: *The Rabbi and His Grandchild*, 1913 (Southampton City Art Gallery, Hampshire, U.K./Bridgeman Art Library)

D. H. Lawrence's remark ("It would take a Jew to paint this picture") about Gertler's work is more problematic. It appears in a long letter to Gertler and refers to his 1916 painting *The Merry-Go-Round* (now in the Tate Gallery), generally considered one of Gertler's most important works, and among the first *not* to deal with Jewish themes. The image, in Cubo-Futurist style, depicts a nightmarish scene of groups of people, including men in uniform, on a carousel, all open-mouthed in fear. The painting is a comment on the futility as well as the horror of war. What might Lawrence have meant in saying that

only a Jew could have painted this picture? His letter is highly complimentary. (His comments were based on seeing a reproduction of the work; as he writes from Cornwall: "Your terrible and dreadful picture has just come. . . . I'm not sure I wouldn't be too frightened to come and look at the original.")[46] He says that this is the best modern picture he has ever seen, and that it is "great, and true" as well as "horrible and terrifying" and even "obscene." He goes on to reflect on the likelihood that Gertler's outer life and human relationships must be superficial, while his "inner soul" must be a "violent maelstrom of destruction and horror," as he is "all absorbed in the violent and lurid process of inner decomposition." Then comes the comment about the Jew, which is followed, by way of explanation, by these sentences:

> It would need your national history to get you here, without disintegrating you first. You are of an older race than I, and in these ultimate processes, you are beyond me, older than I am. . . . At last your race is at an end—these pictures are its death-cry. And it will be left for the Jews to utter the final and great death-cry of this epoch: the Christians are not reduced sufficiently. . . . You are twenty-five, and have painted this picture—I tell you, it takes three thousand years to get where this picture is—and we Christians haven't got two thousand years behind us yet.[47]

Here one has a very different discourse—and, of course, a mystical, Lawrentian variant of it—which locates ethnicity in pseudohistorical, spiritual terms. Nor is it the kind of interpretation one can argue with, though it is easy enough to dismiss as entirely unanalytic (and potentially antisemitic). But its emphasis on the archaic qualities of "Jewishness"—here ostensibly presented in a positive way—is very similar to other characterizations of work by Jewish artists as "primitive." The most prominent example of this is the reception of the sculpture of Jacob Epstein (1880–1959), documented by Elizabeth Barker.[48] Epstein, who was born in the United States and spent his earliest years on the Lower East Side of New York City, later studying at the Art Students League, immigrated to Britain in 1905 and spent the rest of

[46] See n. 36. The fact that Gertler sent Lawrence a photograph of the work is confirmed by Gertler's biographer; see John Woodeson, *Mark Gertler: Biography of a Painter, 1891–1939* (Toronto: University of Toronto Press, 1973), 226.
[47] *Mark Gertler: Paintings and Drawings*, 40.
[48] Barker, "The Primitive Within."

his life in London. He was involved in the London Group and the Vorticist movement, contributing to Wyndham Lewis's periodical *Blast*. Epstein was a major innovator in sculpture and the first truly modernist sculptor in Britain. His work invariably met with hostility, first because of the "obscenity" of his nude figures and later because of the uncompromising antinaturalism of his work. As Barker shows, much of this hostility was directed at his ethnic identity. For example, a 1925 review of his work asserts that his primitivist style was the outcome of an "atavistic yearning of like for like." His name is omitted from a 1933 history of English sculpture on the grounds that "Epstein's ancestry and early environment go far to explain his art. This is essentially oriental. . . . Epstein is with us but not of us."[49] During a visit to Paris in 1912, Epstein was greatly influenced by the African and tribal art on display there, and thereafter he incorporated elements of that work into his own sculpture. The identification of "primitivism" in the work is not in itself remarkable, though the almost universal, highly vociferous dismissal of the work is quite noteworthy. More disturbing is the tone of the critical discourse, especially the racializing of this discourse, which, as Barker shows, increased after 1917. The primitivism of the work was consistently identified with the primitivism of the man and of his ethnic group. The response to his sculpture *Risen Christ* of 1917–19 (fig. 6.4), exhibited in 1920, is especially striking. This work was created as a private memorial to the First World War and was intended as an allegorical representation of suffering.[50] Barker suggests that behind its hostile reception was the view that Jews had no right to portray Christ:

> Whether hostile or supportive, critics shared the opinion that Epstein's
> *Christ* was the expression of an alien mentality and constituted a direct
> challenge to the moral and aesthetic values native to contemporary
> Christian art. Their reviews were based on a common set of terms, such
> as "archaic," "barbaric," "Oriental," "Egyptian," "aesthetic" and "revo-
> lutionary," signifying the otherness of Epstein's *Christ* and offering a
> counter-image to the gentle divinity of Christian convention. Sensation-

[49] Ibid., 44.
[50] For a discussion of the creation of this work and the critical response to it, see Evelyn Silber and Terry Friedman, "Epstein in the Public Eye," in *Jacob Epstein: Sculpture and Drawings*, 209–11.

6.4 Jacob Epstein: *Risen Christ*, 1917–19 (Scottish
National Gallery of Modern Art, Edinburgh)

seeking press articles frequently combined assertions of the *Risen Christ*'s
non-Western racial identity, with descriptions of his "monstrous,"
"revolutionary," "insane," "criminal," "simian" and even "Satanic"
appearance.

One of the more exaggerated examples Barker cites is the following:

Father Bernard Vaughan's diatribe was perhaps the most extreme in tone
although the basic images he used were common to other hostile re-

views. He described the "degenerate" racial characteristics of Epstein's figure, which suggested "some degraded Chaldean or African, which wore the appearance of an Asiatic-American or Hun-Jew, or a badly grown Egyptian swathed in the cerements of the grave."[51]

Later works elicited the same hostility and the same slippage from an objection to the primitivism of the object to prejudices about the ethnic origins of its creator.

The question of whether or not this critical discourse should be read in the context of the history of British antisemitism is a difficult one and is beyond the scope of the present chapter. Elizabeth Barker makes reference to this strand of political thought, and there is certainly plenty of evidence for a long-established (though always changing) tradition of antisemitic thought in Britain.[52] My task here is simply to draw out particular moments of art-critical writings which I believe are indicative of the project of ethnic or racial exclusion as the necessary correlate of the construction of "Englishness." No doubt the rereading of these statements more systematically understood as part of another discourse—that of antisemitism—would provide a different but, I assume, complementary account of the construction of difference in this period. My primary and more limited intention is to demonstrate that in this critical historical period "Jewishness" is invoked in art criticism—often inappropriately, gratuitously, and negatively—in such a way as to reinforce its obverse, namely, "Englishness." This discursive strategy works not only in relation to so-called primitivism but also in relation to the negative response to modernism during the same period, both of which are entirely remote from that visual ideal of "Englishness," the realist rural scene. As Juliet Steyn has shown, the equation of Jewish with avant-garde art (for example, in the critical reception of the 1914 Whitechapel exhibition "Twentieth Century Art") was equally distorted (not all the Jew-

[51] Barker, "The Primitive Within," 46.

[52] See, e.g., Gisela C. Lebzelter, *Political Anti-Semitism in England, 1918–1939* (New York: Holmes & Meier, 1978); Colin Holmes, *Anti-Semitism in British Society, 1876–1939* (London: Edward Arnold, 1979); Tony Kushner, *The Persistence of Prejudice: Antisemitism in British Society during the Second World War* (Manchester: Manchester University Press, 1989). For a discussion of the relevance of antisemitism to the reception of R. B. Kitaj's work in the 1990s, see my essay "The Impolite Boarder: 'Diasporist' Art and Its Critical Response," in *Critical Kitaj: Essays on the Work of R. B. Kitaj,* ed. James Aulich and John Lynch (Manchester: Manchester University Press, 2000), 29–43.

ish artists represented were modernists and not all the modernists were Jews), designed to preserve the (nonmodernist, non-"foreign," non-Jewish) category of "Englishness" and "English art."[53] I take as an example of this the artist David Bomberg (1890–1957), who curated the Jewish section of the Whitechapel exhibition. Bomberg was born in Birmingham, the son of Jewish immigrants from Poland. The family moved to Whitechapel, London, in 1895, and Bomberg later studied at the Slade School of Art. Like Gertler and Kramer, he included Jewish themes (biblical as well as secular scenes from daily Jewish life) in his earliest work. His 1912 painting *Vision of Ezekiel* (fig. 6.5) illustrates a story found in the Old Testament. The following year he painted *Jewish Theatre* (now in the Leeds City Art Galleries). His most radically innovative painting of that period, *Ju-Jitsu* of 1913 (fig. 6.6), verges on the entirely abstract, the increasingly stylized figures of *Vision of Ezekiel* by now so deconstructed as to be virtually unreadable as figures.[54] In the 1914 exhibition Bomberg exhibited in a group of his own work both *Vision of Ezekiel* and *Ju-Jitsu*, as well as the equally abstract *In the Hold* of 1913–14. In his case, the hostile critical equation of modernist and Jewish had some foundation; indeed, Juliet Steyn points out that Bomberg was the *only* Jewish artist in the exhibition whose art could have been characterized as Cubist or Futurist (the general categorization of the Jewish section by some of the press).[55] There has now been a progression from an identification of the "Jewish mark" with subject matter to the very different equation of Jewish-foreign (in this case continental European)-modernist—a triple formulation which produced "Englishness" as both visual realism and ethnic purity.

I have argued that the discourse of art criticism in the period from 1910 to 1920 participated in the construction of the national ideology through the identification (and invention) of excluded entities. These entities were ostensibly particular works of art. In fact, they were particular artists and, through them, a particular ethnic minority. This ideological project was necessarily dependent on the manufacture of

[53] See, e.g., Steyn, "Inside-Out."
[54] Richard Cork has shown how the initial study for *Ju-Jitsu* was far less radical aesthetically than the final version of the painting; at the same time, it can act as a guide to the painting, since the figures in the study are not yet so dramatically fragmented. Richard Cork, *David Bomberg* (New Haven: Yale University Press, 1987), 48–52.
[55] Steyn, "Inside-Out," 222.

6.5 David Bomberg: *Vision of Ezekiel*, 1912 (Tate Gallery, London/Art Resource, N.Y.)

difference and its consequent and persistent reaffirmation. I do not conclude from this either that difference is entirely mythical or that work by Jewish artists should not be approached in terms of the particular situation of those artists, including their ethnicity. In the previous chapter, I suggested that it might be useful to consider Mark Gertler's work in terms of his ethnic background and his related ambivalence about his own heritage and his relationship to British gentile society (particularly to members of the Bloomsbury group).[56] I now conclude by suggesting ways in which the specific situation of certain Jewish artists in early-twentieth-century England may be relevant to the interpretation of their work.

In 1966 Harold Rosenberg addressed the question of whether there is such a thing as "Jewish art." Having reviewed the possible ways in which we may speak of such an art (art produced by Jews; art depicting Jews or containing Jewish subject matter; the art of Jewish cere-

[56] See chapter 5.

6.6 David Bomberg: *Ju-Jitsu*, c. 1913 (Tate Gallery, London/Art Resource, N.Y.)

monial objects; the art of Jewish mysticism; metaphysical Judaica), he concludes that to speak of Jewish art is necessarily to speak of a specifically Jewish *style*. This, he argues, does not exist as a universal phenomenon; hence "we are obliged to conclude that there is no Jewish art in the sense of a Jewish style in painting and sculpture."[57] However, he goes on to suggest that since art produced by Jews in the twentieth century is "the closest expression of themselves as they are, including the fact that they are Jews," and since "the most serious theme in Jewish life is the problem of identity," therefore "this work inspired by the will to identity has constituted a new art by Jews which, though not a Jewish art, is a profound Jewish expression." This formulation allows for the recognition of shared characteristics,

[57] Harold Rosenberg, "Is There a Jewish Art?" *Commentary* 42, no. 1 (1966): 59.

which may include stylistic characteristics, in the work of Jewish artists, while at the same time carefully historicizing that commonality. That is, he makes it very clear that the concern with and expression of Jewish identity (specifically American Jewish identity) is very much a postwar twentieth-century matter situated in a period of "displaced persons, of people moving from one class into another, from one national context into another."[58] It is this kind of sociohistorical exploration of "Jewishness" which I believe is a potentially useful way to discuss the work; indeed, I would venture to say that this is the only legitimate way to talk about such a thing as the "Jewish mark."

With regard to the four artists I have discussed in this chapter, it is possible to map the outline of what such a sociological, or sociohistorical, interpretation might look like. To begin with, although there is no necessary or invariable connection between the work of Jewish artists and the development of modernist and avant-garde art practices in England in this period, these artists were all, at least for a time, in the forefront of such stylistic experimentation. Jacob Epstein was the leading modernist in the field of sculpture, and Bomberg, Kramer, and Gertler were all strongly influenced by Cubism and Futurism, as well their English variant, Vorticism. (The fact that Gertler and Bomberg in particular reverted to pre-Cubist realism after the First World War is not relevant to the question of the nature of their work in the period under discussion.) There were, of course, many non-Jewish artists involved in modernist art practice who produced work informed by the most radical developments in Europe. I am certainly not suggesting that modernism in England was somehow "Jewish," but rather that the active participation of certain Jewish artists in the English avant-garde was a function of their own particular social situation, central to which was their experience as Jewish men from immigrant, working-class, or lower-middle-class backgrounds. A number of mediating factors help to explain their involvement in the avant-garde—these, in turn, the product of their ethnic and familial situations. Central among these mediating factors were a particular training in art, a relatively easy cosmopolitanism, and a clear position of marginality within contemporary British society, together with its correlate, a certain detachment from that sense of "Englishness"

[58] Ibid., 60.

which, as we have seen, was both entrenched and in the process of being reformulated. As I have suggested in the case of Mark Gertler, this detachment from the center (manifest, particularly in his case, in his ambivalent relationship with the Bloomsbury group) allowed and perhaps encouraged a more radical aesthetic than that which was possible for those nearer to the center.[59] Kramer, Bomberg, and Gertler all studied at the Slade School of Fine Art, facilitated by scholarships or patronage, where they were able to mingle with many of those artists who were to build an avant-garde practice on the basis of a rejection of their training at the Slade. Epstein, whose early training was in the United States, studied at the Art Students League, in many ways the nearest equivalent to the Slade in its student population, its openness to lower-income students, and its role as an incubator, within a strong "Ashcan" tradition, of more radical artistic production. Finally, openness to artistic developments in Continental Europe, beyond the Post-Impressionism of Roger Fry, Vanessa Bell, and Duncan Grant (the "official" radicals in England in the prewar period), depended on a certain cosmopolitanism still rare in England but which was far less problematic for artists who were themselves recent immigrants. All four of these Jewish artists visited Paris. Epstein studied there for two years before moving to England in 1905 and visited again in 1912 and 1913. Bomberg traveled to Paris in 1913 in connection with his task as curator of the 1914 Whitechapel exhibition. Jacob Kramer went to Paris to study in 1914. Mark Gertler visited Paris in 1912;[60] his work in the period from 1912 to 1916 (the most radical of his career) was influenced by Cubism (examples of which were also included in the second Post-Impressionist exhibition held in London in 1912) and by Vorticism, itself informed by European Futurism. To repeat, I am not arguing that this particular conjunction of art-school contacts, European travel, and exclusion from dominant social and artistic circles applied only to Jewish artists (or, for that matter, to all of them). My point is that many Jewish artists shared these experiences, as well as the additional one of having to come to terms with their own heritage, their relationship to their families (with, in most cases, their more religious and traditional practices), and their chang-

[59] See chapter 5.
[60] Woodeson, *Mark Gertler*, 82. On a later visit in 1920, he recorded the "enormous impression" made on him by Renoir's work, at the same time saying (in a letter to a friend): "About the more modern stuff I am really not at all sure" (268).

ing attitudes to the role of Judaism in their own lives. In terms of the sociology of knowledge, it makes a good deal of sense to expect something of this confluence of influences to manifest itself in their work. It is in this sense, and *only* in this sense, that it may be possible to talk about "Jewish art." Not only could one continue to explore the various representations of Jewish family life, tradition, and religious practice in the work of such artists; one could also examine, for example, the engagement in modernist art practice of particular Jewish artists in relation to their specific social situations and related aesthetic choices—situations which may include discussion of connection with family, links with, or marginality to, the major cultural and social networks of the period, access to various types of artistic training, the possibility of foreign travel, and so on.

From the point of view of the ideological construction of "Englishness," however, my comments about the legitimate discussion of Jewish art are beside the point. For here the issue is the discursive construction of "the Jew" and "Jewishness" (and, as a subcategory in the visual field, "Jewish art") in the service of the production of the ideology of a nation. Although a sociology of art which explores the work and conditions of production of Jewish artists might be an interesting study, it would make little difference to that other task of critical deconstruction which has been the main theme of this chapter, namely, an examination of the function of the notion of "the Jewish mark in English painting," which, despite its fundamentally mythical nature, had clear political and social effects in a period in which the meaning of "Englishness" was at stake.

Afterword

Modernism, Realism, Revisionism

The preceding chapters have focused on artistic production in England and the United States in the early twentieth century. Their starting point has been the question of modernism as "the painting of modern life," and the ancillary question of the place and meaning of *non*modernist modern art. Inasmuch as the familiar perspective that has privileged modernist (post-Cubist) art as the art of the twentieth century was largely the retroactive effect of a mid-twentieth-century discourse, this book has also taken the longer historical view that allows this development to emerge. For example, in chapter 1 I argued that the women artists of the Whitney circle have been rendered more or less invisible in the history of American art as a result of the high-modernist narrative (closely associated with the Museum of Modern Art in New York, exemplified and reinforced in its acquisitions and display, and consolidated in the postwar period), a narrative that marginalized realism while gendering it female. As the Whitney Museum's 1999 exhibition "The American Century, 1900–1950" made clear, a multiplicity of styles and practices coexisted in the New York art world in the first half of the twentieth century, an aesthetic plurality not yet organized into the hierarchy that was to be established a little later.

Collectively representing a series of studies in the sociology of modernism, these chapters have explored the social conditions in which modernism emerged in England and the United States, as well as the discourses (both contemporary and subsequent) that produced "modernism" and "modernity." Although my primary

emphasis has been on the gender dimensions of this process (chapters 1, 3, and 4) and the complexities of ethnic identity in play (chapters 5 and 6), I have also considered the ways in which social class complicates these issues at certain moments (chapters 2 and 5). Throughout I have attempted to do two things: to emphasize the extra-aesthetic factors (social, institutional, ideological) that have participated in the construction of a particular narrative of modern art; and to contribute to the project, undertaken in the past few years by several critics and scholars, of making visible nonmodernist work in England and the United States in the period 1900 to 1940.

As I suggested in my introduction, however, the dichotomous thinking that underlies my critical approach can be quite problematic. The opposition modernism/realism does not necessarily hold up in the particular cases, nor is it always helpful as a general (or historical) framework of analysis. Definitions of "realism" are multiple, ranging from illusionistic realism (trompe l'oeil, hyperrealism, High Renaissance painting) through social realism (figurative, descriptive, representation of "real" social conditions) and socialist realism (figurative, analytic-critical, representation of "real" social conditions and their underlying structures) to what Brecht called "true realism" (realism appropriate to the twentieth century, which for him was, in fact, modernism). David Peters Corbett and Lara Perry reverse Brecht's view, proposing not that modernism is realism but that realism is (or can be) modernist if one extends the definition of "modernism" to encompass all "art which grows out of and responds to modern conditions, whether it is formally innovative or not."[1] Brendan Prendeville has made much the same point in his review of varieties of twentieth-century realism.[2] Moreover, "realism" and "figurative art" are by no means coterminous (though they are often used interchangeably, including in this book). Nor are modernism and figurative art necessarily opposites; even Cubist portraits are figurative despite the fact that the figure is portrayed in radically new ways. Lisa Tickner has argued

[1] David Peters Corbett and Lara Perry, introduction to *English Art, 1860–1914: Modern Artists and Identity*, ed. David P. Corbett and Lara Perry (Manchester: Manchester University Press, 2000), 2.

[2] For example, he says that "Cubism . . . takes realism apart, but does so for a realist end." Brendan Prendeville, *Realism in 20th Century Painting* (London: Thames and Hudson, 2000), 50.

that, in any case, local modernisms differ "because there are local in-flections to the web of relations that makes up the cultural field."[3]

In chapter 2 I made the point that Kathleen McEnery's "realist" paintings were certainly very *modern* examples of realist art, indeed, that one can see a shift within her oeuvre from the more traditional re-alism of her teacher Robert Henri to work done later, following her stay in Europe, which was clearly influenced by Post-Impressionism and occasionally hints at a post-Cubist and post-Expressionist visual register. In general, I have written as though works of art were either one thing or the other (modernist or realist/figurative), including cases (as with Mark Gertler) where both styles can be found within a painting career. I want to stress that such a dichotomy is basically a heuristic device, helping to structure the field and to highlight ten-dencies and differences. To that extent, my own category of the "An-gloModern" is just as provisional—and, despite its prominence in the title of this book, not entirely serious. I am certainly not claiming to have identified a uniform, homogeneous, trans-Atlantic art practice. At the same time, I do claim that the term usefully encapsulates *some-thing*—a series of visual texts and styles, a shared aesthetic, a range of responses to modern life—that has been defined *negatively* by the later formulation of a particular account of modern art in the period. The fact that, as Andrew Causey has stated, the concept of the real is not stable and that realism itself is necessarily redefined in different cir-cumstances does not mean that the term is not useful; nor does the fact that the boundary between discursive opposites may blur in prac-tice.[4] Certainly one is on the wrong track if one hopes to establish a chronological divide, not least because, as current scholarship has made clear, "styles" and "periods" are themselves ultimately arbi-trary constructions.[5] Nevertheless, I believe it is not only useful but

[3] Lisa Tickner, *Modern Life and Modern Subjects: British Art in the Early Twentieth Century* (New Haven: Yale University Press, 2000), 193.

[4] Andrew Causey, "The Possibilities Of British Realism," in *The Pursuit of the Real: British Figurative Painting from Sickert to Bacon*, ed. Tim Wilcox (London: Lund Humphries, 1990), 19, 26. In her unpublished manuscript "Sackcloth and Ashes, Ges-ture and Form: Kitchen Sink Realism and Abstract Expressionism in the 1950s," Lucy Curzon makes the related important point that "realism was (and is) a continually evolving aesthetic and thus . . . its opposition to modernism (whose definition is also influenced by social and cultural conditions) is only ever momentary" (7).

[5] See Ludmilla Jordanova, "Periodisation," in her *History in Practice* (New York: Ox-ford University Press, 2000), 114–40. See also Jonathan Gilmore, *The Life of a Style: Begin-nings and Endings in the Narrative History of Art* (Ithaca: Cornell University Press, 2000).

crucial to operate with this opposition as the conceptual framework, which allows us to explore processes of privileging and exclusion. Institutional practices of selection and evaluation, after all, are premised on the perception of such a divide.

One approach that late-twentieth-century revisionism has taken has been to discover precursors to modernism in unusual places. Among many examples, some more surprising than others, it has been claimed that aspects of modernism can be found in nineteenth-century Italian sculpture; in Pre-Raphaelite painting of the mid-nineteenth century; in the work of the High Victorian artists Frederic Leighton and Alfred Stevens; and in the regionalist paintings of Thomas Hart Benton.[6] Whether or not it is helpful to identify such tendencies, the inclination to make this search and to announce such discoveries seems to be part of the increasingly widespread recognition of the arbitrary nature of the modernist/nonmodernist divide. More problematic are the aesthetic implications of these revisionist projects, and nowhere has this been more evident than in the case of the "Invasion of the Illustrators." The Norman Rockwell and Maxfield Parrish exhibitions (see my introduction) posed challenging questions as they traveled to major museums, with New York as the terminus for both. Of course, their very appearance may have been the logical consequence of the less dramatic revisionism that was already conceding space to realism, to Victorian painting, and to alternative modernisms. The logic I am describing is clearly expressed in this comment by Robert Rosenblum from the Rockwell exhibition catalogue:

> I had been taught to look down my nose at Rockwell, but then, I had to ask myself why. If it had already become respectable to scrutinize and admire the infinite detail, dramatic staging, narrative intrigues, and disguised symbols of Victorian genre paintings, why couldn't the same

[6] Respectively: Alex Potts, *The Sculptural Imagination: Figurative, Modernist, Minimalist* (New Haven: Yale University Press, 2000); Elizabeth Prettejohn, *The Art of the Pre-Raphaelites* (Princeton: Princeton University Press, 2000); Tim Barringer and Elizabeth Prettejohn, introduction to *Frederic Leighton: Antiquity, Renaissance, Modernity*, ed. Tim Barringer and Elizabeth Prettejohn (New Haven: Yale University Press, 1999), xiii–xxxii; Griselda Pollock, "Interventions: Griselda Pollock Looks at Alfred Stevens" (brochure) (Williamstown: Clark Art Institute, 2000); Erika Doss, *Benton, Pollock, and the Politics of Modernism: From Regionalism to Abstract Expressionism* (Chicago: University of Chicago Press, 1991).

standards apply here? . . . Now that the battle for modern art has ended in a triumph that took place in another century, the twentieth, Rockwell's work may become an indispensable part of art history.[7]

The same impulse that has caused some scholars and art-world professionals to think more critically about the canon and its exclusions—and to turn their attention (and open their gallery and museum spaces) to marginalized or "minor" artists—also obliges them to acknowledge the open-endedness of this move. In other words, once the institutional and political basis of canon formation is acknowledged, the social construction of high- versus lowbrow, of art versus popular culture, can hardly be denied.[8] Sylvia Yount, curator of the Maxfield Parrish show, argues her case for the rehabilitation of Parrish as a "serious" artist based on the historical argument of the separation of art and popular culture: "Parrish's reputation suffered as the ever-widening gap between 'high' and 'low' art, painting and illustration, polarized in the postwar years. As a result, his work is given scant, if any, attention in art-historical scholarship, even by those writers who claim to take a more inclusive view of visual culture."[9] Specifically, she lays the blame at the feet of the influential modernist critic Clement Greenberg, whose 1939 essay "Avant-garde and Kitsch"—generally acknowledged as a key text in the formation of the dominant narrative of modern art—referred to Parrish by name and "firmly placed the artist's work in the enemy camp."[10] (Rockwell's work is also assigned to the category of kitsch in the same

[7] Robert Rosenblum, "Reintroducing Norman Rockwell," in *Norman Rockwell: Pictures for the American People*, ed. Maureen Hart Hennessey and Anne Knutson (New York: Abrams, 1999), 183.

[8] In the context of debates in the related field of critical musicology, Stefano Castelvecchi has pointed out that language makes all the difference here; composers once considered "minor" (*Kleinmeister, minori*) become, for critical theory, "marginalized," with all the ideological implications of that term. As he says, "We all despise marginalization—don't we?" "Statement" in *Musicology and Sister Disciplines: Past, Present, Future*, ed. David Greer (Oxford: Oxford University Press, 2000), 188. My thanks to Ralph Locke for this reference.

[9] Sylvia Yount, "Dream Days: The Art of Maxfield Parrish," in her *Maxfield Parrish, 1870–1966* (New York, Abrams, 1999), 16. The book is the catalogue for the exhibition, which originated at the Pennsylvania Academy of the Fine Arts and traveled to Manchester, New Hampshire, and Rochester, New York, before arriving at the Brooklyn Museum of Art in May 2000.

[10] Yount, "Dream Days," 118. See Clement Greenberg, "Avant-garde and Kitsch," *Partisan Review* vi, no. 5 (1939): 34–49. Reprinted in Francis Frascina ed., *Pollock and After: The Critical Debate* (London: Harper & Row, 1985), 21–33.

essay.) It is certainly a peculiar feature of the Greenberg essay that it has the effect of equating nonmodernist "high" art with popular visual culture, whereas most critics, including those who privilege modernism or abstraction over realism, would still draw a distinction between art and illustration, between even the most clichéd and sentimental work shown, say, in the Royal Academy of Art summer shows in London and the mass-produced, mass-circulated work of magazine illustrators. In confronting the challenge of situating Rockwell today, some critics have tried to solve the problem by discussing the *originals* of his images—that is, assessing him as a painter.[11] Other responses have ranged from firm, if unarticulated, acceptance ("Clearly the time has come to take Norman Rockwell seriously") to uncertain wavering ("Could it be that art professionals, or a few of them anyway, are coming around to thinking he's a good artist? Well, yes. He is a good artist, on his own terms"), to acceptance as "bad art" ("I like the vogue for bad art, which represents a welcome release from the snobbery of past"), to unapologetic dismissal ("A Rockwell extravaganza is just another clever muddle of Dadaism, populism, philistinism, and commercialism").[12] Perhaps the most bizarre corollary to the aesthetic dilemma posed by critical visual studies has been the case of Thomas Kinkade, the immensely successful commercial artist of made-to-order sentimental paintings ("The Blessings of Spring," "Hometown Evening"). The works are mass-produced, finished by specially trained "master highlighters," and sold in malls and shops throughout the United States as part of a multimillion-dollar indus-

[11] See, e.g., Wanda Corn, "Ways of Seeing," in *Norman Rockwell: Pictures for the American People*, ed. Maureen Hart Hennessy and Anne Knutson (New York: Abrams, 1999), 81–93; Charles Rosen and Henri Zerner, "Scenes from the American Dream," *New York Review of Books*, August 10, 2000, 16–20. Toward the end of his long review of the exhibition at its opening in Atlanta, Peter Schjeldahl says: "Rockwell painted beautifully, by the way." See his article "Fanfares for the Common Man: Norman Rockwell, Reconsidered," *The New Yorker*, November 22, 1999, 193.

[12] Respectively: Anita Gates, "Looking Beyond the Myth-Making Easel of Mr. Thanksgiving," *New York Times*, November 24, 1999; Michael Kimmelman, "Renaissance for a 'Lightweight,'" *New York Times*, November 7, 1999; Deborah Solomon, "In Praise of Bad Art," *New York Times Magazine*, January 24, 1999; Jed Perl, "Atlanta Diarist: High Low," *The New Republic*, December 27, 1999. The following is from a letter written by reader James Thompson in response to Schjeldahl's review: "The critical and commercial juggernaut carrying the remains of Norman Rockwell to canonization as a great American master should be stopped." *The New Yorker*, December 13, 1999.

try.[13] The debates about Rockwell raised the possibility of opening up the field further, with the interesting consequence of new and subtle distinctions being drawn between Rockwell and Kinkade, the definition of "kitsch" in flux to deal with this new challenge.[14]

The crisis of aesthetics, of which the Rockwell phenomenon is one manifestation, has been a real one for art historians, critics, and curators. It is a problem, (as I demonstrated in chapter 1) that I faced in considering the work of the artists in the Whitney circle. In the case of Kathleen McEnery (chapter 2), an exploration of the various social and geographical factors that contributed to her "disappearance" and "discovery" cannot answer the question of whether she *ought* to take her place in the canon. (The question is a practical as well as an academic one; the museums that own her work keep it in storage for the most part.)[15] It is one thing to demonstrate the radically contingent nature of the formation of the canon—its historical, economic, institutional, ideological, and discursive coordinates—and the systematic exclusions on the basis of nation, race, gender, and style. Much more difficult is the task of developing an aesthetic which is *not* subject to the charges against the precritical version. The two extreme positions would maintain that (1) aesthetic quality is entirely a product of situated, partial perspectives (and hence there can be no universal aesthetic); and (2) the sociology of art has absolutely no implications for questions of aesthetic judgment, which transcend the contingencies of

13 See Russell Scott Smith and Ken Baker, "Sunny Side Up: Thomas Kinkade's Pretty Pictures Make Critics Cringe as They're Making Him Rich," *People*, April 10, 2000; Tessa DeCarlo, "Landscapes by the Carload: Art or Kitsch?," *New York Times*, November 7, 1999; Susan Orlean, "Art for Everybody," *The New Yorker*, October 15, 2001.

14 The following is from a letter dated November 28, 1999, to the *New York Times*: "By comparison to Mr. Kinkade, and his vapid confections, Norman Rockwell can be appreciated as a serious, albeit minor, artist who tried to avoid clichés rather than deliberately embracing them." Reflecting on the blurring between art and kitsch represented by the Rockwell show, DeCarlo asks: "With sweetness, sincerity and bad taste seemingly in the ascendant, is a Kinkade show at the Guggenheim next?" Her answer: "Well, no. As yet Mr. Kinkade has no champions in the high-art world, not even among those who endorse other popular antimodernisms. . . . Even Mr. Rosenblum draws the line at Thomas Kinkade." "Landscapes by the Carload."

15 The National American Art Museum has one painting; the Memorial Art Gallery in Rochester has eight, only one of which is on display in the gallery itself. The Eastman School of Music and the Rochester Science and Museum Center both keep their McEnery portraits in storage.

the production of art. The more helpful position, in my view, is one that acknowledges the situated nature of aesthetic evaluation while deferring to the relatively autonomous discourses *of* aesthetics, which mobilize their own languages of assessment (style, technique, originality, composition) in making judgments about works of art.[16] Of course this *is* to deny a transcendental aesthetic, but it is also to refuse the reduction of the aesthetic to the sociological. In an important essay on the nature of the canon in the history of art, Keith Moxey concludes that we must accept the necessity of parallel canons, each with its own constituency and values.[17] I do not believe we need to go so far in the evacuation of the field of the aesthetic. It is clear that the traditional canon(s) can no longer be uncritically promoted, and it is just as clear that however much one fills the "gaps" (by adding women, minority artists, realist painters), the canon still remains open to the objection that it is a construct and is thus still always provisional. I suggest that we should not be afraid of working with such a provisional canon, provided we retain a critical reflexivity, a recognition of its fundamentally arbitrary nature, and an openness to rethinking its boundaries. The critical failure of curatorial attempts to abandon chronology, hierarchy, and medium-specificity (as in the first part of "MoMA 2000," which I discussed in the introduction) has demonstrated both that exhibitions need a structuring principle and that a kind of vaguely postmodern abandonment of narrative cannot be the basis for a show. (One could also add that even an apparently eclectic display has still been selected by *someone*, on *some* principles, and that perhaps a hidden agenda is more pernicious than an explicit one.)

With regard to modernism and realism, there are certain limits to revisionism, which for now ensure that the end-of-century activities may not have made a great deal of difference in the mainstream of scholarship and museum practice.[18] It is true that as a result of critical art history and the new museology, Mary Cassatt, Paula Modersohn-Becker, and Gwen John have taken their place in exhibitions, permanent collections, and art-historical texts, as have Jacob Lawrence (with

[16] I have discussed these issues in *Aesthetics and the Sociology of Art*, 2d ed. (Ann Arbor: University of Michigan Press, 1993).

[17] Keith Moxey, "Motivating History," *Art Bulletin* 77, no. 3 (1995): 392–401.

[18] For a related assessment of an earlier moment, see Neil McWilliam, "Limited Revisions: Academic Art History Confronts Academic Art," *Oxford Art Journal* 12, no. 2 (1989): 71–86.

a retrospective at the Whitney Museum of American Art in the fall of 2000) and artists of the Harlem Renaissance. Figurative artists Lucian Freud, R. B. Kitaj, and Edward Hopper had major exhibitions in the late 1990s, and the work of Whitney artists Guy Pène du Bois and Yasuo Kuniyoshi has been more visible in recent years. But it is still unexceptional to come across generic dismissals of nonmodernist work and, indeed, of whole national traditions, as in the following comment: "From an art perspective, England has always been ultra-conservative and, frankly, a bit of a snore. . . . Even since the time of angst-ridden modernists like Francis Bacon and Lucian Freud, British art has remained quaintly tethered to the figurative tradition, as if everyone wished the 20th century would just go away."[19]

More surprisingly, Charles Harrison, whose groundbreaking work on English art and modernism was the starting point for an explosion of fascinating new work on twentieth-century English art, has now re-treated to a formalist aesthetics that, in his view, continues to rank much English art as "inferior" to European modernism, arguing (against those who had followed him) that the best English art is one based on "the very extinction of Englishness."[20] I agree that the criteria for judgment must be independent of the sociological axes of the production and reception of art, but he fails to follow through with any explanation of such criteria, falling back on the uncritical hierarchies that predated his own intervention in the field. I think this case demonstrates the real resilience (and resistance) of mainstream art history. The moment of revisionism has been a fascinating one, and it has provoked important and interesting debates and exhibits. It remains to be seen whether it will have been more than a momentary, millennial awakening. In the meantime, I have presented these chapters as studies in the sociology of modernism. My hope is that they will form part of the continuing dialogue about modernism and realism, and about the place of gender and ethnicity in narratives about early-twentieth-century art in England and the United States. Far too long neglected or condescended to, the "AngloModern" is highly deserving of our attention.

[19] Deborah Solomon, "The Collector," *New York Times Magazine*, September 26, 1999, 46.
[20] Charles Harrison, "'Englishness' and 'Modernism' Revisited," *Modernism/ Modernity* 6, no. 1 (1999): 82.

Index